20TH APRIL - 13TH MAY
THE ANNUAL EXHIBITION OF ESTONIAN
ARTISTS ASSOSSIATION IN TALLINN ART HALL
VABADUSE SQUARE 8
OPEN 12-18, R 12-20
CLOSED ON TUESDAYS

'Young British Art', exhibition brochure, 2001

INTRODUCTION
WHAT'S WRONG WITH
THIS PICTURE?

young

British

art

Nation's crazy notions

An Estonian guy came up to me recently, to show off a brochure for an exhibition he'd organised with some other Estonians at a gallery in Tallinn, the capital of Estonia. It was called 'Young British Artists'. All the artists in it were Estonian rather than British. They'd just appropriated the term 'Young British Artists' for its voodoo power, and the whole event was a joke on the mythology of the British art scene. It was partly about the art of the yBas and partly about the obsessions of the British.

Typical Brits

Brits are very fond of animals and children. Their exhibitions now are full of animals, usually mutants of some kind, or sexually aroused, or dead – for example, sharks and pigs by Damien Hirst, which symbolise death. And racehorses by Mark Wallinger, symbolising class, but with the front ends different from the back ends – symbolising weird mutant-breeding. The children in exhibitions are also mutated somehow, perhaps by nuclear fall-out, and certainly sexualised – like the Chapman brothers' porno-child mannequins.

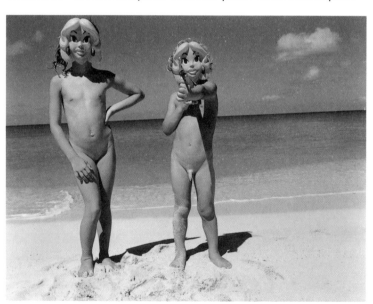

Tierney Gearon, *Untitled*, 2000

Look mum, no pants!

In fact porno children are rampant in British art galleries now, because of the recent craze for featuring nude children in art photos, and then teasing the British media with the notion that they might not be porny.

Estonians

And so the Estonian show was full of all that too. It was full of outrage and shocks, and testings of taboos. International animal rights activists protested against live bees being used as part of one of the exhibits. They posted messages on the Web saying the Estonian guys should be shot and their brains painted on the gallery walls – they said that would be a better work of art. And officials from the Estonian Ministry of Culture went round to put a black cloth over another exhibit, this one featuring some child porn, which by law couldn't be removed for the duration of the show.

Africans

As the Estonian guy described his 'Young British Artists' show and its themes of shock and censorship, I thought it seemed like Africans in the days of Empire, making primitive sculptures representing missionaries – absorbing the Christian message but turning it round so it becomes part of voodoo. But that was wrong, of course, because the art of the yBas is already dark and irrational.

Punks

The Estonians' gag was about having a punk attitude – partly awe, partly wishing to destroy – toward an already punky art. The Estonians wanted the yBas' amazing success for themselves, but they were clear-headed enough to see the distortions of the success: the twisted relationship of the British media to the yBas, and of the yBas to the media.

British Council

Even the British Council as a target for the punky Estonians was a confusing one. Rather than seeing it as a bunch of useless gits, the Estonian artists valued the British Council as a useful institution – in fact they were sorry the British Council was suing them now for wrongful use of the British Council logo on the 'Young British Artists' brochure.

British week

I met the Estonian guy after giving a talk in Riga, the capital of Latvia. The talk was about the British art scene. It was part of an event in Riga called 'British Week'. My audience was trendy and enthusiastic. Like the Estonian guy, they already knew a lot about the Brit scene: they knew the acronym 'yBa' and all the main figures and exhibitions, and the media scandals associated with the

Jake and Dinos Chapman, *Fuck Face*, 1994

exhibitions. They wanted to get an art scene going in Riga, where at present there are no galleries or collectors, and no modern art museum, so they were hungry for even more information about the scene in Britain. I said they should try to be more Latvian. I made this comment because I was struck by the idea of a nation, Britain, having a kind of art that was all about the psychic illness of the nation. And then another nation, Estonia – which was in the process of reinventing itself – seeing the first nation's official type of art, with all its twisted campness and neurosis, as something to admire.

British rubbish

In the lecture, I said art becoming popular in Britain in the last few years had been a great surprise, since it never had been popular in the past. In fact it was hardly thought about at all. But although the main type of art the new popular British audience is familiar with – done by the yBas – is good and amusing, it represents a narrow idea of what art can be: jokey and ironic and not much concerned with anything aesthetic. On the other hand, it isn't completely unaesthetic and the main artists are good precisely because their art has a bit of an aesthetic side. But the reason the art is successful is not because it's good; it's because it's about issues that anyone can get, which touch everyone and which are in the media all the time: sex, shocks, social change, social deterioration, social unease. So when something aesthetic about this kind of art is ever mentioned in the promo-talk for the art, what is said is always transparently rubbish – because there isn't a climate of anyone talking seriously about anything aesthetic. Certainly not in the media world, but also not in the art world any more. No one is used to it, so it's bound to be crude. No one wants to hear about it, because it's difficult. Whereas the whole art popularity explosion is based on non-difficulty, or having shocks instead of difficulty – the same shocks the media are obsessed by.

British ads

In fact, I continued, the art of the yBas is profoundly connected to the media, but not necessarily identifiable with the media or complicit with media evil. It's often funny and sharp on the subject of the mentality of the media. And the same with ads – the art is connected to ads but it isn't the same as ads. It has the same power that ads have of getting information over in a quick blast. But unlike ads, the information is quirky and has a bit of lasting power; it isn't tied to selling products or indeed to any obvious selling point.

Hmm

Recently, I continued – still lecturing – there has been a mini-backlash of artists wishing to be seen as more left-wing and also more generally thoughtful than the main yBas, and not so decadent. The popular audience hasn't caught up with this notion yet, even though the main institutions the public identifies with the yBas – including the Turner Prize and Tate Modern – have all had a go at giving the backlash-art the same level of promotion and publicity. The last few Turner Prizes have all been won by pious pc artists, and in one case spectacularly lost by a non-pious figure, Tracey Emin. Because the public hasn't suddenly become obsessed with pc values and piety, or nostalgia for 60s-style left-wing radicalism, the backlash-artists are able to enjoy the illusion that they really are doing something that strikes against the values of the media. Even though the same artists, blessed in their own eyes as goody-goodies, are still just as desperate as the yBAs to be successful and to be on TV all the time.

Cup of tea

My talk was winding up now. In reality (I said), art that isn't issue-based, or more or less shock-based – whether the shocks are motivated by pc liberal sentiments or frankly nihilistic, decadent, fiddle-while-Rome-burns sentiments – is almost entirely ignored by the official power structure in Britain. That is, any art connected directly and unequivocally to an aesthetic notion of art, rather than a gags and ideas notion, is ignored. And consequently it is ignored by the media, and again by the public. I said I didn't think any of this was a great crime against taste, though, or that Nick Serota, the boss of Tate Modern and Tate Britain, ought to be horsewhipped. Just that it might not be every nation's cup of tea to have a complete closure on anything thoughtful, serious, aesthetic or feeling-oriented in art.

DJ

The main attractions of 'British Week' in Latvia included morris dancing, music by Tippett and Elgar performed by the orchestra of the National Latvian Opera, and tours round some Royal Navy frigates. The arty events of 'British Week' were much more youth-oriented than the main events, and in fact the whole idea of contemporary art in Riga seemed to be connected to a youth subculture of music and partying. I learned Rigan rave had been thriving since 1995. The groovy, youthful Rigans who'd been

instrumental in getting it off the ground were the same people who invited me over to lecture – the British Council paid my expenses, but the rave people were in charge of me for the week. They'd also invited a lot of DJs and musicians over from London, some of whom – a group called Eyecon – were on stage after my talk, explaining what their DJ-ing was about.

VJ

In fact the talkers after me were VJs as well as DJs. VJs are video jockeys instead of disc jockeys. They design entertaining film and video projections for use at music events. The V and DJs thought it was great that art was now perceived by youth to be connected to DJ-ing and VJ-ing. They were overjoyed that the Bluenote in Hoxton Square – the club where they'd performed a few times – was next to the gallery that showed Damien Hirst – White Cube² – because it was a literal connection. I thought this connection was a distortion, though: it was a product of the official support and promotion of the art of the yBas, which meant that nobody ever thought art could be anything else but youth art with entertainment and shocks. So I wanted to be slightly against VJs and DJs at this talk, even though on a personal level I thought they were all nice.

Fridge theme

A second reason it was hard to be pure about my new anti-DJ and VJ principle was that another of the DJs invited over from England was in a band called Fridge, which had done the theme music for *This Is Modern Art*. This was a Channel Four TV series from 1998, which I wrote and presented. As it was a successful series, which won many awards, I had to admit my own culpability in the problem of art being excessively youthful now, even though I'm 46.

Good British author

At the end of 'British Week' there was an all-night performance/installation/rave on the outskirts of Riga, called 'Animal Farm'. The music was good, the V and DJ-ing superb, the art disgusting – just the combo the Rigan audience wanted, so the party was completely successful. The theme was animals, either their slaughter for dinners, which is universal, or to stop foot and mouth – which is more British. But also animalism, in the minds of the 'Animal Farm' organisers, meant the way humans could be looked at as animals, either allegorically, to simplify a complex message, as in George Orwell, or more bluntly – because being obscene is to be like an animal.

Lovely Mozart

The most obscene thing at 'Animal Farm' was a live performance by the Kamichaos Twins – two bald, tattooed guys sticking nails through their necks and hanging chains from them with heavy weights on the end, which they swung to and fro. One was Belgian, one was Scottish. During the act, opera and choral music played at ear-splitting volume, so that at one point one was treated to the spectacle of a Kamichaos twin getting an audience member to hammer a nail into the twin's shin, while being deafened by the *Kyrie Eleison* from Mozart's *Requiem*.

British head

The art installations at 'Animal Farm' were all in smallish, glass-walled, brightly-lit rooms, a bit like prostitutes' booths in Hamburg or Amsterdam. One work was a row of real severed chicken feet with the talons all painted with nail varnish. Another was a mechanical toy duck eating a chicken dinner, with the walls all covered with huge photo blow-ups of distressing battery-farming scenes. There were a lot of films at the event, as well, by British artists and by artists of the Baltic States. One was animal-oriented in an obvious way – a girl lying on her back in a field, filming her own legs and the muzzles and arses of cows as the creatures plodded around her. Jake and Dinos Chapman's film, *Bring Me the Head*, was definitely on the man-as-beast side of things. It featured porn actresses massaging each other's nipples and simulating oral sex with a disembodied head, which had an erect penis instead of a nose.

Poor country

Just before I was invited to Riga I had a premonition of the kind of surrealism I was about to experience there, when I opened the post and found a real British Council press release, with information about a show of real British art, of the post-yBa, or pseudo-thoughtful/left-wing kind, called 'Wales'. The show was organised by the British curator Alex Farquharson and was just about to open in Zagreb, the capital of Croatia. I remember thinking it was like a bizarre version of the old days when the British Council used to send Henry Moore sculptures to Europe after the Second World War – it was to help war-torn lands with modern art. Only now they were helping an Eastern European country where there'd just been some of the worst atrocities since the Nazis, not with art that stands for peace or humanity, or for Man being in a good relationship with Nature, but for a kind of nutty, amusing, swimming, giddy feeling.

Puzzle of protest

From the press release for 'Wales' I learned Welshness featured as a theme, but not in a way that had any weight or meaning. And a theme of protest and politics ran through the show, but it was a tease to work out what the protest might be – if you failed at that you could always work out what the Welshness might be.

Tales of Wales

Maybe John Cale, who is Welsh, was protesting against gall stone operations in *Songs to Drella*, his late-1980s homage to his deceased early mentor Andy Warhol, who was Czech and who died from complications resulting from a gall stone op. Or maybe the inclusion in the show of a film of Cale performing these songs was a celebration of the Welsh people's natural joy in singing. One Conceptual artist from the 1960s, Keith Arnatt (is he Welsh?), was going to be showing photos of urine stains left by his dog on their evening walks back from the pub, which I supposed might be in Wales. Another work was going to be photos by artists who aren't Welsh of boards in the windows of someone's house in Clare Road, Cardiff, all of which were covered with printed protests against Cardiff City Council.

Droning boredom of Manic Street Preachers

And there was going to be another documentary in 'Wales', a film of Arthur Scargill giving a talk at 'Unconvention' in 1999. This was an event put on by the British artist Jeremy Deller at the Cardiff Centre for Visual Arts. Apparently the great union leader spoke of '…war photography, the involvement of South Wales miners in the Spanish civil war and the miners' strike of 1984/5, and the activist message of the Manic Street Preachers'. Fantastic!

End of intro

This has been an unconventional intro. It wasn't exactly a plain guide to some twisty pathways about to come up. It was quite twisting itself, with many different scenarios: the 'Wales' show, 'British Week', the Estonian fake 'Young British Artists' show, my lecture in Riga about the real yBas – and somewhere in there a benign Britannia with her little frigates. But now it's time to start reading the book. Music by ancient Modernists and Victorians plays – Tippett and Elgar. The sounds go out to meet the sounds of Eyecon. The notes carry the good news to all nations of the yBas and post-yBas, their difference and similarity. Their art is a hot

international export, and a balm and an inspiration to trouble spots around the world. Let's tip the morris dancers overboard and sail up the Thames now, toward the most successful modern art gallery there's ever been.

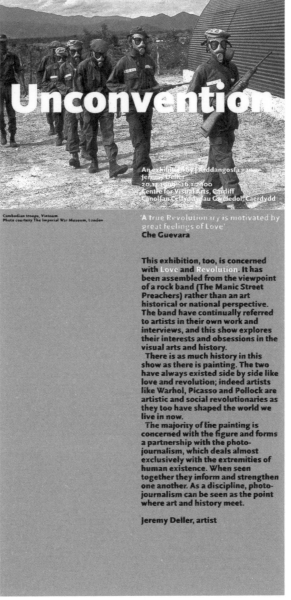

Jeremy Deller, 'Unconvention', exhibition brochure, 2000

Cambodian troops, Vietnam
Photo courtesy The Imperial War Museum, London

'A true Revolutionary is motivated by great feelings of Love'
Che Guevara

This exhibition, too, is concerned with Love and Revolution. It has been assembled from the viewpoint of a rock band (The Manic Street Preachers) rather than an art historical or national perspective. The band have continually referred to artists in their own work and interviews, and this show explores their interests and obsessions in the visual arts and history.

There is as much history in this show as there is painting. The two have always existed side by side like love and revolution; indeed artists like Warhol, Picasso and Pollock are artistic and social revolutionaries as they too have shaped the world we live in now.

The majority of the painting is concerned with the figure and forms a partnership with the photo-journalism, which deals almost exclusively with the extremities of human existence. When seen together they inform and strengthen one another. As a discipline, photo-journalism can be seen as the point where art and history meet.

Jeremy Deller, artist

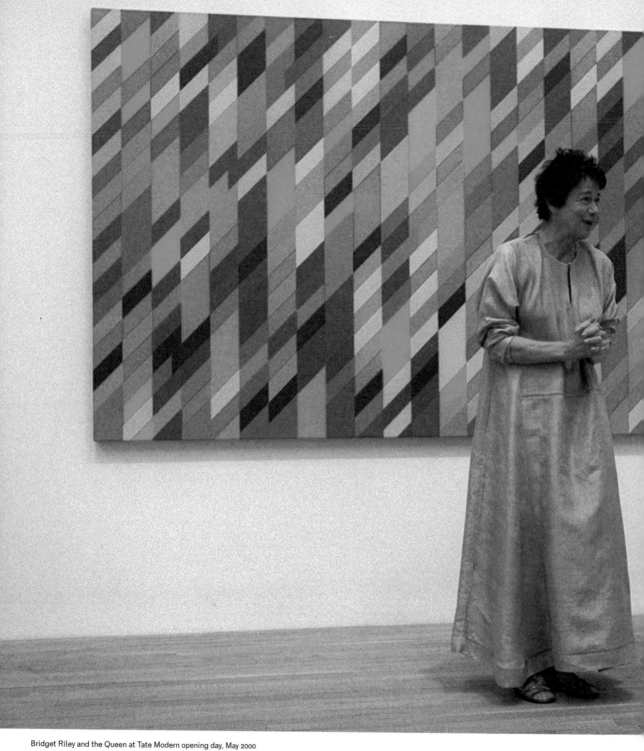

Bridget Riley and the Queen at Tate Modern opening day, May 2000

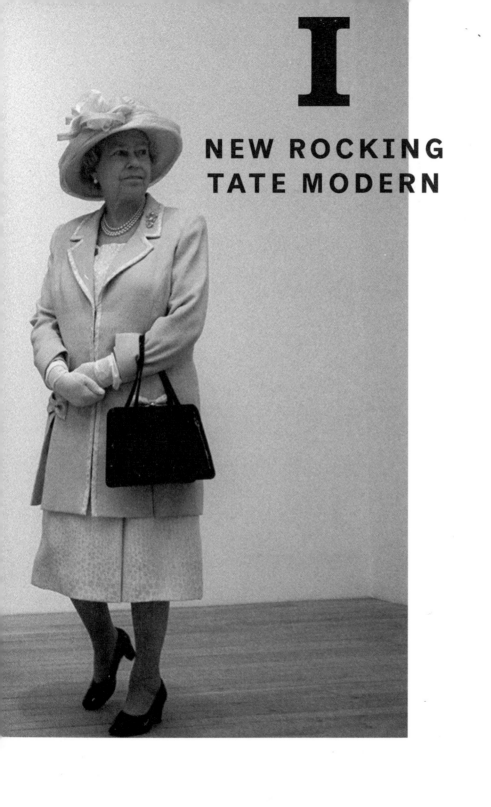

I

NEW ROCKING
TATE MODERN

Tate Modern light show opening party, May 2000

Opening party

On reflection, all the elements of our new art-crazy nation were laid out in microcosm at Tate Modern's opening night party, on 11 May 2000. There was a bit of unreal social protest in the form of placard wavers outside the gallery. And there was some historical awareness, unhinged from any conventional idea of meaning, in the musical theme for the party: a genuine northern brass band playing acid house (ecstasy-friendly type of music that first became popular in Britain in 1988). There was some teacher-ish show-and-tell in the explanations on the gallery walls, which 'explained' in a completely coded and frankly arch way – which no one outside the art world could be expected to get anything from – new democratic meanings that art might possibly have now. And in the party mix of right-on artists and trendies with society power people and fashion and pop people, there was the new idea of art's social status in Britain, and its relationship to money and success.

A thousand pounds

The crowds thronged outside Tate Modern as the sun set. Everyone had a glow about them of being an invitee and not one of the uninvited. They'd read in the papers that in the run-up to the party, touts were offering black-market tickets for a thousand pounds each. The thought added to the pleasure of being there, even if it was untrue – which it obviously was. Guilt-free art lovers crossed picket lines put up by envious artist-outsiders. They didn't know who was protesting out there. Maybe it was the Stuckists. They'd heard of them because whenever their name was mentioned in the press, Tracey Emin's name was too, and she's someone everyone wants to read about.

Good horrible

Earlier, the Queen had been in to bless Tate Modern. It was a lovely spring day. Then at seven the party began with the sound of the brass band, quite horrible to hear. But it was good if you thought about the possible meaning: the non-synchronicity of acid house anthems with brass bands, but also of both with the Tate.

Big lumpy

The party guests came down the industrial-scale ramp and got their first blast of the Tate Modern interior architectural experience: enormous space, white transparent panels and electric light, high walls, metal escalators, bunker-like exciting modern emptiness and sudden looming geometric substance. They got champagne and canapes and showed themselves to each other in little clumps round the bases of some big lumpy bronze towers – all three of them making up a single installation by Louise Bourgeois, sponsored by Unilever. The guests went out into the gallery's lower side spaces and up the escalators, and looked out of the immense windows down onto the just-arrived crowds still milling below. They could see people near their level standing on top of the bronze towers and looking out into the vast space of the atrium, where presumably huge machinery used to be when it was an industrial building – before industry started to disappear, replaced by technology and culture. And if it was someone they knew, whom they didn't want to fall off, they got a feeling of vertigo.

Jeremy Deller, *Acid Brass*, 2000

Many levels

Up on the top floor the guests saw videos by Bruce Nauman that swore at them, and a lot of other conceptual art films that droned on in darkened rooms. Coming down to the lower floors again, they entered high-ceilinged spaces where sinister little confrontations of mismatched types of art awaited them: Monet with Richard Long, Sol Lewitt with Cézanne, Lucian Freud nudes with Picasso nudes. They went around spotting celebrities – Wow, Yoko Ono walking through the Fluxus room! They felt OK about all the amateur actors acting woodenly in the films and videos. And they didn't feel oppressed by the wooden-sounding titles for the themes of the different floors; a conventional theme like 'Still Life' with a few more words added on to make it seem more intellectual, like 'object' or 'memory'. If you'd arranged to meet someone in 'Landscape, Matter, Environment', you might be thinking about thematic structures. Or you might be thinking about structure and display anyway, because it was a shock to see art at the Tate in a modern setting, instead of as it had always been in the past, in a setting more like some kind of old palace.

Human isolation

The reason I was at the Tate Modern opening party was that I was doing some TV work for the BBC. Every now and then the camera cut away from Kirsty Wark, the main announcer – one of the presenters of *Newsnight* – standing on one of the Louise Bourgeois towers. And a live three-minute TV item would start up in which I'd take a celebrity round one of the exhibits and we'd have a slightly disconnected discussion. Suzie Orbach, the former therapist of Princess Di and author of *Fat is a Feminist Issue*, said what she thought might be the meaning of a 1970s Mario Merz igloo from the *Arte Povera* movement, in terms of human isolation and ecology. Jilly Cooper, the popular novelist, listened with amused tolerance to a one-minute lecture from me about the phenomenology of perception in the Minimalism room. And Tracey Emin responded thoughtfully to questions about Andy Warhol – I started up a half-remembered stock anecdote at one point about how his first batch of Elvis paintings had been rained on and he'd decided to do them all again there and then, and she asked, 'Is that relevant?' And she was right, it wasn't. But then, what was?

Tony Blair with Richard Deacon sculpture at Tate Modern opening day, May 2000

Respect for oompah

Earlier, I'd registered a definite buzz of approval coming from the audience for *Acid Brass*, the brass band event. Art trendies who melted into the Tate Modern party crowd for slightly dull events of the evening – for example, modern dancers performing on Formica-top cafeteria tables – put themselves on display for this one, wanting to be seen to be paying homage to its creator, Jeremy Deller.

Jilly Cooper

'You've got to think of the object, your own self, and the space around the object', I told Jilly Cooper in the Minimalism room, at Tate Modern, in front of the BBC cameras. 'Ha ha!' she laughed assuming it was a joke. She was happy to go along with a lecture about something in which she had no interest, because she wanted to repay me for a favour I hadn't done yet. It was to take her round the galleries in Hoxton Square – the bit of Shoreditch, in East London, that been gentrified beyond recognition in the last few years, that an emphasis on art and art venues. It was so she could get some ideas for a new novel set in the art world.

David Thewlis

Jilly Cooper was the second celebrity who'd asked for this kind of thing recently. The other one was David Thewlis, the actor from *Naked* and *The Big Lebowski*. I was supposed to be interviewing him this evening at Tate Modern, as well, but he was stuck somewhere and couldn't come. He'd run across the road and stopped me in Old Compton Street, one day, and said a novel he was planning had me getting shot at the end, at the Turner Prize. He came round to my house to tell my wife and me about it, over dinner. He asked questions about Turner Prize protocol: for example, was it realistic for an installation to be installed half an hour before the award was announced? In exchange he told some good stories about Marlon Brando, with whom he'd worked on *The Island of Doctor Moreau*.

Marlon Brando

Apparently the great actor took David aside one evening when everyone was at a low point, nerve-wracked from the endless shoot in the tropics and the ego clashes going on. He said he had some advice that would make things go better for David. 'God, what could it be?' he thought. Would it be breath-control or crystal wearing or vegetarianism or reading the Bible or listening to tapes of the Maharishi? Would it be method acting, reciting the Koran, holding back your semen on the point of ejaculation? I'm just imagining these possibilities now. In fact it was an instruction for next morning's shoot: 'Wear a little pair of blue whiskers' – which we didn't really understand. But we were in a good mood because he's a star, so we laughed anyway.

Artists against fascists

Up an escalator – just before the Tate Modern opening party ended – I bumped into Jon Thomson who used to run the Goldsmiths' College BA course. He said he didn't like the fascistic architecture here. 'Hmm', I said, to seem part of a discussion while not particularly feeling it had any meaning. 'Fascistic' was a bit high-blown. The architecture was mostly of interest from the outside and in the main entrance. The rest of the building looked like any other art centre, a bit tacky and anonymous – fascistic would have been better actually. It wasn't the architecture that was objectionable but the overall mood of the art displays.

Get round to hanging fantastic painting one day

The idea with the displays wasn't to make the art look glorious or

overwhelming or intimidating – which might have been fascistic –
but to make it look jazzy and unconventional, which meant making
it look sensationalist, over-packed with meaning and exciting
contrasts. Sometimes the space just seemed suddenly to run out.
One little corridor-like nook housed a lot of works on a white theme.
One of them, Jasper Johns's *White Numbers*, was hung so it was
impossible to look at it head-on. It was as if it was still waiting to
be put somewhere, and one was only seeing it at all by accident.

Great

No one minded all this nonsense, though, because there was a
lot of good will toward Tate Modern, which soaked up all doubt.
I remember driving along the Embankment in that sunny spring
period, in the days before the opening, seeing the building there,
on the other side of the Thames and marvelling at the change that
had come about in British social life – contemporary art was now
at the centre of it. Suddenly there was a big contemporary art
industry. Great, I thought – and I'm in the industry!

Curator alert

But the fact is, it's impossible to take the place seriously – it's a
plastic tourist attraction mixed with pseudo-religious values. It's
impossible to trust the controlling vision because it doesn't seem
serious. A room might look quite good, maybe a Bridget Riley room,
or a room of Anthony Caro sculptures or some Surrealist paintings,
but it will always feel accidental. Or else, it will feel as if the control
is in the hands of people educated beyond their intelligence. (I keep
thinking: 'Uh-oh – curator alert!') Another room will house a wall of
drips by Richard Long and a stone circle by him, and a couple of his
photos, all surrounding a Monet painting of water lilies from the
1920s, as if in ambush. This confrontation is about a mind-numbingly
literal take on an up-to-date idea of landscape, and a list of values
that the landscape in art is supposed to have, which some anaemic
curators have dutifully memorised. They feel proud they can see the
connection between that and some kind of misplaced issue of equal
rights. In the meantime everyone has to look at something they've
done with Monet and Richard Long that is just visually horrible.

Plenty of Polkes

A room of Sigmar Polke paintings will suddenly appear. Why?
There are millions of them in German museums. It isn't a decision
to do with anything profound or important; it's about appealing to

21

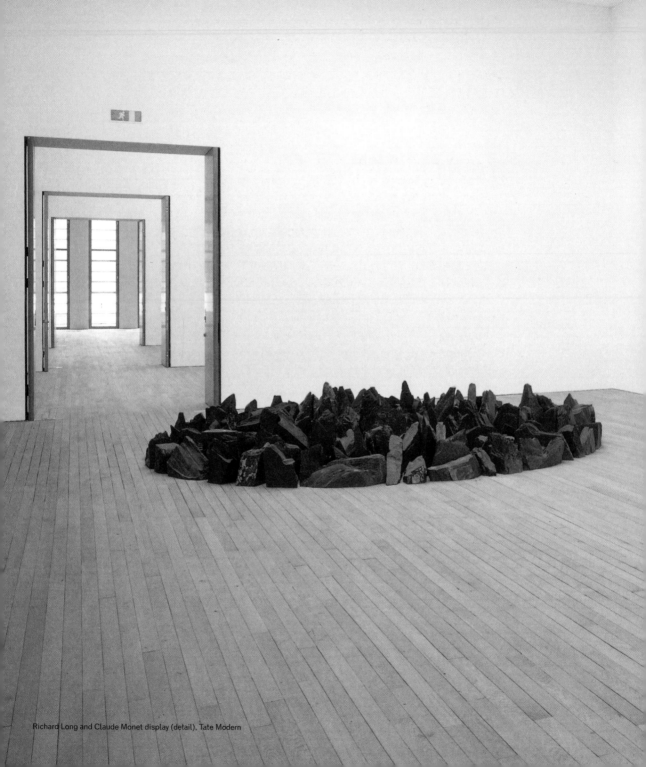

Richard Long and Claude Monet display (detail), Tate Modern

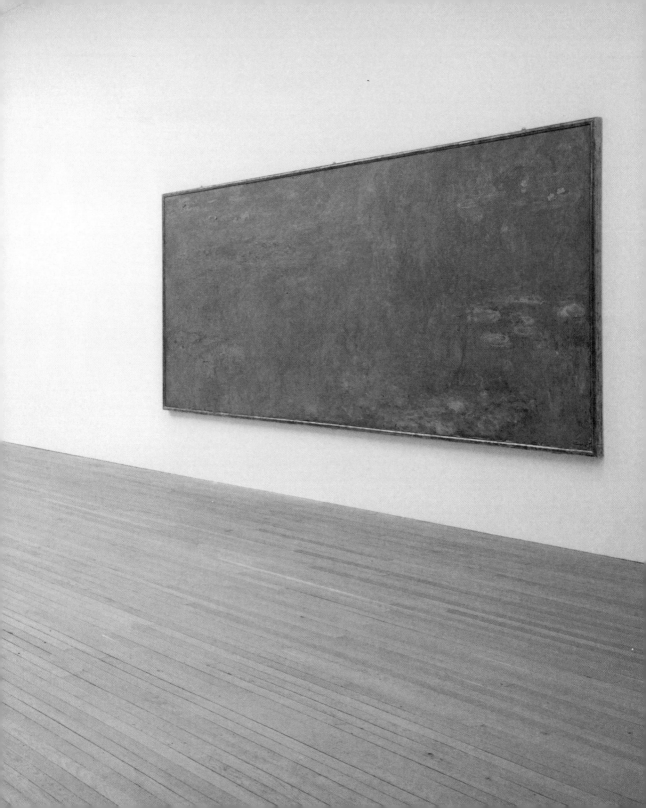

a streamlined, international-exchangeable notion of museum correctness. Why not have some original ideas about your own culture instead of being internationally obvious?

Vast crass splashy

Presumably Tate Modern's curators say things like, 'Goodness me, how exciting of us to mix up the old and new and not be conventional – and in fact a chronological hang is a relatively recent convention in itself: it only started in 1840, or whenever'. But in a climate of non-belief in anything, non-belief in chronology isn't particularly exciting – in fact believing in it might be more exciting. Thematic hanging is not evil but you kind of want it done by mandarins. In reality, you go to Tate Britain and see a Lubaina Himid (right-on sentiments about identity expressed in amateurish, community art-centre painting style) in a room with a Hogarth, and it's not a case of a conservative eye being outraged by a daring curatorial assault on fixed notions of museum display – it just makes your head ache because it's a mess. And that's the case with Tate Modern as well. Of course, anyone could imagine seeing the Richard Long stone circle and the Monet painting put together, and if the general atmosphere was calm enough it might look good. But the atmosphere at Tate Modern is hysterical, like a ghost-train, with forced meaning-surprises popping up round every corner. And only someone who was a bit seriously blind could ever think a vast lot of overbearing, crass splashes in drippy clay mixture, done by Long – as a special commission from the Tate – directly on the wall opposite the Monet, might be nice.

Millions of people

On the other hand, during its first year five million people passed through Tate Modern's doors. On some Saturdays alone 75,000 people went there. In the 1970s it was common for fewer than that to be the entire audience for a contemporary art show at a big public venue in London.

Fuzzy and free

The security guards at Tate Modern no longer have the traditional screws-in-a-prison look. They wear jolly, unintimidating outfits. As with Tate Britain's guards, their orange shirts are designed by Paul Smith. They look like dads wearing their Christmas presents. Other nice people who seem like they might be from youth Christian groups, who wear fleeces with TATE printed on them in little fuzzy-

edged letters, come up and offer you subscriptions for *tate*, the Tate's middle-brow, good-mood, vanilla–mentality house magazine. It's a silly, woolly, crowded, meaningless place, but I go there anyway; I suppose for the same reasons everyone else does: it's friendly and free, it's part of modern trivia.

Live down provincialism

In some ways it seemed only natural that there should be a Tate Modern. It's like a warehouse show from the 1990s. An industrial building vacated and then taken over by art. But this warehouse show is permanent instead of temporary. And the whole operation is establishment instead of anti-establishment. It's the London Symphony Orchestra having Beatles haircuts. The new giddy, amusing, slightly empty idea of art that the self-help warehouse shows of the 90s stood for, in a punky way, is now the official idea of art that Tate Modern stands for, in a dutiful way. Before, the Tate didn't stand for anything particularly. It was provincial and a bit shabby and scrappy compared to modern-art galleries in New York and Germany. That was about it. But now it stands for playful empty ironic vacuity, hyper-professionalism, a sort of innocuous chumminess, pc values and slightly diluted sexy fizz.

Feeble is fine

The Tate curators don't really have any ideas about art. Or at least the ones they do have are feeble. But no one expects them to have any better ideas. Both the Tates are successful anyway without them. One is a fantastic architectural success – at least until you get right inside – and a big sign of art's new popularity. And the other is an old marble pillar thing, but at least it's still got the Turner Prize.

Feel OK

The massive crowds go round Tate Modern and say, 'Salvador Dali, I recognise that' and 'a urinal, I saw it on TV'. They shuffle past walls crowded with photos and paintings, some old stuff by Man Ray or Edward Weston or something, which they vaguely remember from somewhere; and through rooms with piles of something or other in the middle, maybe by Tony Cragg, who they haven't heard of. Or they see Sam Taylor-Wood's *Brontosaurus* and laugh good-naturedly at the waggling willy. (They laugh a bit more hilariously at an all-grey abstract monochrome by Gerhard Richter, and the wall-label 'explaining' it.) They see a lot of structureless, visually inert paintings of floppy torsos by the Dutch artist Marlene Dumas,

shown opposite torsos by Matisse. They have a good old flop in the café, and maybe buy some souvenirs in the bookshop, and then go home feeling fine.

Big excitement

People want what the Tates have got to offer – not just Tate Modern but Tate Britain too: their hideous clashing rearrangements of older art, with crass mixings-in of the new with the old, and their over-spectacular shows of the new. There's a big excitement about art culture, and the fact is the Tate operation is considered to be the head office of excitement.

Sam Taylor-Wood, *Brontosaurus* (still), 1995

Britain is best

If Tate Modern is the headquarters, the branch offices are places like the Royal Academy and the ICA and the British Council. Between them they send out the message to the nation and beyond these shores that British art's old loser status, as far as up-to-date art goes, is finally over. Plus, we haven't just drawn level with the rival art scenes in New York and Germany and other parts of Western Europe – we are inching slightly ahead into first place.

Jesus is top

Whenever the Tate boss, Nick Serota, talks about art it's always a bit unreal. You sometimes can't quite believe what you're hearing. It's one thing for him to be a master of ratings and promos and hype and getting the public in, in their droves – which is like Tony Blair's skills in the early days of New Labour. But it's quite another to be asked to take seriously Serota's ideas about art's spirituality, and the connection of present-day art with the great traditions of pre-Modern art. You can fall off your chair with amazement at his references to the Renaissance and Jesus, and so on, when he's on TV explaining the works of international jet-setter artists, such as Baselitz or Anish Kapoor or Rachel Whiteread, or whoever.

Ecce homo

Religiosity was happening in spades the other night, when it was Serota's turn to give the important annual David Dimbleby lecture on cultural matters, on BBC television. He mentioned Christ about three times, I think. And then he showed a slide that actually was Christ – Mark Wallinger's *Ecce Homo*, a sculpture that stood for one year on the fourth plinth in Trafalgar Square. (The three other plinths have old statues on them, whereas this one has always been empty for some reason.) Serota must have thought this really clinched the point. But it was a wrong point to try and make in the first place, and a lop-sided way of clinching it.

Italian guy

Wallinger's *Ecce Homo* was an effective gag on the notion of what a modern perception of Christ might be. It worked because of its position in Trafalgar Square: a humble smallish fellow surrounded by great monuments to power and nationhood. It had no particular sculptural qualities, except the sculptural qualities that the bodies of human beings might be said to possess anyway. In terms of form, it was a work of minimalism – a punctuation mark in a big space. It

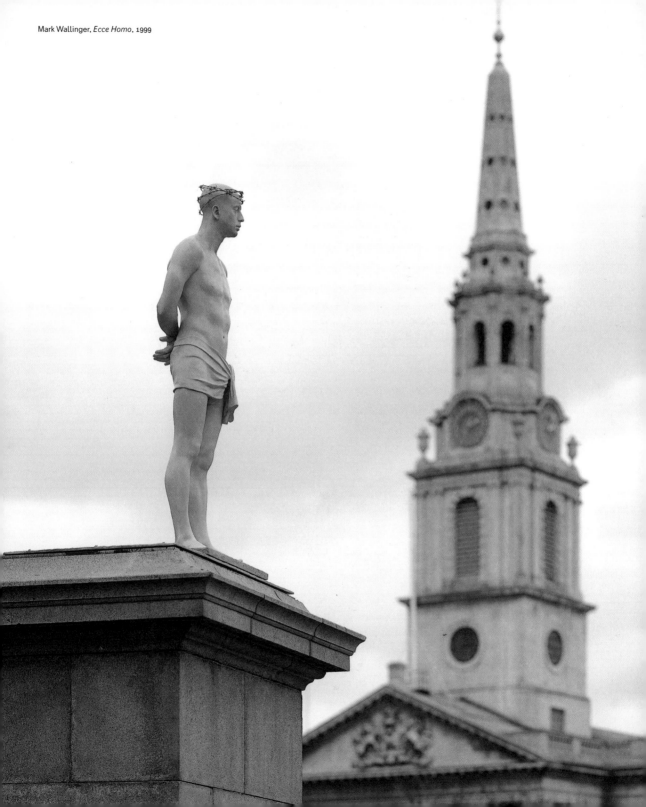

Mark Wallinger, *Ecce Homo*, 1999

was just a cast of an Italian guy who worked at the foundry, finished off in a special resin, which made it look like marble.

Top guy

A talented and imaginative artist, Wallinger is nevertheless a product of his own time, not of the Renaissance. And the claim that his art expresses spirituality is as questionable as the claim, made just as often, that it expresses socialism. Such claims assume a great substance and weight whereas what the viewer sees is lightness. In fact he's good because he thinks about the modern secular present, and the religious, high-minded, higher-values past, and he comes up with intelligent and interesting ways of putting the two together in order to make a point about their difference. He may genuinely believe he is a great artist, equivalent to Michelangelo. Or he may believe that the only way to get his ideas over is to *play* the great artist, which is understandable because it's the normal way for artists to carry on now, to make a living. But anyone should have a right to question either of those positions. And they might expect a leader in cultural matters to do a bit of creative questioning too, on their behalf. But here was the highest culture boss, the Tate's director, broadcasting to the nation on the BBC, not questioning anything at all, but just putting over a bit of outrageous mystification. The fact that half the audience seemed to be asleep whenever the cameras showed them isn't necessarily reassuring.

Pets bad

On the other hand, Serota's task in life is very different from mine, so his perceptions might be different. A lot of his job must be to raise funds, to get things happening for the Tate empire, and basically to be engaged in politics of some kind (although obviously not the protesting kind), so it's not truth-searching or truth-telling that mainly occupies him. And I suppose he's always getting letters from people wanting their auntie's painting of a cat to be in Tate Modern instead of installations and videos. So he probably has a different idea of an art audience than I do. His idea could well be of quite seriously philistine people he feels it's his duty to correct in some way.

Wall-chart mapping history of City Racing, at 'Century City', Tate Modern, 2001

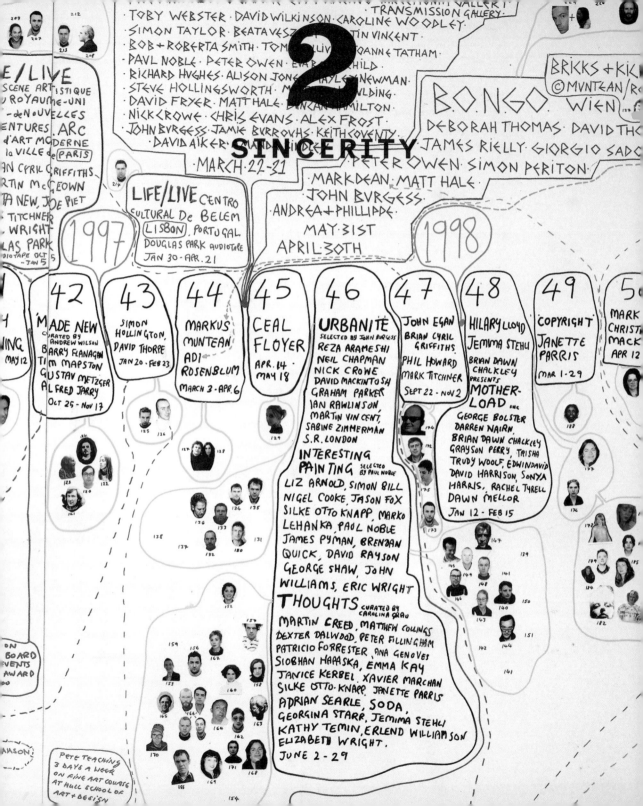

TOBY WEBSTER · DAVID WILKINSON · CAROLINE WOODLEY
TRANSMISSION GALLERY
SIMON TAYLOR · BEATA VES... ...TIN VINCENT·
BOB + ROBERTA SMITH · TOM ...IV... JOANNE TATHAM·
PAUL NOBLE · PETER OWEN · EVA ...HILD·
RICHARD HUGHES · ALISON JON... ...AYL...NEWMAN·
STEVE HOLLINGSWORTH · M... ...OULDING·
DAVID FRYER · MATT HALE · DUNCAN HAMILTON·
NICK CROWE · CHRIS EVANS · ALEX FROST·
JOHN BURGESS · JAMIE BURROUGHS · KEITH COVENTY·
DAVID AIKER·

BRICKS + KI...
©MUNTEAN/R...
B.O.N.G.O. WIEN ...
DEBORAH THOMAS · DAVID TH...
JAMES RIELLY · GIORGIO SADO...
PETER OWEN · SIMON PERITON·

2
SINCERITY
MARCH 22-31
MARK DEAN · MATT HALE·
JOHN BURGESS·
ANDREA + PHILLIPE
MAY 31ST
APRIL 30TH

E/LIVE
SCENE ARTISTIQUE
U ROYAUME-UNI
-DE NOUVELLES
ENTURES. ARC
d'ART MODERNE
la VILLE de PARIS
N CYRIL GRIFFITHS
RTIN McGEOWN
TA NEW, JOE PIET
TITCHNER
WRIGHT
LAS PARK
IDIOTAPE OCT ...
- JAN 5

LIFE/LIVE CENTRO
CULTURAL De BELEM
LISBON, PORTUGAL
DOUGLAS PARK AUDIOTAPE
JAN 30 - APR. 21

1997

1998

42 MADE NEW
CURATED BY ANDREW WILSON
BARRY FLANAGAN
TIM MAPSTON
GUSTAV METZGER
ALFRED JARRY
OCT 25 - NOV 17

43 SIMON HOLLINGTON, DAVID THORPE
JAN 20 - FEB 23

44 MARKUS MUNTEAN ADI ROSENBLUM
MARCH 3 - APR. 6

45 CEAL FLOYER
APR. 14 MAY 18

46 URBANITE
SELECTED BY JOHN BURGESS
REZA ARAMESHI
NEIL CHAPMAN
NICK CROWE
DAVID MACKINTOSH
GRAHAM PARKER
IAN RAWLINSON,
MARTIN VINCENT,
SABINE ZIMMERMAN
S.R. LONDON

INTERESTING PAINTING
SELECTED BY PAUL NOBLE
LIZ ARNOLD, SIMON BILL
NIGEL COOKE, JASON FOX
SILKE OTTO KNAPP, MARKO
LEHANKA, PAUL NOBLE
JAMES PYMAN, BRENDAN
QUICK, DAVID RAYSON
GEORGE SHAW, JOHN
WILLIAMS, ERIC WRIGHT
THOUGHTS CURATED BY CAROLINA GRAU
MARTIN CREED, MATTHEW COLLINGS
DEXTER DALWOOD, PETER FILLINGHAM
PATRICIO FORRESTER, ANA GENOVES
SIOBHAN HAPASKA, EMMA KAY
JANICE KERBEL, XAVIER MARCHAN
SILKE OTTO-KNAPP, JANETTE PARRIS
ADRIAN SEARLE, SODA,
GEORGINA STARR, JEMIMA STEHLI
KATHY TEMIN, ERLEND WILLIAMSON
ELIZABETH WRIGHT
JUNE 2-29

47 JOHN EGAN
BRIAN CYRIL GRIFFITHS
PHIL HOWARD
MARK TITCHNER
SEPT 22 - NOV 2

48 HILARY LLOYD
JEMIMA STEHLI
BRIAN DAWN CHALKLEY PRESENTS
MOTHERLOAD INC
GEORGE BOLSTER
DARREN NAIRN,
BRIAN DAWN CHALKLEY
GRAYSON PERRY, TRISHA
TRUDY WOOLF, EDWINDAVID
DAVID HARRISON, SONYA
HARRIS, RACHEL TYRELL
DAWN MELLOR
JAN 12 - FEB 15

49 COPYRIGHT JANETTE PARRIS
MAR 1-29

5 MARK CHRIST... MACK
APR 12

...ING
MAY 12

ON BOARD EVENTS AWARD ...

...AKSON

PETE TEACHING
3 DAYS A WEEK
ON FINE ART COURSE
AT HULL SCHOOL OF
ART + DESIGN

Flop at Tate Modern

What was the next thing after irony, for the London art world? It was sincerity. You could find it demonstrated at 'Century City', which opened in March 2001. Not that it was a successful show. In fact it was Tate Modern's first big flop. It just didn't get the crowds in. The reviews were uniformly hostile. You'd go to the gallery and there'd be the usual difficulty getting round the main spaces because they were heaving with bodies, whereas the space allocated to 'Century City', which you couldn't get into without paying a £7 fee, looked delightfully empty. (Although, of course, it wouldn't have been delightful for the main curators, Emma Dexter and Lars Nittve. And as a matter of fact Lars Nittve resigned from his job as boss of Tate Modern soon after 'Century City' ended.)

Not all flop

There was something by me in 'Century City', but it wasn't very good. It was some diaristic writings made into a poster, on a long wall of posters commissioned for the event by Pete Lewis, the artist-curator. I went to the opening of the show, found the wall, walked up the length of it, found my poster at the other end, read it, winced, and then enjoyed the poster next to it, by Wayne Lloyd. It was a reproduction of a free expressive painting made up of abstract patches of colour. The words making up the title – *How We Won The War On Socialism* – were disposed throughout most of the area of the painting, with a few other words and phrases in smaller type scattered around: for example, 'Greens' over a patch of green, and 'End of Drip' at the end of a drip. I liked the double meaning of 'Greens' and I admired the general batty purity of the concept: he'd painted something nice and meaningless and then undermined it by overlaying something else even less meaningful. Whenever I ask him what he's been doing lately, it's always something energetic. Once the answer was something to do with Flipper the TV dolphin, involving a performance where he poured tuna oil down a sink.

Chardonnet

I admired some other 'Century City' exhibits too, in glass display cases, where you couldn't easily tell if they were art, or some kind of documentation from a social history of art – flotsam collected from a site where art had gone on once. Something like this was suggested by the row of artists' books or pamphlets issued by the curator Matthew Higgs, during the early 1990s, under the title *Imprint* – simply a few A4-sized sheets photocopied, folded in two and

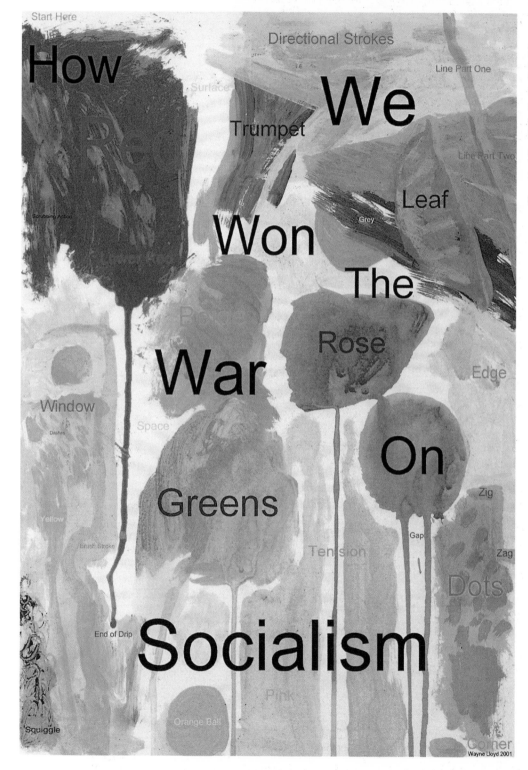

How We Won The War On Socialism

Wayne Lloyd, *How We Won The War On Socialism*, 2000

Wayne Lloyd

stapled together by hand. I had written one of these. It was a kind of poem made up of quotes from rock songs – from the 60s through to the present – interspersed with quotes from an interview with the critic Clement Greenberg, which I'd conducted myself in 1991. As Greenberg got more drunk his conversation became more random-seeming, and the song-lyrics picked up on some of the arbitrary violence in his mumbling. It sounds puerile, I agree – and I always assumed no one ever read it. But then Iwona Blazwick – who recently left Tate Modern to take over The Whitechapel Gallery – told me she'd taught it on a curating course once. Another project Matthew Higgs organised in the mid-90s was artists' ideas of what might be on the menu for their last suppers. I saw my contribution, where I'd listed all the unhealthy Snickers bars, Zabagliones, fry-ups and so on – which I couldn't eat at the time because I was dieting – and then I had to wince when I saw I'd somehow spelled Chardonnay, the aspirational wine of the 1990s, *Chardonnet*.

Help yourself

Near my *Imprint* effort – which is called *Rock Streams and Greenberg Streams*, if anyone wants to order up a copy from Matthew Higgs – was another *Imprint*, this time by Stewart Home. This author and art activist is a kind of one-man youth subculture (or early middle-age subculture, since he is now getting on). He has recently become a sympathetic figure for the art world. Previously he was an outsider, but because his writing and self-presentation are iconoclastic and against the establishment – and art now wants to flatter itself that it is incredibly liberal and radical – the art world now acknowledges him. I think he's a good artist but in a tradition of artist-outsiders. He's often much funnier than the insiders, but he doesn't bother enough with the object side of art to count as a contemporary artist as such. He's a fellow traveller of would-be protesters within art. He's more genuinely a protester than they are, but strictly speaking they're more genuinely artists, because technically he's a writer. As far as sincerity goes, he's not a sincerist but an ironist. But the artists acknowledge him because they think he's a genuine socialist, something they're a bit misty-eyed about. So they get him slightly wrong in terms of their ideas about themselves. But because these ideas are slightly wrong anyway, the confusions average out. Whether it was strictly art or not, I liked his gesture, once, of offering his body after death for sexual use if any necrophiliacs wanted it – he had a special necrophiliac-friendly card printed, like a kidney donor's card, which anyone could carry around in their pocket.

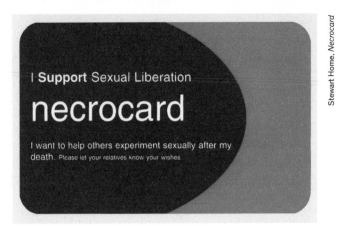

I **Support** Sexual Liberation

necrocard

I want to help others experiment sexually after my
death. Please let your relatives know your wishes

Run away

Another bit of amusement, in the same glass case at 'Century City',
was some photos and texts by the young artist Hayley Newman.
One was about her hiding in a bin bag in New York until some dustbin
men came at four in the morning, and then running away. Another
was about some special crying glasses she'd worn on the tube. Both
were parodies of 1960s and 70s international Conceptual art. What
was impressive about the works was her feel for the prescribed
language of Conceptual art documentation of that period, and the
type of information Conceptual art classically prefers: that
characteristic mix of the slightly affected and the ultra-precise.

Ad man you're a bad man

Plus, I liked AD MAN YOU'RE A BAD MAN! – a headline on one
of BANK's art magazines. It was a story about a little wide-eyed
innocent six-year-old denouncing capitalism. Apparently from her
hospital bed – she was terminally ill – she'd said she wouldn't wish to
live in a world where Charles Saatchi was allowed to own all the art.
BANK, an artist collective, produced these tabloid-style magazines
for a few years. The made-up stories were about the infrastructure of
the art world. They were frankly adolescent. GILLIAN WEARING
THIN, one headline went. Another one said SIMON PATTERSON –
EIGHT YEARS ONE IDEA! This is a reference to the London tube
map this artist designed in the late 80s or early 90s (no one
remembers when it was any more), called *The Great Bear*, with all
the names of the stations changed to philosophers, comedians,
actors and football players, and so on. At the time it was considered
a brilliant example of art picking up on chaos theory, and it somehow
demonstrated how art and science were both scintillatingly radical.
It was a time when, within the art world, books on fractal geometry

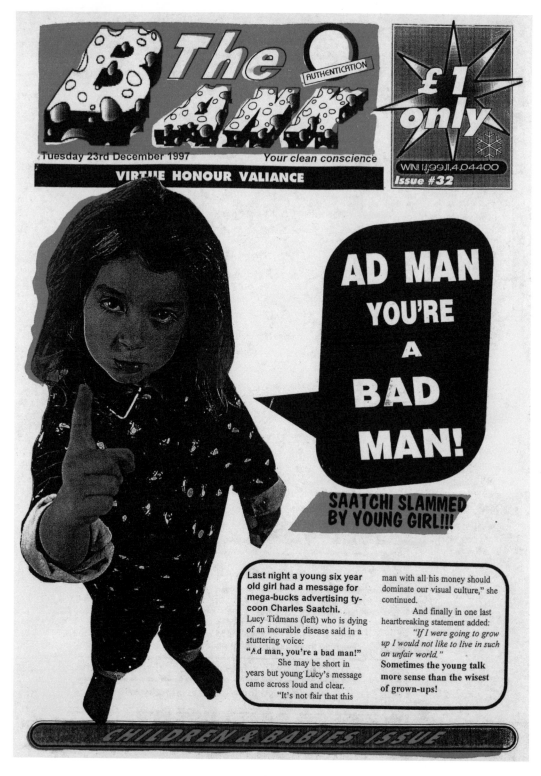

were as trendy as books on the seminars of Lacan. But then, although Patterson produced a lot of other works that could just as easily be seen as comments on chaos theory, unfortunately the art-world fashion for obsessively mentioning that particular theory died out. The BANK take on the Patterson problem, however, just went straight for the cheap insult. And they might well regret that one now, as it's quite rightly considered bad form to just come out with un-argued brutal put-downs of artists. On the other hand, it wouldn't have been funny if they'd been more careful. Another BANK headline I liked for its complete stupidity was about the artist Sam Taylor-Wood, who at one time did a lot of videos that used classical music as the soundtrack for images of grungy, modern, sexy-looking people. It read SAM TAYLOR WOULD – NOT DO ANY MORE ART USING OPERA!

Mumbai jumbo

Already 'Century City' is sounding much better than it seemed to be at the time. I think the very fact I had so many works in it suggests what an out-of-control mess it was. However, I monitored my responses to it as a kind of research experiment, to try and find out what the present-day mood of art is. And now I'm letting you in on what happened during the experiment. The idea of the show was supposed to be to have a look at the culture of certain cities. As well as high-profile places such as Cubist Paris, revolutionary Moscow, Freudian Vienna, and so on, Bombay/Mumbai, Lagos and Rio were included. The catalogue said the city displays were about the way artists and creative people had metaphoricised or dramatised cities. It had the feel of something someone might say in a seminar at art school, or at the pub if they were drunk after a private view, or to the mirror at home if they had an interview next morning to be a curator at Tate Modern.

Gumbo

It was the London section of 'Century City' that sank the whole show as far as the critics were concerned: it was visually feeble. Nobody could understand why that should be so, when young British art had made such an impact in the 90s and it was a London phenomenon. The reason was that, like the other sections, the London one was about a mix of art, architecture, design, photography and fashion, and not just about art. Also, it was about presenting a lot of documentation as well as art objects. This approach made for a boring visual effect but it conformed to a new trendy notion: that it

is better to think of art as something that has evolved alongside or in tandem with other culture forms – or subculture forms – rather than something that exists in up-its-own-arse, ivory-tower isolation. Art is one flavour in an interdisciplinary big lovely gumbo.

Sunday school poseurs

The bad aspect of the otherwise harmless broadening-out notion of art proposed by 'Century City' was its naive and clichéd idea of what it means to be political. Nevertheless, this notion – that art should be pc and it should always have a bit of infantile Sunday school moralising to it – is absolutely accurate to how the art world thinks of itself now. This is what sincerity is. Artists who aren't on the main yBa scene want to express their difference from the yBas. They present themselves as desperately cool and emotionally distanced, like the yBas – so it's clear they really are artists. But they want it to be known that they have a desire to make a little tentative probe into sincerity now and then.

Good handicapped guys

The pop subculture products chosen for the London section of 'Century City' were largely much better than the more flat-footedly pc art products by artists who'd always been perceived to be a bit too pious to be taken seriously by the trendy centre-stage art world – but who now were being tentatively welcomed on board. (One of these was Sonia Boyce. 'Sonia Boyce has made a blanket of Afro hair wigs, which viewers are invited to touch', read the wall-label, explaining a work by this artist – who has been around for years but never really enjoyed the glamour spotlight before. The expectation raised both by the work itself, a lot of wigs lying there in a formless bundle, and the daftly pious explanation, was that it should conclude: 'Sonia is eleven'.) Among the good pop subculture products were ad-style posters by *i-D* fashion photographer Nick Knight, showing physically handicapped people wearing Alexander McQueen fashion gear. I think one of them might have been Paul McCartney's fiancée. These were memorable because you couldn't tell at first what the theme was, which is unusual for anything billboard-sized. But then when it struck home, you realised fundamental concepts of advertising and display were being cleverly explored. Elsewhere, the same photographer had some photos of different black family gatherings, into each of which he'd computer-inserted a photo of an albino guy. It was another *i-D* fashion spread, with the albino modelling different clothes in each shot. These made me laugh,

although I admit someone more intelligent than me might object that the idea is shallow, since an albino will always be a bit noticeable. But I'm not sure we're really ever talking about anything that *isn't* shallow, in this particular area of culture. Another *i-D* set-up by the photographer Jason Evans featured black male fashion models wearing various types of gear. These photos scrambled certain stereotypes in an intelligent way. Whereas the settings were always suburban, *c.*1940s-seeming, the clothing style referred to different time periods: sometimes stylish, contemporary and cool, sometimes slightly more absurd – kind of young gentleman outfits. This was impressive because it made you question what you were seeing, even though the individual elements – handsome guy, ordinary-looking place – were utterly normal.

Good Brian Epstein idea
'Jeremy Deller has captured 60 hours of handheld video footage recording the life of the city', began a lengthy wall-label introduction to another work in the London section of 'Century City'. It was a lot of TVs showing streams of video footage of different urban scenes, as if you'd just turned on the TV and there was somebody's home movie of a school play being shown. But then some more home movies would cut in, a riot, a free concert, or whatever, and you'd realise that was all that was ever going to happen – this raw stuff was never going to be transformed in any way. Deller used to be considered a minor yBa. He studied Baroque painting at the Courtauld Institute and then he started putting on a lot of installations involving stars of the rock world, and notions of rock and pop culture – where iconic meanings of saints and gods and so on, which you might expect to be thinking about if you were looking at a Baroque painting, would now be on the agenda when the image was not a saint but someone from The Who or The Happy Mondays. Recently he has become one of the leading figures in the backlash against the yBas. His art has actually become more grandiose than it was before. But also there is a desire on the part of art's insider-audience to read a lot more into it. This applies to works by him from the past as well as the present. I thought of one of these old works now – a sign in the street reading BRIAN EPSTEIN DIED FOR YOU. I suppose the idea of a rock-biz Big Manager kind of guy being on a level with the Redeemer is funny because it's slightly reminiscent of the 60s controversy over the question of whether The Beatles were bigger than Jesus or not. And here that notion was brought together with ordinary church

Jason Evans, Four prints from the series *Strictly*, 1991

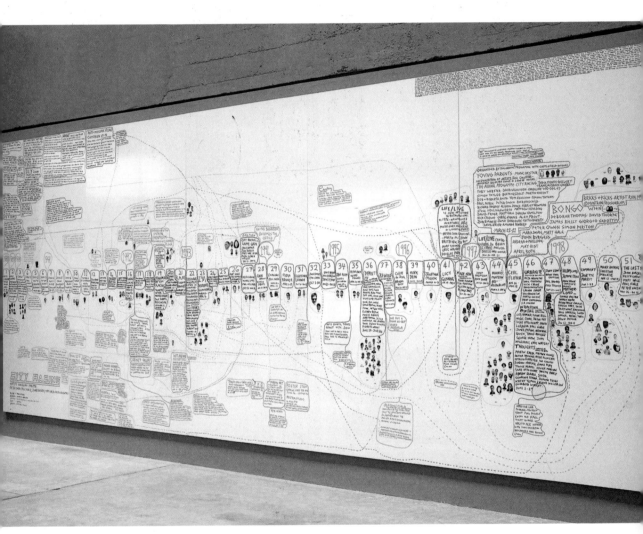

Wall-chart mapping history of City Racing, at 'Century City', Tate Modern, 2001

recruiting signs, which you see every day but hardly notice. But now, because of Deller's new status as a god, it's somehow become against the law not to perceive a slight but amusing work such as this as a heavily profound work – one that will help save the world from decadence. So now having to stand in front of his TV sets looking at unedited gibberish, I felt a bit fed up with Deller. I didn't feel the TV sets were helped by being accompanied by a lot of self-righteous spieling from him – quoted on the wall-label, and endorsed by the swooning curators at Tate Modern – about how marvellous anti-capitalism marches are. I'm not at all against them, of course, but I felt this was just empty moral high-grounding.

Dubious load of old shows destined to last forever

Also at 'Century City', I saw that City Racing, the now defunct gallery that had been run in the 1990s by artists from a disused betting shop in the Oval, had become practically apotheosised it was so holy. There was a hand-written wall chart documenting the history of the place, done by one of City Racing's artist-organisers. Every exhibition they'd ever put on was listed, with the names of everyone in them, and with their photo-booth portraits stuck on nearby. The writing was done in felt-pen by one of the artist-gallerists, Matt Hale. I know him and he's perfectly nice. But I read it all and it came across as something by someone educationally subnormal. I found myself looking for some kind of allegory or hidden cleverness. Would I uncover it if I stared long enough at thoughts like 'Keith runs office from bedroom'? In fact it wasn't a sociological idea that this City Racing documentation got over most strongly (or at all), but a certain type of design aesthetic that is trendy in art now. It's one where whiteboards and felt-pen markers are important: a kind of parody of an advertising presentation to a company.

Super

Reading the catalogue essay for the London section of 'Century City', I gradually built up a list of shorthand moralising tips about new sincere attitudes in art. Artists having a 'can-do' attitude: good – results in self-help group shows (mysterious things from heroic past). Bad capitalism, and bad Thatcher, but curious stock market collapse in late 80s: neither bad nor good. However, plenty of billions wiped off stocks and shares (exact statistic looked up in over-designed, trendy, mid-90s book from France about psycho-

geography, probably). Result: mass breakout of grungy warehouse-shows – obviously good. Art only good if it's a hybrid of art and fashion, or art and design, or art and DJ-ing, or almost anything else. Whereas fashion and DJs and almost anything other than art (except capitalism): always good.

What Maisy saw

Another reason I go to Tate Modern so much is to look in the bookshop. It's a gift shop as well as a bookshop. It's always crowded. You can get pencil cases and biscuits in the shape of Tate Modern. The tables in the middle are piled with stuff. There are always gleaming piles of my books. The other day I noticed they'd been joined by piles of *Maisy* books: *What Maisy Saw* and *Maisy's House* and so on. BUY ANY 2 MAISY BOOKS AND GET A FREE PAINTSET, a sign read.

BANK. *The BANK*. Issue no. 29 (detail). 1997

urday 20th December 1997

ENTERPRISE RESEA

only

WIN!!6.3.4.0130004

Issue #29

*T*URNER PRIZE BEAUTY PAGEANT

Choose from:

Angela Bulloch Christine Borland

*Mirror, mirror on the wall
who is the fairest of them all?*

This is the question being asked by all red-blooded

Fiasco

When the Tate Gallery divided and the old Tate turned into Tate Britain, there was a three-day seminar to kick off its new mad thematic displays, with a lot of people from different cultural areas invited in to give talks – film people, architects, sociologists, artists and others. The lead-in event was an evening talk headed by the sociologist Stuart Hall, with a panel of about twelve others including political journalists and art critics as well as Janet Daley from *The Moral Maze* on Radio Four. Stuart Hall wanted to think about what 'Britain' might be in a context of art and cosmopolitanism, and what the role of a gallery devoted to British art might be in that. And because he's a naturally thoughtful guy, you could suddenly see what a good idea it was to have a Tate Britain, even if it was starting off with a curatorial fiasco.

Zzzz

The next day the shorter seminars got going. One talk was supposed to be artists explaining their ideas. I was on this panel, miscast – I felt – as a celebrity populariser of new art. The moderator was Tim Marlow, editor of *tate*, and the two artists were Cornelia Parker and Gavin Turk. The artists showed their slides and explained what their concerns were in the time-honoured art-seminar way, slightly sleep-inducing. A smooth glide from basic description – 'This is a hair I found on Freud's couch' – to a general consensus throughout the room that powerful meanings are definitely happening.

Grrr

It was supposed to be a friendly celebration of culture and progress, not a lot of tortured searching for significance. But suddenly I felt alienated from the cosy pieties of these two (perfectly good) artists. Last night's seminar was about important things, but what I was hearing now was ridiculous.

Staccato

So whenever it was my turn to talk I tried to be staccato instead of warm and lulling. To be observant about what might be considered odd about what they both did: Cornelia Parker's silver teapots and stuff dropped off the white cliffs of Dover, and Gavin Turk's objects that look at the cult of celebrity. Why was art like this? Why was it popular? Why not something a bit less emotionally distanced? What did the public think they were looking at? But I began to be aware of a sea of faces looking dismayed. I realised I'd been outrageously

ungenerous about Tate Britain, and insensitive and slightly boorish. And rather than observant I'd been incoherent and sulky.

Get down off that stage you bastard, you'll never work again!
When Tim Marlow asked the new director of the gallery, Stephen Deuchar, what he thought, he said, 'Well, I was thinking of giving Matthew a job before but now I'm not going to!' And afterwards, Nick Serota came up to the stage to complain as well. He said I hadn't changed, I only tilted at windmills: 'And they're all of your own invention!' 'Ha ha', I said. 'Well, that's all reality ever is, your own invention!' But it was just nervous babbling. In fact I was alarmed at the way he looked a bit uncharacteristically thunderous. I felt he really meant something incredibly harsh, like: 'You'll never present the Channel Four Turner Prize TV programme again!'

Turner Prize not rigged
There's always a reason for the Turner Prize going to a particular artist in the line-up each year, and you can usually see it coming. Damien Hirst was nominated once and didn't win, but then he won a different year instead. But after that unsure moment of him losing, you could always predict who'd win. It's not that it's rigged, though, as the Stuckists want to believe, and as many people carelessly claim in their understandable resentment at feeling left out. And it's not that the line-up of nominated artists is baffling or mad. It's quite coldly logical. They are trendies who have a track record in art, and they each stand for some kind of general theme the art world is fascinated by. Is painting dead? Are photos art? Should art be streetwise? Is sex art?

Public not totally included
The Turner Prize judges are international art-world people who roughly know what all the art ideas are at any given moment (except for the odd pop celebrity they've now started getting in, who's there to be glamorous but not to know anything). The judges always include one or two heads of international art centres or museums. You can match them up with the nominated artists – so-and-so has put on a show of so-and-so's installations, so therefore they will be rooting for that artist. The list of artists to be nominated each year is supposed to be drawn from names submitted by the public – 'the public' doesn't really mean the public, but a few hundred people in the art world. This non-involvement of 'the public' is the only bit of absolute untruth about the event,

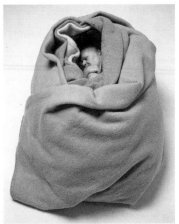

Ron Mueck, *Untitled (Man in Blankets)*, 2000

but it's an acceptable bit of hypocrisy. Otherwise it would just be chaos. The judges don't 'judge' exactly. They have some kind of argument that lasts a few hours and at the end they come up with a winner, in order to make some kind of statement.

Youth super

When Wolfgang Tillmans won the Turner Prize in 2000, it was a statement about youth: the Tate wanting to show it's on youth's side basically that's where the ratings will always be – you can't run a museum on low ratings. Tillmans's photos are often in fashion and style magazines, but they're in art mags as well. Now his photos have been in the Turner Prize, he's reached an even wider audience. Middle-class people see them in the papers, and discuss them. 'Hmm, he's got an eye', they say. Or 'Isn't he just an airhead?'

Tattoo, black eye, naked – always a winner

Art has a passion for photography at the moment: it's realistic; it's democratic because anyone can do it; it's modern and it's glamorous. There are a few different categories – kind of snapshot, more formal, and extremely formal. Extremely formal often involves some kind of special developing process or artificially heightened colour. The enlarged snapshot-look, with someone young, preferably with a tattoo or a black eye, or naked, is the most popular.

Other cross-over artists not yet in Turner Prize

Other successful cross-over artists – that is, crossing from pop culture to art culture – besides Wolfgang Tillmans, include Ron Mueck, the photo-realist sculptor who made *Dead Dad* in

Ron Mueck, *Untitled (Baby)*, 2000

'Sensation' at the Royal Academy, and Chris Cunningham, who made the film *Flex!* in the exhibition 'Apocalypse', also at the Royal Academy. Ron Mueck is from the model-making world; and Chris Cunningham is from the pop promo and Hollywood movie special effects world – he did some special effects for *Alien III*. These artists, whose work is really updated Victorian sentimentalism (all subject matter, little aesthetic interest), are given the benefit of the doubt by the art world, at least temporarily, although they could be turfed out at any moment if the wind changed – say from eclecticism to purism, which is always possible, though unlikely.

Dornford Yates

As far as the popular audience is concerned, though, these cross-over artists are great, basically because they have up-front subject matter that anyone can immediately relate to. They aren't particularly amazing on an aesthetic level but no one's interested in that level anyway. I met Robin Vousden, one of the directors at the Anthony d'Offay Gallery, in a restaurant one night, when a Mueck show was on at d'Offay, and he said the audience comes streaming in, they don't ask any questions, they're content to just stand there and stare. Robin was eating alone and reading a book when I interrupted him. 'How superb that you're reading Dornford Yates!' I said. After that, I went to the Mueck show myself, and it really was quite good – there was a realistic wax or fibreglass man in a womb-like blanket, which looked good, and some kind of baby on the wall.

Crikey!

Chris Cunningham's film, *Flex!*, about life's eternal cycle of birth, sex and death, features two naked actors writhing and fucking, and thumping each other a lot. It has a little too much over-acted wincing and gasping on the sound track. But at one point the screen suddenly fills up with the man's naked erect penis, and as the screen is about fifteen feet high it's an impressive sight.

Remember special textures

Steve McQueen won the Turner Prize in 1999. It's often hard to remember this artist's name, because the mind won't allow it, somehow. It is his real name, of course, but maybe he should change it. But in any case, his main work in the Turner Prize show that year was the film *Deadpan*, with himself standing still while the front of a house fell on him, a sight gag from Buster Keaton. When I first saw it, I couldn't get it and I imagined it might be some kind of statement

about race and the American south – the house looked like a shack in the south. But that was wrong. I still don't know what it's supposed to be about, apart from some kind of mystery quality of 'the grain of the film', which I learned is something you should always try and mention when pretending to understand any of McQueen's films. I heard a Tate curator using that phrase the other day when speaking of McQueen's greatness. In a way, it's a kind of aestheticism to talk like that, but a bullshit kind. Of course, it's not McQueen's fault that his supporters can be a bit phoney. In fact it's not even really aestheticism but just a mindless bit of quoting – hoping no one will notice – from Roland Barthes, who talks about 'the grain of the photo' in *Mythologies*.

Public gets it wrong anyway

On the other hand, I didn't think it was outrageous that McQueen won the Turner Prize. The decision was about acknowledging that films are hugely in, in art. Films being in has got something to do with a lust for reality that art has now. Also, I knew he hadn't come from nowhere. He has an international following, and there's an idea about him of some kind of seriousness. Museum bosses and high-echelon art writers in New York often support him in order to put down other British artists whom they want to believe are vulgar. So when there was a sudden panic during the run-up to the award night that Tracey Emin might be vulgar, it made sense that she shouldn't get the prize and McQueen should instead. Even though the public assumed Emin would get it because she's so famous. In fact they think she got it that year anyway. And they think she got it another year as well because they saw her being drunk on TV.

 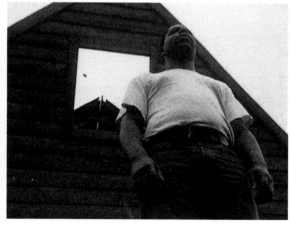

Steve McQueen, *Deadpan* (stills), 1997

4

DON'T LOCK ME IN

Locked

Because I never knock on the other doors in my studio building in Derbyshire Street, Bethnal Green, when I go there, to say hello to any of the other artists who might be in too, they think it's all right to lock me in. At least this was the justification I was given for why I keep being locked in – which I read on a note one morning pinned to the inside of the front door, headed *Instructions not to be locked in.*

Trapped

Security is tight at the studio because of the break-ins when we first arrived. Now there are bars on all the windows and nobody can get in when the building's locked. But nobody can get out either. So if someone leaves the building thinking they're the last out, and locks the metal grill outside the front door, padlocking it to the metal fixture on the pavement, having just padlocked the heavy wooden inner door as well, anyone still inside could be stuck there for days. Recently I was there late, got locked in, and found my mobile phone had run out – and the public phone in the corridor had been changed recently to only take incoming calls (because everyone has a mobile phone now) and it was broken anyway.

Blobbed

I went up and down the corridors in a panic. Then I went upstairs and broke into Fiona Banner's studio. There seemed to be some new works by her on the floor in an expressionist style, with blobs – but I wasn't in the mood for critical analysis. I got onto the roof through the skylight and felt briefly calmer with the fresh air on my face. I saw freedom below – but there was no safe way down to it.

Burned

I prised open the metal shutters over Fiona's studio window, made a rope from some fifteen-ounce cotton duck canvas I fetched up from my own studio downstairs, tied it to a metal thing near Fiona's window, and climbed out. But the reality of climbing down a wall sideways is different to the imagining of it one might do in one's panic to be free as quickly as possible from a confined space. And when it came to it, I let myself slide and gave myself some nasty rope-burns.

Spiders

I was in the studio in the early evening a few days later and there it was – I heard the metal grill going again! I ran to the door and

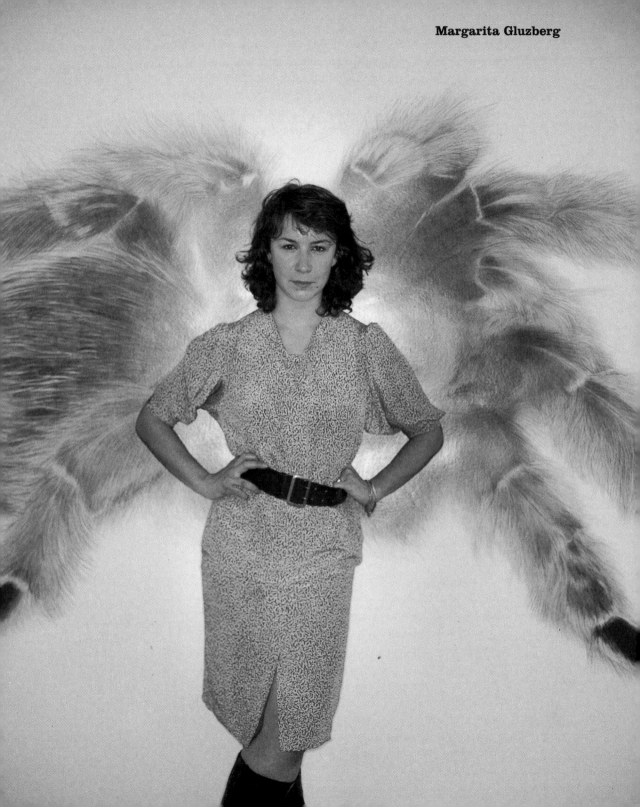

started shouting at Margarita Gluzberg – who draws spiders – standing out there with her key still in her hand. But in fact she was opening the grill and coming in, not going out. Effectively she was freeing me, not locking me in, as she now pointed out.

Highly educated

'OK OK! But it was really disturbing all the times I was locked in before!' 'I wasn't locking you in!' 'Well, you did before!' 'How do you know it was me?' 'You all did!' 'No, Fiona Banner did!' 'It happened three times!' 'I don't care!' 'You're so thick! You're so stupid! You idiots! Stop locking me in! You child!' 'Actually I've got a degree!'

Simon Patterson

I started furiously writing out notices on sheets of A4 paper, to the twelve other artists who share the studio – to tell them to stop locking me in – and shoving them in their little boxes where their post goes, their private view cards and rates bills and so on. Then I got them all out again and furiously screwed them up while Margarita phoned Simon Patterson (creator of *The Great Bear*, who usually works upstairs but who wasn't in today) on her mobile, to tell him I was shouting.

Fury

I stormed out to my car and drove into the rush hour – and then phoned 40 minutes later from Soho, still in the car, to apologise. But as soon as Gluzberg said anything at all, I stopped apologising and started lecturing her again. So after that, I had to re-dial in order to absolutely finally apologise this time. But now I got shouted at myself by some drivers because I'd gone the wrong way down some kind of lane off Brewer Street. 'I'll never fit in that studio community after this', I thought, winding the wheel round furiously to reverse – with the other cars all backed up before me, the drivers gesticulating furiously.

Calm

A few days later I let myself in the front door again. I saw that the reversible notice I'd carefully written out, in post-fury calm, which read MATT NOT IN STUDIO on one side and MATT IN STUDIO PLEASE DON'T LOCK ME IN on the other, had been graffitied so that it now read MATTS SNOT IN STUDIO and LOCK ME IN FOREVER.

Pay more for motherfucker

'Well, you're the queen of anecdote, aren't you?' This is what Colin Lowe was saying when I was at the house he shares with Roddy Thomson. I was there for dinner. I'd brought round the first payment in cash for one of their works, which they'd agreed I could pay for in installments. It was another version of a painting they'd done in 1996 called *Saatchi 'n' Motherfuckin' Saatchi*. When I'd admired the original version in a fund-raising raffle in a studio in Kings Cross, it cost £50. Now I was going to be paying about 26 times that, but I felt it was worth it.

Remarkable men

My meetings with them – what were they? The first was with Colin Lowe at 'Yer Self Is Steam', a mixed exhibition in 1996, curated by BANK, in a building in Charlotte Street. The show was of bits of writing by artists. Colin and Roddy's contribution was an illiterate poem in what appeared to be a parody beatnik style, in very closely-spaced amateurish-looking typing – something about the green walls and a rotten cultural meltdown, or cultural twilight, I think. I could see it was a masterpiece straight away and ought to be in the Turner Prize – in fact I plagiarised a phrase from it for the commentary for one of the episodes of *This Is Modern Art* a few years later.

Fictional man

Colin was in the street after the private view. Somebody introduced us. I said I admired his work and asked him if he wanted a drink, as everyone was going to the pub now. Then he launched into an insult tirade and I couldn't understand why, it just seemed to take him over. My glasses slid down my nose because of the nervous sweat. 'Do your glasses always do that?' he asked. Somebody came up and asked him if he was going for a drink now – 'Yeah, otherwise I'll have to go with this motherfucker', he said, meaning me. Another time they came to a book launch of mine. Colin put his cigarette out on the cover, which had a picture of me on it. The fag went right on the face. It seemed a bit violent. When I left later, he called me back for a drink – 'No!' I called. After that I'd bump into Roddy at openings, and he didn't seem so unhinged. He said Colin wasn't either, in fact. They just both thought of me as a fictional person.

Grilled

I invited Colin and Roddy to contribute some writing to a special

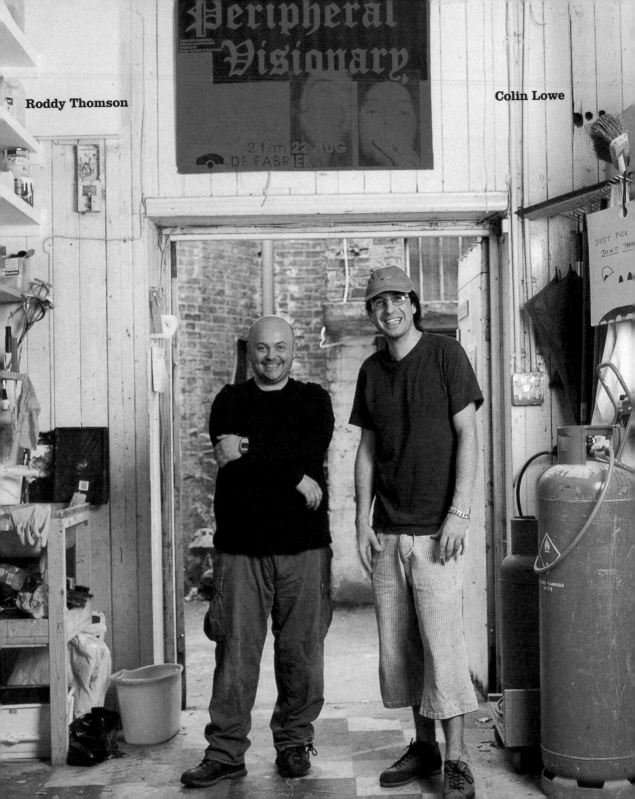

Roddy Thomson

Colin Lowe

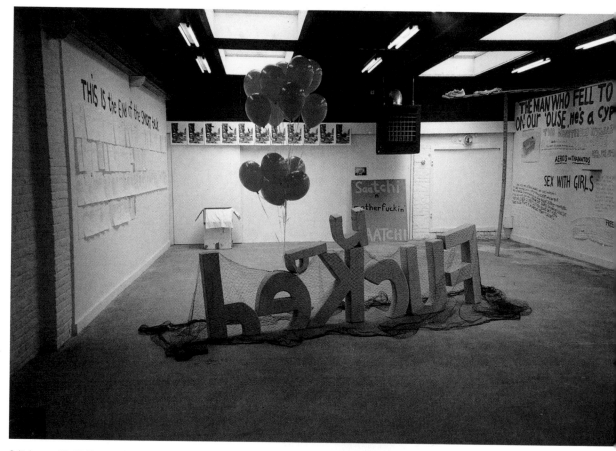

Colin Lowe and Roddy Thomson, *Fucked* (installation view), 1997

section of *Modern Painters* I guest-edited in 2000, on the subject of Britishness. They sent in their writing and I had a lot of trouble from *Modern Painters* people over it, from the publisher and editor down to the lawyer. At one point David Sylvester, the great and dignified critic, who died in 2001, was asked to phone me up and put me right. Feeling on the edge of tears because of the stress, I said, OK, there were some inconsistencies of spelling – but it was an inspired allegory of the rise of young British art! David said, 'Matthew, will you wait two minutes while I get my fish fingers from the grill?' Eventually the article went ahead with the illiteracies smoothed out – for which I was sorry as they were perfectly comprehensible, and in any case part of the rhythm – and the personally offensive and legally explosive bits erased, or nullified somehow. Also, I had to put in a defensive and overlong introduction that distanced the publishers and staff of *Modern Painters* from the content of the essay.

Drunk

By now I was getting to know Colin and Roddy a bit more. They'd be fine during the day and turn frightening at night. Because of the drink, I supposed. In fact I asked Colin directly about this once – well, it's in the future still, as far as the tense of this story is concerned – and he agreed it was the drink. 'But that's the same for everybody isn't it?' he asked. 'It's just part of drinking, isn't it?' I don't know – it's all right to be insulting if you consider someone's not real and if you're drunk. Is this a well-known thing now?

Pub bad

Anyway, that hasn't happened yet. At this point I'm at their house and it's a year or so ago, if that's possible in literary time. I've been drawn into their world a bit. They've told me about their home in a pub in Camden from where they've just moved. They thought it would be great having the upstairs floor of a pub – but the pub family kept imposing their personal problems on them and coming into their space and it finally drove them mad, or at least out of Camden and over here to Seven Sisters.

Go home

After I'd arrived earlier on, they'd gone out and bought beers, and then they returned and finished cooking the dinner. Some of their friends were there too. We sat out in the garden and then in the dining-room. The atmosphere was jolly, the dinner good. Then some

of them went to bed. Suddenly the atmosphere turned alarming, like the moment in *A Moveable Feast* when Hemingway describes the effect of a single cocktail on Scott Fitzgerald. Instead of being good hosts, Colin and Roddy now laughed at each other's obscurities, but frowned, sulked or groaned at anything I said. My smiles became painful masks as I struggled to feel all right, instead of naturally feeling all right and having a pleasant expectation of things getting even better, which is the expectation I'd had earlier. One of the remaining friends said she was doing a course on colour, so I started a lecture about Gauguin, as I was about to do some filming in the South Pacific about his life there. But everyone hated that, and they hated it when I said an artist they probably never thought about much usually and probably didn't even dislike – but now suddenly they hated – was good. Then Roddy – who I now realised I'd cast as the smoother-outer of choppy waters and come to rely on him sticking to this role – simultaneously laughed at a joke about me going home, and indicated to me with secret glances that I really had better go home now. And Colin was telling me I was the queen of anecdote as a setting-up point or interesting framing context for the subject of an amusing anecdote of his own that he was about to deliver. But because the framing structure, with its clear meaning, stands out a bit sharply for me at the moment, I can't remember what his anecdote was.

Colin Lowe and Roddy Thomson, *Charcoal Raft of the Medusa*, 1998

P.H.Coate & Son 113 Beaconsfield Road
Meare Green Court London
Stoke St Gregory N15 4SH
NR Taunton
Somerset
TA3 6HY 6.9.00

Dear Mr Coat

I am going to be on the telly advertising a work of art, eight years in the making. Utilising your thick sticks I have come up with something quite awe inspiring combining cannibalism, tempestuous seas, and issues of personal space. The whole tableau fits into an old fashioned marmalade tin and is about as much use as an ashtray on a motorbike, nevertheless Channel Four have failed to see the Achilles heel and are coming round to film my shameless and frankly boorish attempt at a transcriptive analogy which on reflection has been watered down further than a bottle of Vimto at a diabetic kids party.

My dilemma, sir, is to source a supplier who would be willing and able to supply me 'truncheon' sized charcoal and would be prepared to be remunerated in the next life,

Could you send me a catalogue and pricing details and any literature you may have to hand on the charcoal burning as the only visual information I have is the Jack Daniels advert on the tube. I am sending a postal order to cover you for postage.

I can get hold of a car with a roof rack if this is of any use to you in planning this transaction,

Looking forward to working with you closely on this project. I have decided to move to Stoke St Gregory, just down the road!

Yours in every sense of the word

Colin Lowe & Roddy Thomson

Colin Lowe and Roddy Thomson, Letter to PH Coate & Son, 2000

Stand out obviously

Then a few days later my wife told me Roddy had phoned to see about him and Colin going round to her mosaic studio, because they might want to have some of their art made up in mosaic. He'd mentioned I'd asked them to be in a new series I was working on, the follow-up to *This Is Modern Art*, called *Hello Culture*, also for Channel Four. 'Did he mean it?' he asked. 'Yes', she said, 'he's not cruel' – meaning I wouldn't say it only to take it back later. But then Roddy said to her – mishearing – 'No, he's not very cool, is he?' My own wife! They just assume she'll agree because it stands out so obviously and it must stand out even more to someone who's intimate with me.

Write letters

Colin and Roddy came round the other evening. They wanted to talk about the TV series. I'd suggested they paint a text-painting, listing a Top Ten of famous cultural suicides – Kurt Cobain, John Berryman, Virginia Woolf, and so on – for an episode about nihilism. They got out the letters they'd been writing to manufacturers, requests for sponsorship in the form of free materials. A letter from them to Daniel Quiggin & Son, the firm that makes Kendal Mint Cake, requested off-cuts to make a cake version of Caspar David Friedrich's *The Wreck of the Hope*. The letters had a magnificent style of hopeless faux legal-document pedantry, combined with a subtle edge of menace. I particularly liked the way some of the sign-offs suggested the writers might be in prison or a mental home:

> *Please respond to this letter using my pseudonym*
> *as I think my post may be being tampered with.*
> *Yours truly…*

And as with all their writings I thought they were poetry of a kind that only they could do:

> *If there is a soul in the heel of the Wickes empire, then*
> *it may be possible that your humanity could extend to*
> *compensating me on my tragedy.*

They always offered their victims something in return for whatever they were demanding. But not something anyone would ever want, even if they could unscramble the offer:

> *Considering the novelty of my idea in an art historical*
> *context may seem shocking to a mint-cake manufacturer*
> *I assure you Mr Quiggin your patronage would not go*
> *unnoticed in each and every public opportunity in any*
> *exhibition context and believe me this one is no shelf-sitter!*

Set fire to boat

Colin and Roddy said they didn't like the Top Ten suicide idea.
For the episode, they'd been thinking of their own idea for a text-painting. They didn't know what it was yet, but they'd have it ready
on the day – maybe they'd do it on glass so the TV viewer would have
to use a mirror to read it. That would be great, I said. They thought
they might set fire to one of their models of Gericault's *Raft of the
Medusa*, as well. The models are only a few inches high. They use
sticks of artists' charcoal for the planks of the rafts. And instead
of Gericault's dead and dying figures, there are cut-out photos of
Colin and Roddy and a lot of little balsa-wood models of crates for
shipping art, each stamped with their names – as if both their lives
and their art were doomed, and also they might have to eat each
other. They could burn one and chuck a fiver on, they said, and let
it all go down the toilet. Then they suggested they could be filmed
at the leisure centre in their swimming trunks.

How enjoyable

After Colin and Roddy left, I thought how enjoyable all their ideas
had been. I don't know why I should like this strand of art, which on
the face of it sounds pretty non-aesthetic. I suppose I like the loser
stance: the way they comment in a futile way on the main action
from the sidelines. But in fact their art isn't unaesthetic. Something
aesthetic always seems to develop from their basic position. But the
basic position – the position of someone who feels a bit defeated –
is always still there loud and clear. They certainly are masters of
doing the wrong thing if their aim is to get some power. They want
to be true to themselves and to not resist going on drinking, as
well. They'd take up my offers of friendship and patronage, but
they couldn't resist keeping a bit of distance at the same time,
so as not to be overwhelmed. While I was thinking this, I heard my
wife drunkenly laughing at one of their letters where they'd asked
a charcoal manufacturer for free sticks of charcoal to make a
Medusa, so Channel Four could promote it on TV. It was a
reference to myself, of course, but whether it was the real or
fictional version I don't know.

5

PROTESTING

Jeremy Deller and Alan Kane, *Folk Archive* (detail), 2000

Billy Childish, *Billy and Tracey in His Studio*, 1981–2

Eugene Doyen, *Quiet Lives* (production still), 1983

Artists against anything

In the art world at the moment the theme to adopt, if you want to be seen as a bit out there, is protest. It might be rural pagans against modern cities, miners against Thatcher, or Cubans against US imperialism – you just temporarily take over an already established political rhetoric and try and find ways to re-stage it in terms of a contemporary art installation.

Artists against art world

If you're an art-world outsider who wants to protest, only one theme makes sense – outsiders against the art world. And one of the most successful of the outsider groups – but only in terms of getting noticed – is the Stuckists. Ironically the Stuckists' success is entirely due to their name having been coined by Tracey Emin, the group's great Satan. Whenever you hear about them, you hear about

her, which is why they're noticed at all, not because of their art. When you see Stuckist artworks in their press releases or in the papers, it seems like sentimental adolescent expressionism that really does look a bit stuck. 'Your art is stuck!' Emin complained to Billy Childish, one of the group's founders, about the old-fashioned, spiky-formed, staring-eyed, expressionist paintings he was still doing at the time – when she herself had turned expressionism in and done a course somewhere in philosophy and learned about conceptual art. 'Stuck! Stuck! Stuck!' So this became their name.

Billy Childish

Billy Childish already had a profile before Stuckism, as a cult rocker. He runs a band called Thee Headcoats. They play Link Wray-style rockabilly with a purist angle (clear, twanging, *c.*1962 guitar sounds) plus a punky angle (quirky, personal lyrics). It's all Childish's idea, with his tunes, guitar-playing and words, and his production. He has a very definite, recognisable and effective style for the album covers, and the band's identity, even down to the spelling of the band's name, with Thee instead of The. He also publishes poetry, some of which is about his life with Tracey Emin.

Don't learn codes

In 1997, years after they split up, Childish put on a performance with Emin at the South London Gallery, in connection with a show of Emin's work that was on there at the time. The performance

The Stuckists, *Art or Arse* record (front and back), 2001

was a kind of public shock therapy event, with them both going over what had gone wrong between them. He gave a few readings from his poetry, which were gripping because the content was often disgusting, and it was shocking to see the subjects of these stories of violence and betrayal, anal sex, abortions, diarrhoea and the clap, standing right there in front of you. And then after the readings, they aired some of their old arguments for the audience. It was quite good theatre: harrowing, embarrassing, amusing. It contributed a little to Childish's mythology, but more to hers because it was more her event. It's quite interesting to compare the Childish and Emin career paths, and wonder why one should make it to superstar level and the other not. You can never know if what's holding someone back from superstardom is that they unconsciously don't want it – because they're too authentic – or if it's just that they're not good enough. After all, the Stuckists' platform is sincerity – but then, so is Emin's, their hate-figure. So it's a mystery. Although, it isn't really – as an artist, you've got to be a lot more sophisticated than Childish is apparently willing to be. Nostalgia and sentimentality work in his rock act, because he knows rock's codes, but in his art his sentimentalism works against him, because he won't allow himself to become familiar with art's codes – presumably because he feels it would corrupt him. And it's the same for the Stuckists' protests against the Turner Prize, and against conceptualism, abstraction and formalism in art. Their protests are in the name of sincerity but 'sincerity' is meaningless in this context – and basically the Stuckists' protests are meaningless too.

Be engaged plus distanced
Protesting doesn't have to be authentic, it's got to be successful – you've got to successfully frame the protest, somehow, so it fits with what interests the art world. A good example of this could be found in 'Intelligence', at Tate Britain, in 2000. This exhibition, with its pretentious 'Sensation'-challenging title, was the first of a proposed series of triennial enormous round-up exhibitions, supposed to demonstrate new trends in current British art. It was spectacularly staged and in fact the purely spectacular element – the huge, white, gleaming spaces, and the sight of an appropriate-looking artwork here and there (fitting in without being particularly anything more than appropriate) – was quite enjoyable. But the main significance of 'Intelligence' was that it featured a collaborative project by Jeremy Deller and Alan Kane, called *Folk Archive*, which introduced a new sophisticated angle on protesting.

All pictures pp. 69–73
Jeremy Deller and Alan Kane,
Folk Archive (details), 2000

Triumph of the scraggly

Folk Archive was a showcase for genuine scraggly folksy objects
that the two artists had rounded up. The objects were basically
throwaway crap, given an air of the mysterious by a contemporary-art
context. As well as objects, there were photos and videos of folksy
goings-on in the countryside and far-flung corners of Britain, so
the overall impression was of a mix of folksy sights: country fairs,
Women's Institute events, gurning and pipe-smoking competitions,
demos, assemblies, events involving football crowds, hand-painted
bicycles, tattoos, amateur drawings of beloved political leaders.
Some of the objects stood out from the mix more than others: there
was a morris dance prop of some kind – a decorated horse's skull
and bridle – and a Jimmy Saville scarecrow with NOW THEN NOW
THEN written on a bit of card. Also, there were some knitted dolls
representing the members of the Manic Street Preachers, picked
up from somewhere in Wales. It would be misleading to give the
impression that the whole thing was a cynical exercise, since it was
clear the creators of *Folk Archive* believed that what they were doing
had social worthiness. They really believed it was a morally good
thing to archive the products of 'the folk'. But you could say that's
the equivalent of an expressionist really believing his feelings run
deep. In fact *Folk Archive* was convincing on the level of structure
rather than morality or worthiness. That is, you had to marvel at the
way the artists had pulled it all together and made all the textures
and details chime and relate and seem to amount to something.

Unfeeble

When I first went into the *Folk Archive* room, it seemed too much
like what anyone might expect from an art student's feeble attempt

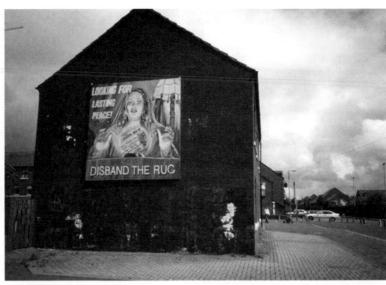

at meaning. I looked at a photo of a hand-painted sign at a fête somewhere, saying 'Art exhibition', and thought, 'Wow, this is pathetic'. But then as the private view buzz went round about the installation, I thought it was clever to be pathetic. After that I noticed the photos had a look of first-year art student pretentiousness, which is a look you'd want to think twice about before risking. But it was clear these artists absolutely knew what they were doing.

Folk against slickers

Folk Archive was about folk versus slickers but only in a figurative way, not a real way. The point wasn't to free the folk (or something) but to protest that contemporary art is lifeless and folk art is lively. And to create the illusion, in the space of an installation, that this old chestnut or nonsense cliché is actually a profundity: to make it seem that the second notion (folk art is full of authenticity) has a meaningful and critical relationship to the first (contemporary art is out of touch with lived experience) – when really that's just not necessarily true. My most abiding memory of the 'Intelligence' private view is of the incredible embarrassment when some Welsh folk singers who'd been invited along started singing in the *Folk Archive* room, and rhythmically rattling the bells on the harnesses of the folksy hobby-horse thing in the middle of the space. In the pub afterwards everyone said how good it was, but I remembered the horror on the faces of the middle-class audience, when it was actually going on.

Plenty of sashimi

At the private view of 'Intelligence', Owada were playing: this is the band of Martin Creed, named after the bass player, Kako Owada. Creed is a very good conceptual artist. His meaningless little stagings of nothingness are full of comedy and amusement, completely straightforward and un-solemn, but always lively. Owada happened to be making a horrible sound that night, since the acoustics of the Tate are unfriendly to guitar bands. But because it was Martin Creed the audience members were all convinced they were having a delightful time anyway. In my resentment – and self-hatred at having resentment – I began helping myself to snacks carried in classy shiny white bowls by waitresses. I felt embarrassed to force the waitresses to stand there and wait while I dipped interesting-looking rice parcels and fishy things into orange goo and ate them. The waitresses seemed hostile. Some of them spoke

but I couldn't understand what they said, because they were Japanese, and because of Owada's clanging. Then I realised they were whole meals I was picking from. The waitresses tried to deliver them to members of the private view audience who'd ordered them. And every time I sabotaged one of them, they had to go back and get a new one from some other part of the gallery, where the meal supply was kept – then they'd bump into me again and I'd sabotage the new one. Immediately after that awkwardness, Nick Serota came up to me in one of the first rooms of the 'Intelligence' show; it had a list on the walls of the names of every person Douglas Gordon – the Turner Prize-winning artist – could remember ever having met in his life. 'Hello, Matt! How do you like it?' Serota asked. And I had to have another little private groan of remorse when I saw the look of pained bewilderment and surprise come over his features – which are usually set in an expression that the writer Peter Ackroyd, memorably described to me at a dinner party recently as 'gripped' – when I said I hated everything so far and I couldn't stand Owada. Of course, it was only the nervousness talking.

Abiding taste for Situationism
In the pub, after the 'Intelligence' opening, Alan Kane, the co-curator – with Jeremy Deller – of *Folk Archive*, said he had a bone to pick with me: it was that I'd said on TV that Situationism was 'mostly rubbish'. It's true I did say it but actually I don't believe it – I just wanted to protest against contemporary artistic people bending my ear with their stuff on this subject. If they really believed in Guy Debord (suicidal founder of Situationism) they wouldn't be artists. But I didn't go into all that. I took my knocks and paid homage to *Folk Archive*, which was only right.

End of taste for *Blimey!*
Actually I had to take some other knocks. 'Everyone knows it's crap', Kane said, referring to my 1997 book *Blimey!*, about the London art world, as if it really is a widely accepted view, and also an innocuous enough thing for him to say to the book's author. But I interpreted it to mean that the yBas have to be attacked now because their ethos is outdated. It's a new fashion tic for conversations. The central group of main yBas is too glamorous and the media accepts them, so their art can't be resisting power, which of course all art must do. And because *Blimey!* is often thought of as a book of apology for the yBas, it makes sense to say it should go in the dustbin now.

Alan Kane

Obscure protesting

Another recent exhibition showing the various ways in which artists of today can have a go at protesting against something was 'Protest and Survive' at the Whitechapel Art Gallery. It included *Pain in a Building*, an installation by Liam Gillick. It was in a room on its own. There was a slide projector whirring away. The slides all seemed to be of buildings. A recording of his own homemade electronic music played at the same time – apparently in a random relationship to the slide sequence. A wall-label explained the buildings were in Thamesmead, which was built after the Second World War and then used in the 70s as a location for *A Clockwork Orange*. The label said the installation was towards a movie that was going to be made by somebody later, with somebody else producing, and somebody else writing the script.

Liam Gillick, *Pain in a Building* (detail), 1999

The mind of Liam Gillick

As ever with this artist, I couldn't imagine how anyone who didn't read art magazines every hour of the day could get a handle on this work. Or even be able to tell it *was* a work, or if a business conference hadn't been going on and everyone had just popped out for lunch. I had to admit it was impressive, and it went with everything else impressive about him. He's an absolute master of a certain type of modern conversational style, which he perhaps even invented himself, of sublime mystifying pretentious post-modern stylistic arty meaninglessness, mixed with a hint of old-fashioned Labour voting. I saw something else by him in New York recently that had Pol Pot and Coca Cola in the equation, or non-equation. And all the time I see these coloured metal structure things he's done, in various exhibitions, which seem to be a bit industrial or post-industrial, or remind one of an airport or office from the 70s. Their visual status is somewhere between something you'd never bother to look at all and something you might vaguely notice. But I can't tell if they're like this because anything more impactful would be too formal, or – well, I don't know, the negating possibilities are endless. Plus, he does a lot of books and film scenarios and animations that are all never about anything but have a few semi-intriguing historical or political references that are never followed up.

Tremendous marvels

Reviews of Gillick's shows in art magazines are always tremendous marvels of listing: one thing after another, not leading anywhere – except possibly to a triumphant quote from the artist where he'll

Liam Gillick, *Applied Distribution Rig* (installation view), 2000

say he's interested in states of inbetweenness. I think the US Defense Secretary in 1963 was a character in an animation he produced once. There is a hint of spooky time-bending when one of the characters says something about some kind of technology, or some technological phrase, not having been invented yet, because it was only 1963, and another character says, 'It will – it will'. I may not be remembering this accurately, but somehow I can't be bothered to look it up.

Fantastic god
But I respect Gillick's genius for the indeterminate. Recently he's become a god for curators. They all want him to come and give talks on their curating courses. They're amazed by his fantastic ability to say something is not as simple as you just said it was, and to create a feeling of fascinating complexity out of what anyone less gifted might take to be only thin air. In the catalogue for 'Intelligence', one of the organisers said she'd modelled her whole idea for the show on his mind.

Urban design referencing
Gillick often says vaguely left-wing things, which I always frown seriously at and nod to show concern, as it seems only right. And this certainly turns the curators on too, and makes them go crazy for him. I think with his urban design-referencing structures, plus his

Liam Gillick

interest in sociology and general city-experience, he represents
for curators a fashionable spin on modern romanticism. Instead of
finding a romantic nostalgic glow in industrial artefacts rather than
in the disappearing countryside (which is the usual modern spin
on romanticism), we get a romantic glow from the ideology of
yesteryear.

Protect me

I came out of Tate Modern the other day and there was Gillick, going
in, looking the same as ever: handsome, intelligent, tousled, like a
successful grammar-school boy from the 1960s. The scene was a bit
novelish, like Anthony Powell – the way the chancers and strivers who
were young in the earlier sections of *A Dance to the Music of Time*
turn up in later sections in positions of power. He said he'd been
protecting me from some woman who'd been calling him for my
number, for a promotion for the Turner Prize. She wanted to get some
art-world people in a white space, like a gallery, and then for them to
look at the camera as if they were looking at art. 'And do you know
how many she's got?' he asked. 'How many?' 'None! I asked her how
she got that job!'

Amazed in Germany

Then Gillick said he'd been amazed in Germany recently when
someone actually started quoting something from one of my books.
He imitated a German-accented guy intoning solemnly some quote
or other. 'As Mettyoo Collingss sess in *It Hurrtss*...' He laughed
at the memory of it and exclaimed, 'I couldn't believe it!' 'Ha ha', I
laughed too, fighting down the urge to cry: 'Yes, I know what you
mean, it *was* a weak book, wasn't it! If only I could rewrite it!'
Instead, I asked if he wanted to come round to dinner tonight, but
he said he couldn't – he'd promised to go out with Maureen Paley
because she was looking after Ross Bleckner. And even this was
hilarious, I thought – the London art scene's mad social rise since
the 80s, when it was a provincial backwater compared to New York,
the centre of the world.

Historical protesting

Some big survey shows are historic – they look at avant-garde art's
recent history. It's to confirm what's going on now. Fluxus, *Arte
Povera*, US Conceptual and Post-Minimalist art – all these
movements of the 60s, which were considered lively but ephemeral
at the time, are now seen as incredibly solemn, and must only ever

be talked about as the equivalent of Beethoven and Rembrandt.
The tatty old products of the movements are worshipped as powerful
icons of subversion. 'How clever of those people to anticipate
the great art of nowadays' – is more or less the official line of the
curators, and consequently the line of the reviewers.

Eat oranges and stop war
'Live in Your Head' at the Whitechapel Art Gallery in 1999 was one
of these historical protesting shows. It was a survey of international
Conceptual art from the 1960s and 70s – the hot era for the art of
today, in terms of themes to redo. At the entrance to the show was a
pyramid of real oranges, from which anyone could pick an orange and
eat it. It was an exact replica of an artwork from the 60s by someone
who's forgotten now. At the time it probably had an association of
The Beatles' Apple Corporation, with its famous logo of an apple
cut in half, which would have seemed light and amusing – but partly,
also, connected to protests against US imperialism.

Acknowledge greatness of glass of water
The private view of 'Live in Your Head' was crowded with oldsters
and trendies. In some ways the oldsters might have felt bitter about
the youngsters since it was their ideas the youngsters were now
recycling as up-to-date, camp amusement, while the oldsters had
mostly been knocked out of the art world for being too old. But some
of them had triumphed, although not against youth exactly. They'd
triumphed by reinventing themselves – sometimes becoming
spokesmen for youth. For example, there were a lot of stylish
Japanese art students going round the show; they'd stop in front
of Michael Craig-Martin's *An Oak Tree* – his glass of water on a
shelf from 1973 – and actually kind of bow before it.

Great free flowering
Near some Gilbert & Georges in 'Live in Your Head' I ran into the
artist John Stezaker, who had a career in the 60s as a socialist
Conceptualist and then over the years successfully reinvented
himself as a deconstructionist apocalyptic science-fictionalist
collagist. He laughed with amused recognition at the idea of the
social tensions that might exist now between old and young in
the art world, and said he was amazed to see so many of what he
referred to as 'the living dead' here tonight. He said the rhetoric of
the organisers of 'Live in Your Head' was that the Conceptual art
moment of the 60s and 70s had been a great free flowering of

creativity, but he remembered it as the most uptight period in art he'd ever witnessed.

Factuality
There was a magnificently mind-numbing work in 'Live in Your Head' from 1971 by John Hilliard – a grid showing successive stages of a camera recording its own image at different shutter speeds. It had factuality, time, directness, clarity and a slight feeling of giddiness at absurdity. All these would be goers in a Turner Prize installation today, but they wouldn't have any connection to freaking out, being sexually liberated, pro-equality and against war and racism, which they would have done in 1971.

Mary Kelly in time machine
If an artist from the 1960s or 70s, Mary Kelly or Victor Burgin, say, was brought into the present and shown art made today, they'd be horrified: they'd recognise the forms but find the ideology and attitude incredibly alien. Today's fashionable art comes out of a style and mood that was basically formed in the 80s, when the motto was 'sod the miners, let's boogie'. Now we've got political conservatism and official subversion in a happy marriage. But gradually the oldsters have grown into the same world the young ones now dominate, and the oldsters accept the values – in fact Victor Burgin has just been appointed head of Goldsmiths'.

Sorry to motivate Victor
I don't know if Victor Burgin really accepts today's art values, because I don't know him personally. But – ironically – if he started redoing his old posters from the 70s, which used to say things like *7 per cent of the population owns 94 per cent of the wealth*, they be a hit, because of the new political climate. The percentages are probably not much different now, but the revolutionary point in re-doing these posters today would be something less than real revolution: it would be blank revolution or amused revolution or revolution where nothing is expected to change.

How to be now
It's hard to sum up the climate now exactly. Have some conscious-ness of right-on thought. Be aware of social issues. And try and get some of that into the fragmented forms of contemporary art in an emotionally and politically completely weightless way, while still clearly referencing emotions and feelings.

Michael Landy, *Breakdown* (installation views), 2001

Destroy all stuff

An example of art doing the above to the max is Michael Landy's *Breakdown*, an installation put on in the middle of Oxford Street in spring 2001. It was hard to understand what this work was saying exactly, and what its supporters in the press thought they meant, when they eulogised it. Basically he had all his possessions broken down and destroyed and it was supposed to be some kind of challenge to consumerism. The destroying process was quite theatrical and elaborate, involving a whole team of destroyers in yellow outfits, and a special rig that the team operated. All his clothes and records and other personal bits and pieces, including his car and his artworks, and artworks by his friends that he owned – including a Damien Hirst – were crushed down to tiny chips. You could go and watch the thing happening over a period of a few days. Meanwhile, newspaper articles came out, marvelling at the thoroughness and scale of the operation, the amazing planning and effort that had gone into it. The destroying process cost £70,000, apparently. Sponsorship was provided by the firm. The organising was done by the Artangel Trust, a body of administrative theatrical angels – who provide finance and resources for art the trust deems to be worthy. In the *Evening Standard*, it was said that after the event, Karsten Schubert, the dealer, took Michael Landy round to Gap and bought him £350 worth of clothes. Sympathetic automatone workers offered him free sessions. It doesn't really seem to add up to Andrei Rublev (medieval Russian icon painter who was incredibly poor and spiritual; Andrei Tarkovsky made a very moving film about him in austere black and white). Anyone who was at *Breakdown*, though, says it was very stirring. And all you really hear about it is stories of spontaneous cheering and tears bursting out. 'This artist *must* be nominated for the next Turner Prize!' is the idea now. So he can get some cash, presumably.

6
SENSATION
AFTERGLOW

Marc Quinn, *Alison Lapper (8 months)*, 2000

Shock failure

When you go to the Saatchi Gallery these days, you see all the news cuttings from New York framed in the reception area, telling the story of the 'Sensation' scandal over there in wacky headlines and cartoons from New York tabloids. They say things like GIULIANI'S DUNG DEAL. They first went up at the time of 'Ant Noises', Saatchi's wittily anagramatical sequel to 'Sensation'. By this time 'Sensation' had turned out to be a failure abroad. In New York, when it was at the Brooklyn Museum, the left saw it as morally wrong – a self-serving scam by Saatchi who owned all the works. And as aesthetically bad – merely going for shocks. And the right saw it as blasphemous because of Chris Ofili's painting of a black Virgin Mary with an elephant dung breast. Then, more because of the right than the left, museum directors in Australia and Japan, who'd been lined up to take on the show, now cancelled it. They feared they might lose their jobs if there was another blasphemy scandal.

Shock normal

In reality 'Sensation' wasn't particularly bad, morally or aesthetically. The artists who were supposed to be obscene or shocking or both, with their gruesome flies, their kebab vaginas and penis noses, their saucy lists of sex partners, and their portraits of murderers, played a game. It was to ask: 'Have we as a society really come to this? Is this what we are now?' It was a questioning, or pseudo-questioning game the public already knew, at least to some extent. They didn't know much about Bruce Nauman or Gerhard Richter, or the steps in art history that had led to the forms of 'Sensation'-type art becoming possible as art. But they knew all about the content and imagery of 'Sensation', since the world of voyeuristic value-free fascination is everyone's world now.

Deny shock

But the controversies in the papers over 'Sensation' did highlight an odd denying tactic that the art world goes in for when the public is shocked by art. In the case of Ofili's painting, which obviously has quite a punky attitude about it and is definitely wanting to be a bit provocative – in fact this is an inescapable part of its excellence – the Brooklyn Museum said there were 'tribes in Africa' who saw dung as sacred, and really it was a 'spiritual' painting. And the other day when there was a press scandal over Tierney Gearon's photos of nude children peeing in the snow and playing naked in the bath and so on – in Saatchi's photo exhibition 'I Am a Camera' – the art world

stormed in to say how innocent the photos were. They were just kids doing normal kid things, completely natural, etc. But why would they be in the show if they didn't have a bit of controversy about them? And what could the controversy be if it wasn't sexual? (Come *on*, art world!) There was a massive sulk about Marcus Harvey's portrait of Myra Hindley – with its use of stencilled children's hand-prints – in 'Sensation', as well, when it turned out to be a shocker for many people. Artists come up with something clever that's shocking, but then when the public actually is shocked, the response of the artists' promoters or managers is to say shock is the last thing any artist would ever be concerned with.

Manufacture shock

But Saatchi is still an excellent art-world amusement figure. One of the best we've ever had. I feel he spends his whole time in some kind of playroom, manufacturing scandals, and laughing, and then going round to Nick Serota's evening soirées, or wherever he goes, and saying (as if butter wouldn't melt in his mouth), 'Goodness me, how could those newspapers be so sensationalist?'

Aversion to shock

There were a lot of new Marc Quinns on show recently at White Cube. This artist has cornered a bit of the shock market. He cast his own head in his own shit on TV a few years ago, as a variation on his idea of casting it in his own blood a few years before that. It really was quite hard not to turn away gagging when the shit was shown in close-up, being scooped out of some kind of Tupperware. These new works at White Cube were marble statues of amputees – real amputees and disabled people. The show was well reviewed, with all the articles saying the sculptures were like the fantastic art of the past, because they didn't have any arms, like the *Venus de Milo*. So the general public and the press, as opposed to the art world, are still fascinated by shocks in art, and they'll convince themselves that something is important if it's got a few daft shocks in it. But the art world is nervous about the daftness of shocking art now (although other types of daftness are still fine). Marc Quinn still plugs away at shocks, and a few other artists do too, but on the whole there's a different climate in art now, away from shocks. It may turn out to be a mistake for the art world to turn its nose up at shocks, because the popular audience might forget about art, and revert to getting its shocks fix from the movies, TV and the papers, where it always got them before.

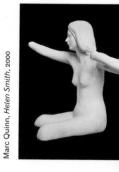

Marc Quinn, *Helen Smith*, 2000

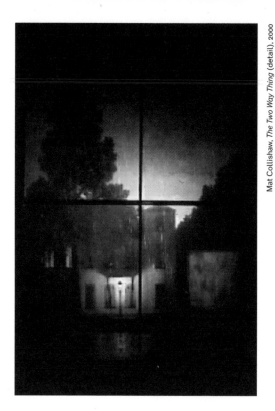

Mat Collishaw, *The Two Way Thing* (detail), 2000

Excellent shock

The other day I saw a good shock work by Mat Collishaw at the Lux Gallery in Hoxton. He's totally at ease with the shock theme, and comes up with a lot of fresh variations on it, many of them involving ideas of nature and the universe, and the crackling current of primal sexual energy that runs through everything that exists. This one was a series of single-scene films, with a teasing suggestion of narrative building up as you went from one little scenario to another: butterflies mating, an old-fashioned fireplace with a coal fire crackling – the crackling amplified hugely throughout the gallery space – a flower pulsating a bit obscenely. The pay-off scene was a window in a room, with a rain storm outside and a TV screen faintly glowing in the corner of the window, and on the TV a blurry, violent, fuzzy, anal sex orgy going on. The whole thing was given an air of enjoyable sinfulness by the darkness, the sense of being in a peep-show, and the individual films all being shown within a range of old Victorian cabinets. A couple of weeks after it opened there was an apology in the listings pages in *Time Out*, regretting that *Time Out* had misidentified one of the orgyists as Tracey Emin, Collishaw's partner.

Mat Collishaw

Shock failure

'Apocalypse' at the Royal Academy in 2000 was intended to keep the art shock-wave going for a big paying audience, which 'Sensation' started in 1997. However, the only work in it that made any impact on the public was *Hell* by the Chapman brothers – otherwise it was a failure. But no one minded – the public hardly noticed the show and the art world didn't care anyway. It was co-curated by Max Wigram, an independent curator who used to be an artist (his artworks were photos of himself as James Bond), and by Norman Rosenthal, the Academy's exhibitions secretary. Rosenthal created such a successful scandal out of 'Sensation' when it was first shown that people are generous toward him and probably feel he should be allowed a few failures.

Loft shock

You went into 'Apocalypse' through a claustrophobic reconstructed little bit of a real house in Germany, which its owner – a genuinely mad German artist – had spent years making into a madhouse, with shrinking walls and nightmarish enclosed spaces and doors leading nowhere. You could see a video monitor showing the real thing in Münchengladbach. It's good for an artist to make his home into a nightmare because usually they only want to make it into a loft in Hoxton.

Jake and Dinos Chapman, *Hell* (detail), 1999

Jake and Dinos Chapman

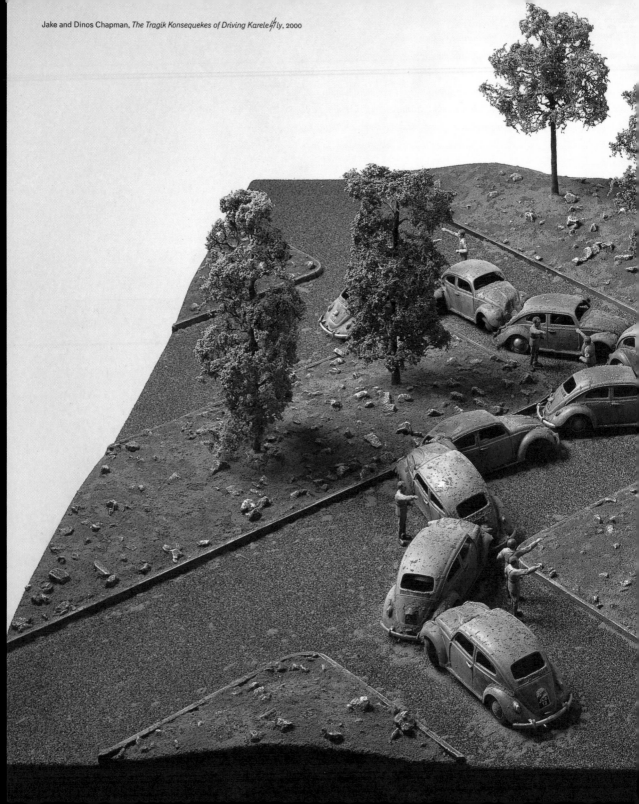

Jake and Dinos Chapman, *The Tragik Konsequekes of Driving Karele�ur ly*, 2000

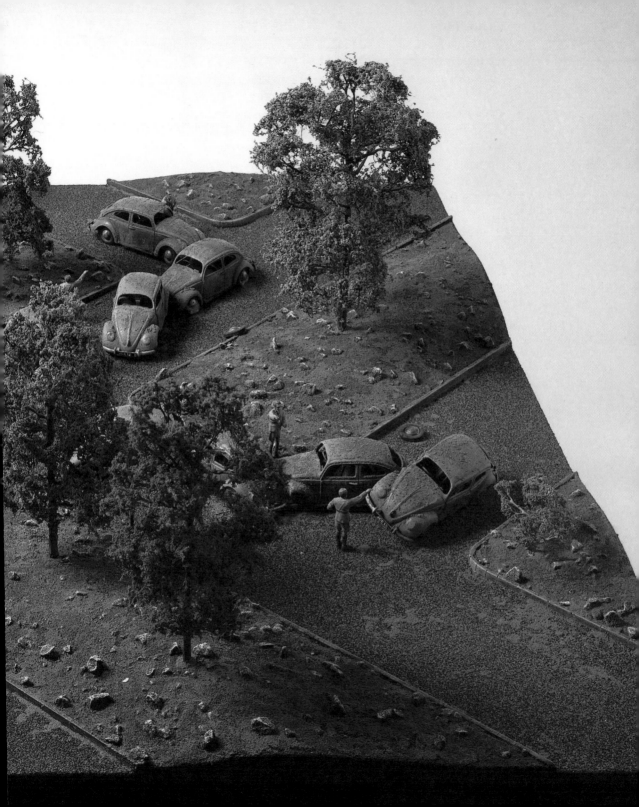

Shock Hitler

'Apocalypse' was supposed to have been inspired by the Chapman brothers' installation *Hell*. In fact this work – the show's centrepiece – had a lot going for it. Another one I saw by them in Switzerland recently was a miniature road junction with a lot of crashed German VW Beetles and their drivers – identical miniature Hitlers – all having road rage. Perhaps it was made as relief from the great labour of finishing *Hell*. It was simple and pure, with endless possibilities of amusing modern meaning: masculinity is frightening, shouting is bad, drive carefully, don't read so many George Bataille books. *Hell* was much more elaborated. The 5000 little individually modelled Nazis – re-modelled from Airfix soldiers – swarmed through nine glass vitrines, torturing and eating each other. There were grotesque concentration camp parodies, but also strange little puppet theatre scenes – corpses being made to act and dance by evil puppeteers. And battle scenes, Goya-esque decorative body-parts scenes, and evil-worshipping scenes – the Nazi leaders all worshipping in a Nazi church. There was a feeling of *Apocalypse Now* and generally an epic filmic feel, which was amusing because the work was still only made of plastic Airfix toys, which are childish. Children in this context might remind one of the Chapmans' shocking sex mannequins. So you could say there was a theme of innocence v. corruption – if you thought of the shocking things the little Nazis were doing to each other.

Sopranos not real shock

Are the Chapman brothers evil? *Hell* is a sustained bit of camp, death-camp camp – a playful take on evil. It's not really evil. It's about what people are interested in: sensationalism, taboos, a bit of narrative, some interesting detail, something gruesome in the papers, some macabre laughs. It's not about real Nazis so much – just as *The Sopranos* isn't really about gangsters so much.

Stop shocks

Don't just reflect the numbness of society and be fashionably nihilistic – demand that the future be better! This is a frequent sermonising line on the Chapmans, or negative interpretation of what they do, in the art magazines – if the writer's on a high horse, or wanting to claim the moral high ground.

7

LAUGH FROM FEAR

Jemima Stehli, *Strip No. 4 Curator*, 1999

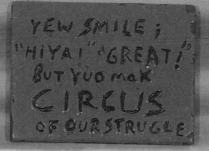

Numbers down

BANK is now made up of two members only, Milly Thomson and Simon Bedwell. There used to be more but they gradually dropped out, with the last one, John Russell, leaving after a row. It's a bit tragic for Russell now. Although he's made a new start as an artist (collaborative paintings and performances with Fabienne Audéoud), a lot of works by BANK that made the group's reputation in the art world were based on his input – his jokes, thoughts, ideas, reflections and musings and so on, as well as his painting and sculpting (etc.) skills. For example, their magazines with their clever, funny headlines – how will history know who really thought that stuff up? I hope it will give him some relief if I make it clear in this book that AD MAN YOU'RE A BAD MAN! was his idea. On the other hand, no one said the path of virtue was an easy road to follow. If you agree to subsume your personal identity within a collective, on ideological grounds – perhaps believing that individualism is bad – then you can't really complain if once you've left the collective, no one talks about your individual contribution.

Impressive

I went round to BANK's studio a few weeks ago and made little noises about buying something, but they demurred because they were about to have a show and they wanted to keep everything together. The show was supposed to be in the gallery in Brick Lane that the Chapman brothers run. So BANK were excited because they'd been depressed about not having any gallery at all representing them – and now an impressive one was going to be hosting them. But then a few days later it was postponed for some reason, and Milly said Simon was feeling like a loser for not immediately agreeing to sell that painting, and doing a lot of evasive muttering instead of sucking up to me.

Surly good

But that's wrong, of course, as BANK's surly, self-destructive, self-conscious, introspective attitude – combined as it is with critical intelligence and a flair for spotting weaknesses in the art system – is what will make winners in the end of whoever's still in the group.

Words good

Recently BANK have been turning out a lot of paintings with incoherent phrases on them. Or if not incoherent, inexplicable.

Simon Bedwell

Milly Thomson

Streams of angry ranting, or sputtering single words or phrase-fragments like 'Freud' or 'fraud' or 'pathetic' or 'pathet' or 'prol-kitsch' or 'you only laugh from fear'. The words are on abstract blobs. As paintings they don't all work equally well. Some have too much going on in every direction, visually, or else the opposite – they are too pat. But many are good on all levels, and in any case the attitude is always right.

Poignant

You could interpret the words as a comic expression of the frustration everyone feels as they try to be more successful in today's world. But I like to think the satire is more specifically on the art world – in particular the art-world's use of a critical language that art world types pretend to be at ease with. Made up of bits that don't fit together, it's a Frankenstein language: it can never be loved, it can never really be alive. When you see it written down there's always three-quarters more type there than if the same point was being made by someone who was literate. Not that anyone who'd ever really read any books would ever want to make those idiotic points. And the sound of it is always ghastly and painful. Plus, it doesn't communicate anything anyway. It's a self-referential, total non-communication system for fake, travesty-academics, and people to whom nothing has ever really happened in life. The words in BANK's paintings aren't this language, but the sputtering sound of someone wishing to use the language, but who can't quite get it together. The language is bad in the first place, when someone who has some expertise in it is using it. And when it's someone struggling to appropiate it, to impress their friends, it's bad too. There is a touch of sadness about BANK's satire – which I can relate to – because although this language is not at all radical or revolutionary, if you're in the art world it's really all you've got.

Low level

When BANK were round for dinner the other day, Simon looked a bit down in the mouth and said they never smoothed the way enough socially with art-world power people; because of their surliness they always made such types feel uncomfortable. I laughed and reassured him. Actually I was reminded of a reading I gave from *Blimey!* at the Chisenhale Gallery once, just after it was published. The next act on was BANK – they were going to give a slide lecture about all the group shows they'd organised over the years in various temporary locations, and in their own gallery (which they called

Galerie Poo Poo, as a joke on pretentiousness). During my talk, someone in the audience waxed lyrical about the greatness of *Blimey!* – 'It worked on so many, many different levels!' this person exclaimed. But then John Russell interrupted and said dryly, 'Well, name something on *this* level...' – gesturing with his hand, palm down, raising it to medium-height from just below medium-height. And it wasn't even his turn yet!

Terror at nudity

The art world is fascinated by any art that literalises, in an obvious way, something theoretical. Partly because such art takes art ideas out of the theoretical dimension and puts them into the popular dimension, which is right-on. But mainly because it gives the art world a Janet-and-John lesson in theory – for which the art world is always grateful. Jemima Stehli, whom I have known for years, was also round at my house that evening with BANK. Eventually she got out some photos of herself stripping, from clothed to naked, viewed from behind, with me in the picture too, fully clothed, staring at her. My wife thought it was a bit much and a frosty atmosphere set in.

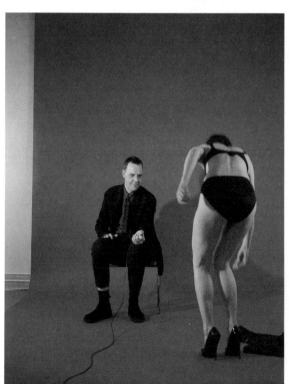

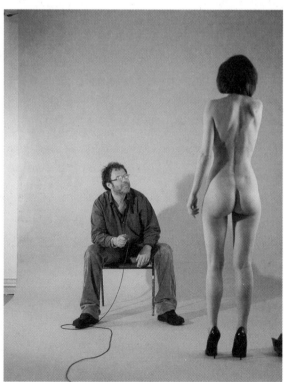

Jemima Stehli, *Strip No. 6 Critic*, 2000

Jemima Stehli, *Strip No. 3 Critic*, 1999

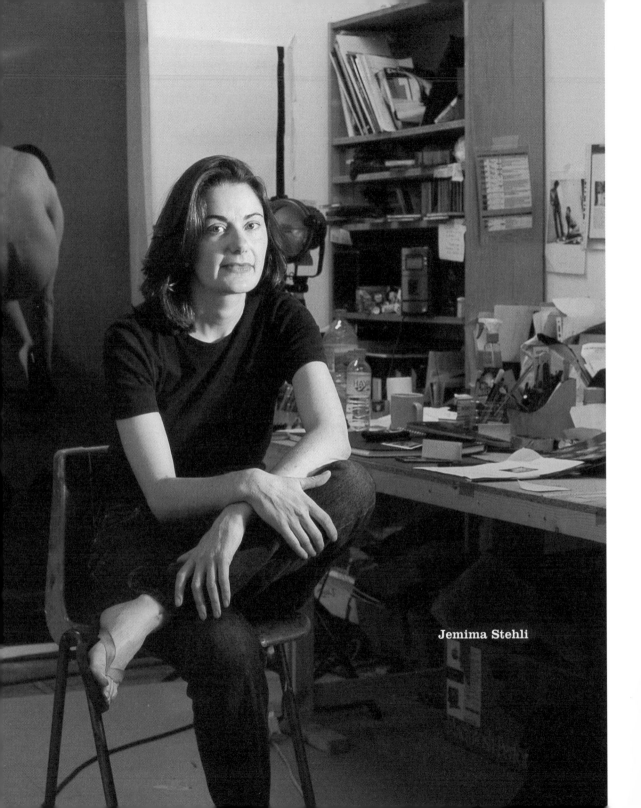

Jemima Stehli

In fact the evening, which had been lively before, now petered out awkwardly. The photos made up one set from a series, all on the same theme, showing male art-world professionals – writers, curators, critics – clicking the camera shutter by remote control at different stages of Stehli's strip. The series got a lot of attention from art reviewers on the newspapers and style mags when it was first shown at the Lisson Gallery. It was taken completely seriously as a modern critical feminist twist on the tradition of the nude in art. It was considered to be about the male gaze, in a very direct way – some males actually gazing. The curator Matthew Higgs and the art writer John Slyce look a bit blank in their shots, so the reviewers all took it for granted that their blankness was really middle-class terror at nudity. In *The Guardian*, Adrian Searle, who sat for one set of photos himself, wrote that in mine I was leering and had out of control body language. When I read this I was surprised as I felt I was just sitting normally instead of self-consciously – I thought he looked a bit prim in his. But then when I looked at the pictures again the other day, with me in my casual clothes, and him more formal, I thought we both looked pretty normal. And I don't know if either of our expressions, or our body languages – or the body languages of anyone else in the series (including Jemima's) – really said anything about anything.

Next page: Fionna Banner, *Don't look back* (detail), 1999

HER VOICE...

MUST BE SOMETHING ABOUT HIM IN I
IKE. DYLAN REPEATS BLOKE LIKE HE'S
HS. THE GUY FROM THE ANIMALS IS DO
THAT DONOVAN'S ALL RIGHT, IN HIS N
DN'T HE? THAT'S THE HEADLINE. 'DONO
VEL VOICED, AND SMOKES EIGHTY A D
S A SIGN FOR THE GIG, IT SAYS SOLD C
OUT HIS HEAD OUT OF THE WINDOW. IT
E DOES AUTOGRAPHS. HE GOES ON IN L
LES AWAY, AND THEN SOMEONE GOES I
EN THEY PLUG IN ANOTHER LEAD AN
UMBER IS, 'IN THE DIME STORES AND
E AND FAILURE IS NO SUCCESS AT ALL
NG LOW. HE LOOKS SO SMALL, HE'S I
ONT OF THE GUITAR SHOP LOOKING A
TICKS ON THE END. DYLAN SAYS HE WIS
N SIGN PAINT ABOUT DYLAN, IT LOOKS
LIKE THIS IN NEW YORK. STILL IN DEN
E LONG FACE IS ON THE PHONE: HE SA
E MIGHT UNTIE HIMSELF, WELL WHAT I
SSMAN HERE AND HE'D VERY MUCH LI
A FACE AND SAYS WELL WHAT DO YOU
RE'S SOME MORE CHAT ON THE PHONE
THE SHOW WITH YOU, BUT WE'RE IN A
WITH, THANKYOU. ETC. THEN HE GETS
S ON, HI WELL WE SPOKE IN NEW YORK
NLY OFFERING HALF, OK SPEAK LATE
E CONSPIRACY ABOUT IT. IT
EM PLEAS

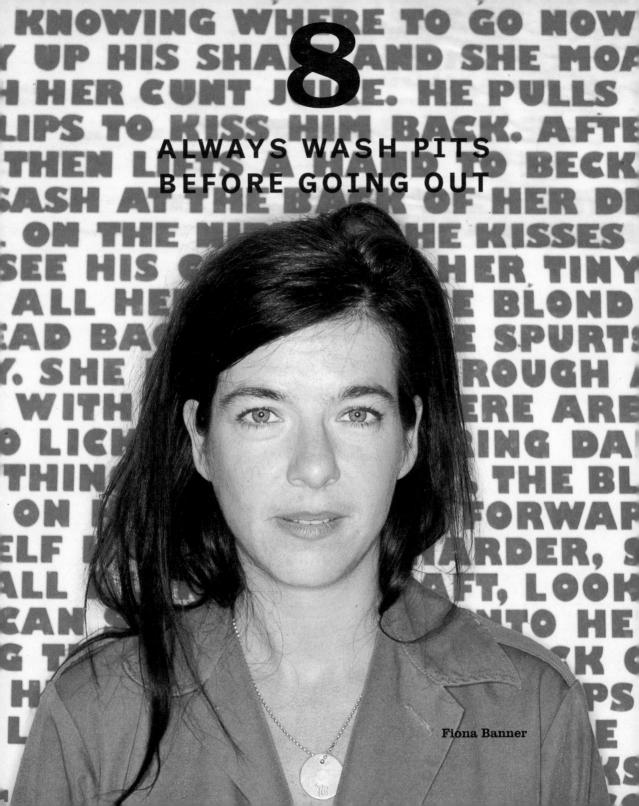

8

ALWAYS WASH PITS
BEFORE GOING OUT

Fiona Banner

Tap adrenaline

I find all private views nerve-wracking, but like many people I'm
addicted to the fear. We don't know what it is we fear exactly, but
we know private views are prime sites for it. Why do we want to
keep tapping it?

Tap Fawcett

I went to the party at Tate Britain after the announcement of the
Turner Prize shortlist for 2000, with my wife and my new little
£59 Olympus camera. I saw Anthony Fawcett, who arranges art
sponsorship by Beck's beer, and tapped him on the shoulder. I'm
always amused when I see him: it seems awful that art should have
anything to do with corporations but it seems naive to find it awful –
so what can you do? He did the PR for John and Yoko's bed-in in
the 60s. In fact he did their PR for two years and then he did it for
Crosby, Stills and Nash. He is a tiny, friendly guy. Tonight he seemed
to be surrounded by glamorous women. He wore a jacket with a swirly
white-on-black pattern, like art. He had his own camera to show me.
It looked harmless enough at first, but when he operated the zoom
with a cackling laugh, a gasp went up from the women – it was like
that scene in Chris Cunningham's *Flex!*

Neil Tennant

I tried taking a photo of Neil Tennant in front of Glenn Brown's
transcription of a nineteenth-century apocalypse by John Martin.
Because I didn't know how to change the little digital controls, I
was stuck on the anti-red-eye function, which means it takes a while

for the shutter to click. In the extra split seconds Tennant kept moving behind someone's head. I was anxious that it might be deliberately to avoid me, because he believed I was obsessed by the Pet Shop Boys.

Falsity
Then we ran into some friends. They tried to sense from me what the Turner Prize buzz might be this year so they could agree with it. I felt uncomfortable because I knew I should look after them, but I was too restless. I couldn't concentrate or stay still. We were in Tomoko Takahashi's space, and now someone official-seeming, a Patron of the New Art, perhaps – the body of collectors that invented the Turner Prize in 1984 – came up. 'It *is* marvellous, isn't it?' she said. 'She's really done herself proud, hasn't she?' '*Yes!*' I enthused falsely.

Doubt
I tried a couple of other photographic subjects: Fawcett joshing heartily with Wolfgang Tillmans, who everyone knew was going to win; people standing by the Turner Prize sign, other people smiling at photos by Tillmans. The Tillmans scenes reminded me of when I'd seen Charles Jencks here recently – the architect and writer who invented the term 'Post-Modernism'. Him facing the Tillmans works seemed like an allegory of modern emptiness: doubt facing doubt.

Rank
I felt more and more ill at ease and realised the adrenaline was

making me sweat. I was horrified at the idea of smelling at the Turner Prize – so I decided not to make eye contact with anyone I knew, so I wouldn't have to kiss or embrace them. But as soon as I thought this I saw Tracey Emin and Patrick Brill – the artist who works under the name Bob & Roberta Smith – and I had to kiss her and embrace him. 'I thought he was Billy Childish!' Emin exclaimed, because she'd seen Brill from behind in his leather jacket and flat hat. She embraced him with relief – glad he wasn't spearheading an invasion of the Stuckists – who were in fact demonstrating outside.

Immense block of writing

Inside the pub, after the Turner Prize opening, was a sea of familiar faces. A whiny voice started up in my ear. It was an artist who always seems to be organising new studio spaces, in order to feel powerful, I expect. He had thousands of square feet in Cremer Street, he was saying now. He was with Graham Gussin, the conceptual artist who wired a room in the Tate once so the footsteps of the audience became art. I let part of my studio space to him for a few months. They both seemed to believe they were in one of those English films of the 60s, about swinging London – which were impossible to enjoy because of their clunking artificiality, but which are now part of nostalgia – where the script instruction suddenly says 'horseplay'. 'Wot's your name then? Arabella?' one of them asked my wife, to show that a silver teaspoon in the mouth was far from being their experience as tiny tots: they were children of the street instead. Graham asked me if I was glad he wasn't in my studio any more. 'No, I really miss you!' I lied. Then I got to another dense bit of

Left to right: Jeremy Deller, Fiona Banner, Andrew Wilson

the pub where Fiona Banner and Margarita Gluzberg were leaning. Fiona made some cracks about my having to escape out the window from her studio that night when I'd been locked in downstairs. I laughed bitterly and then apologised again to Margarita for shouting at her, which I always do now whenever I see her, as an automatic reflex. A curator from Berlin was introduced to me, but I was giddy now from Guinnesses, plus the champagne I'd had in Tate Britain earlier, and I couldn't think up any nonsense to contribute to the curatorial pseudo-intellectual power talk in which she was attempting to engage me. I turned to Fiona instead and said I'd noticed some blobs in her studio that fateful night and she said, yes, and started explaining what they were, but I can't remember what it was now. Usually her art is just to list everything that happens in some film or other, in an immense block of writing, which you'd think no one in their right mind would ever want to read. When you do strain your neck to read it, it's often a bit macho and you can feel drowsy from the unrelenting faux-Hemingwayisms, as much as from the lack of paragraph breaks. Fiona seemed to not be here any more and in fact had gone to the bar. Before she left, a man started taking over her wisecracks about the studio, filling them out with – I felt – almost a professional surveyor's eye for detail. I turned towards him now. 'You seem to know a lot about my studio', I said – perhaps in a slightly slurry voice. 'Who are you?' He said he'd been going out with Fiona for two years but she never acknowledged him in public.

9

GUIDE TO ASPECTS
OF THE EIGHTIES

Impact of intimidating German Neo-Expressionists

Marcel Duchamp (inventor of notion that art can be anything) is always being cited as a great influence on the yBas. But it's pretty unbelievable, because he's so refined and intellectual. It's much more believable to think of German Neo-Expressionists like Baselitz (upside-down images) and Lüpertz (Nazi helmets and so on) or Kiefer (burned landscapes) having an impact. It's not their imagery or their artistic ideas that were influential on the British scene, but their relationship to success. The German art scene of the 60s and 70s was incredibly stylish and weird, full of interest. But by the end of the 70s – although still marvellous – it had become a well-oiled business machine. The stars were strivers, narcissists and showmen. They each had a special act to draw attention to themselves: a way of putting a frame round themselves that said 'ARTIST', but in a transparently unbelievable way. It was a shock when they arrived in Britain around 1981. They made you get used to meanings in art suddenly being not just slightly unbelievable, as they had been with US Minimalism (square boxes) and Conceptualism (texts on the wall) and so on, which you'd see in odd shows here and there, but really quite shockingly unbelievable. All the artists were amazingly commercially successful. It felt almost bizarre – why hadn't anyone in Britain thought of that before? The stars all seemed to have the same shaved heads and scars – their heads were like fantastic sculptural monuments. They were part of a big art promo operation with connections to all the international museums. They just swaggered around Europe and the US with great big swag bags marked 'SWAG – put dollars in here!' It was fabulous.

Pay more if distressed

In the 80s, surfaces no longer had their old fixed meanings. It was the same in art as in everything else – a new fakeness to everything. The distressed look in interior design – this was an 80s thing. Anselm Kiefer's paintings always had a tastefully roughed-up look. Looking at them now (which isn't a trendy thing to do any more), an observant person might think the craze for him was the result of an unconscious connection wealthy collectors made between his surfaces and their own expensively distressed walls. In fact he was the innovator of that look, which only took off in interior design in the later 80s – the look of something deliberately made to seem a bit beaten-up, and older than it is.

German poppers

Number one: Sigmar Polke (free-floating imagery copied from photos, presented in a context of swirly transparent abstract blob paintings). And number two: Gerhard Richter (grim, visually boring copies of photos, in oil paint, plus lots of different types of abstract paintings, all extremely anti-lyrical and pro-forcing the audience to do a bit of thoughtful chin-stroking). Put one and two together and you get the sheer amazement of their rise in the 80s – they went from Pop art also-rans, who'd get a pathetic mention in a Thames and Hudson Pop art anthology, which students might get out of the art-school library, to world art *über*-leaders. This was another remarkable change in art consciousness, in Britain. Today, British painters who are trendy worship Richter. They see him as the old master of the death of painting. They worship Polke almost as much, although with Polke there is a slight stepping back because of his impish perversity, which can easily go wrong – and pall – if you try to imitate it. Whereas anyone can imitate Richter, because of the mechanical look of his painting style, and many do.

Bettina and Siggy

My ex-partner, Bettina Semmer, bumped into Polke in Cologne the other day. She'd been his student, years ago. He was in the Walter König bookshop with his video camera. He'd come in there from a Magritte exhibition in a new gallery next door. He famously never appears anywhere, but here he was. 'Hello, Bettina', he said. 'How are you?' 'Good', she said. 'And you?' 'Bad, very bad'. Then they went back to the Magritte show. 'Why don't you buy one of these?' she asked. 'I've got no money!' 'You're swimming in it!' 'I'm going to lock you in this cupboard…!' That's his personal style, so you can believe it probably went like that.

Hans Haacke, *Taking Stock*, 1984

Joseph Beuys in the 80s

Will future generations resurrect the Joseph Beuys (mystical performances and installations, often having a tasteful grey or browny-red colour) legend? It's hard to imagine it from the perspective of now. He seems impossible, with his Rudolf Steinerism and Jungianism. But of course his political Greenism could be the factor that today's politically conscious artists might suddenly get ironically obsessed by. In the 80s he was someone it was impossible to not be aware of. Awareness of him went with absolute bafflement at his programme of spirituality and shamanism. I remember Bruce McLean (comedy art) announcing in an 80s performance at Riverside Studios, once: 'Joseph Beuys and his fur coat – more House of Aquascutum than house of the shaman!' There was hyper-awareness of Beuys's style and look – especially his use of vitrines to house disturbing or horrible objects, which so impacted upon Damien Hirst (via Jeff Koons) – but a complete mental blankness when it came to Beuys's content.

Evil Thatch

Hans Haacke, originally from Germany but since the 60s a New York resident, is a sympathetic, old-fashioned, left-wing protestor artist, who uses various media. Although slightly dull, he is a hot guy for now, because his old plodding sincerity seems very similar to the new empty sincerity of nowadays protest art. Recently he was invited by the powers that be to do something amazing in London, and the result was that he got a lot of old works out of the Victoria & Albert Museum and put them in the Serpentine Gallery. Everyone was amazed by the genius of the idea, especially when he also put some new works in the V&A, including some of Marc Quinn's amputee sculptures. The reviewers couldn't believe how natural the Quinns looked in the V&A's sculpture rooms, and they thought only the greatest of minds could ever have thought of that. Another amusing thing about Haacke was his totally rubbish portrait of Mrs Thatcher from the 80s, which was intended to be a withering indictment of art's craven relationship to power. The mindset of the painting is absolutely at one with shows of today such as 'Protest and Survive'. It spells out in a hilariously unsubtle way things you must know if you want to be against that fictional character in Jimi Hendrix's 'Machine Gun' on *Band of Gypsies* (although, sadly, the aesthetic beauty of Jimi's guitar-playing would probably be lost on Hans): 'Evil man make me kill you – evil man make you kill me too!'

Endless freebie Venice Biennale trips

80s impression Number 7: British art journalists at the Venice Biennale. They'd mass at the barriers on the first morning of the three-day press opening, in their safari outfits, looking absurd. The same ones have probably been doing that since 1895, when the Biennale was launched to celebrate the wedding of King Umberto. Then you'd see them over the next few days here and there in the leafy groves of the Biennale gardens. 'Seen anything?' 'No!' Actually for the oldies that's still going on the same today – it hasn't changed at all. For the younger journoes, though, there's a whole new attitude. They go there and check out what's happening so they'll know what to talk about at ironic bean-bag parties, with rocking curators hunched over the turntables, at three in the morning on the Giudecca.

Clemente and Cucchi and so on

Italian *transavantgardia* painting had an impact on the rise of the British scene, also in about 1981. It ushered in a bit of a taste for decadence. The art was all fluffy style, with no attempt at all to pretend that anything substantial was going on. It was about mythological stories and poetic states of mind, and done in an incredibly limp, semi-illustrational way, with a bit of outrageous solemnity here and a bit of obscenity or humour there. It was in fact often quite funny, at least in a nihilistic way. But it had total international, art-establishment support. It wasn't any of these elements in themselves that had a lasting impact, but the way they all combined to give the impression that decadence was good and would be rewarded. You'd go into an exhibition at Anthony d'Offay's, of some paintings in a throwaway style of cherubs farting – and you'd read in the catalogue something about Aeschylus and the greatest poetry ever written. The essayist would be someone who'd been a boss at the British Council or the Hayward Gallery, or somewhere. You'd faintly wonder, 'What kind of moral position is this for art to take?'

Suck out bananas

Something else striking from the early 80s, I remember, was when I went round a Terry Atkinson show at the Whitechapel Art Gallery. Atkinson is a former member of Art & Language (important international Conceptual art group, which started up in 1966, and still goes strong). He left the group in the early 70s, because he felt Conceptualism might be becoming a mannerism, or a dead

language, and started experimenting with his own forms of realism. This Whitechapel show was a survey of his solo efforts of the last ten years, where he'd used a lot of photos of historical and political events as source material for odd-looking paintings and drawings. Someone from the Courtauld Institute who I'd met socially a few times was giving a free Sunday afternoon guided tour of the show. I joined the little crowd that gathered around him at the entrance to the show. Whenever I'd met this Coutauld guy, I always had the feeling he had no idea what he was talking about but that he was so arrogant, he would never know he had no idea and would just go on braying upper-classly forever. Although I know many Courtauld graduates who don't at all conform to it – ranging from the trend-setting conceptualist Jeremy Deller, to the beauty-revering abstract painter John McLean – this one formed a negative stereotype for me, which I have never quite been able to shake: someone whose idea of communicating anything about art is to go around deploying a lot of abstractions in an empty space. Not in a beautiful or elegant way, like abstract art, but in a hideous, dead way. In later years I would see his name at the top of articles, and on the covers of important-looking art books. I opened up one of these books at random in the bookshop in Tate Britain the other day, and the chapter heading read: *Monet and the Development of a Nominative Effectualism*. But whenever I rail against this kind of thing to anyone, they roll their eyes and look pityingly at me – because they're fed up with hearing it. In any case, the most immediately obvious feature of these Atkinson works was that they were done in a deliberately inept cartoon drawing style. But the guide never talked about this. He had no trouble reeling off lists of meanings and references he'd read about, but he kept running into difficulties when it came to making the meanings connect. He couldn't see that the art bit was the very bit he couldn't get. He brayed on anyway, tossing out occasional patronising summings-up for the uneducated. At one point, he tried to find a dramatic climax for a list of historical events that he hoped to relate to one of the works – which seemed to be about the US's exploitation of some Third World country's banana crop – and finally exclaimed in desperation, 'Well, they're just sucking all their bananas out!' It was the last straw for a woman in the audience who cracked up laughing. And then everyone else did too. It sounds childish, I agree, but it was the relief from having to keep up politeness in the face of so much incompetent showing-off. But also it was confusing to never hear any explanation of the style of the drawings. Hadn't he noticed they had that style? What was it for? Was he blind?

BBC2's *Late Review*.
Left to right: Tony Parsons, Mark Lawson, Alison Pearson, Tom Paulin

10

HOW ORDINARY PEOPLE
LEARN ABOUT ART

1
Television

One way ordinary people get their information about what's happening in art is from *Late Review* on BBC2. It's striking how different the line-up of panellists looks, compared to, say, a line-up of German artists. When you see *Late Review*, if it's still going – maybe it's been axed now – it reminds you that as a nation we've only just changed from ignoring art and not knowing anything about it, to feeling we've got to have something to say about it at all times. In the 70s I used to marvel at the profundities the panel on Radio Four's *Critics' Forum* came out with when they had to talk about art. 'The eyes really follow you around the room!' they'd say. And *Late Review* pretty much keeps up the old great tradition. I watched it once when the panel had all just been to the National Portrait Gallery to see an exhibition there. There was a portrait of a Russian composer that Tom Paulin liked very much, but he found one of Mussolini execrable and he wasn't going to countenance it. He really did think the meaning was all in the choice of the subject – if it was a right-wing subject the art was bad, but if it was a lovely composer it was good.

2
Newspapers

The Guardian is my favourite. As well as its regular art columns by Adrian Searle and Jonathan Jones – Searle's are always magnificently thoughtful, while Jones's are worthy and well-researched and make me nod off a bit – it sometimes gets non-experts to have a thought on the subject of contemporary art. For example, Andrew Marr, the political correspondent, (now moved on to some other paper) will ponder on the meanings of the Turner Prize. In the past, a normal *Guardian* writer would be baffled by the Turner Prize and express the alienation of all *bien-pensant* liberal people. But more and more *The Guardian* now wants to edge up to the Turner Prize and to contemporary art generally, deploring a bit here but warming to a bit there, and on the whole expressing sympathy and interest, basically because it's good for sales.

2a. Very nice
It's not all jam with these newspaper guys, though. A *Guardian* editor phoned up the other day and said the paper would like to reproduce a 'very nice' essay I'd written for the 'Beck's Futures' catalogue. 'Er, OK', I said. The only problem was they weren't very happy about paying, as *The Guardian* was the official sponsor of the exhibition. Also, could they cut it by at least half? They would do the cutting themselves, and then send the new version to me that afternoon so I could OK it – but then it'd have to go to press straight away. I thought that sounded unrealistic as it would inevitably come back as gobbledygook and I'd want to turn it back into reality and

then there'd be crying – and surely there wasn't time for all that? 'Well, we'd better forget it then, hadn't we?' he said, suddenly impatient to be getting on with nicer work.

2b. Please cut me in half

The Observer once literally cut a review I'd written in half – right there in the middle, it just suddenly ended. It was a review of the Turner Prize when Chris Ofili won. 'We had some extra ads in at the last minute', they said, when I phoned up to complain.

2c. Thank you very much – may I have another?

Another editor on *The Observer* commissioned a front-page article from me about the plans to put a series of contemporary-art sculptures in Trafalgar Square, which resulted initially in Mark Wallinger's *Ecce Homo* being in the square, and eventually Rachel Whiteread's *Plinth* (upside-down transparent resin replica of plinth, on top of real thing). When I sent in the copy, I didn't hear anything for a while. Anxious to know if it was OK, I phoned the editor and was told everything was fine: just 'a few punctuation points'. A few seconds after putting the phone down, I called again to ask to see the changes. Sure enough, when the fax came through, it turned out he'd re-jigged the article so it now featured his own unhilarious jokes throughout.

3.
Magazines

There are many art magazines that cater for the ordinary person who might like to follow what's going on, such as *Modern Painters*, *Art Review* and *The Art Newspaper*. But ordinary people can have a go at trying to read ones expressly designed for art pros, if they want. A handful of new ones have started up in the last few years. *Untitled* is one, *Everything* is another. These two are low-budget. The writers are usually young, but they still fancy themselves as great radical thinkers, so it can be hard to bother to get up the energy to read them sometimes. *Contemporary Visual Art* is another relatively recent arrival (perhaps it existed before, in a slightly different form, and was called something else). It is a high-budget glossy but practically impossible to bother with, except as something for the waiting-room table if you're a dentist. The pictures are shiny but the writing is a right old festival of pomp and swank. The authors are usually slightly sad older artists and art department heads.

3a. More caring

The main art-world publications are still *frieze* and *Art Monthly*. *Art Monthly* is likeable because it keeps up a lively debate, and it sometimes gives the impression of genuinely caring about things.

Frieze is too style-conscious to be meaningful, unless you're a semiotics expert, in which case you can have fun deconstructing the hidden meanings of the intriguing-looking headings and layout, and the choice of subjects – which are usually Internet, footwear and home gadget-oriented, rather than art-oriented. The writing in *frieze* is so mannered, artificial and fearful of saying the wrong thing, that you might feel the need is less for a semiotician than a family therapist – someone to find out exactly what's troubling these teenagers.

3b. More conservative

The late 1980s saw the birth of *Modern Painters*. This one is amusing and always worth investigating. It started out as an absolutely crazy, Tory-seeming nostalgia mag – nostalgic for a time of golden British art that never was – but then gradually changed during the 90s into something more confusing. Nowadays, *Modern Painters* often puts international celebrity art trendies on the cover, in a bid to seem in touch with youth. It can seem odd, because the contents are not predominantly trendy. However, a genuinely trendy art magazine such as *frieze* – the trendiest – is a beautifully designed, aesthetic art object in itself, but in its content it can seem sterile, and you can find yourself wishing there could be something in it that came as a surprise once in a while. And the main card *Modern Painters* has going for it is unpredictability – it genuinely does have something surprising and moving in it, sometimes. For example, it seemed quite an amazing cleverness on the part of the magazine's editors – I thought – to have got Frances Partridge (observant and humane Bloomsbury diarist, now aged a hundred and one) to write something for them, describing what it felt like to see herself impersonated in the movie *Carrington*. In a million years, no one on *Art Monthly* or *frieze* could ever have had that idea. The fact is, *Modern Painters* on the whole doesn't accurately describe the art world. But it's not really designed for art-world pros, however much it would like to woo them in. Mainly it's for non-pros, or cultured types living in the country – a middle-class provincial audience that doesn't always get to the Leeds Playhouse as much as it would like. They have a perfect right to wish for a magazine where they can understand the language. And as a matter of fact, they probably think it's only right that celebrity trendies they've seen on TV should be on the cover – they say, 'Oh good, I think I'll read that later', and they fully intend to.

3c. Bollocks and shite

Art Review is another magazine that has attempted to change its character over the years, just as *Modern Painters* has tried. It used to be a harmless little monochrome bi-weekly pamphlet for old biddies. But then it was relaunched in glamorous full colour as a vehicle for the thoughts of the writer and journalist David Lee, which mostly consisted of him saying 'bollocks' and 'shite'. Then suddenly he left and started his own radical pamphlet, published from his garden, I think.

4
Books

This source of information is more or less totally out of bounds if you want to know anything about art. Because art-book language and concepts are much too difficult for ordinary people – or so it is popularly believed. However, *Moving Targets* by Louisa Buck, published by the Tate's publishing division, is designed expressly to beat that problem. It's a book about the British art world, it's cheap and it's easy to understand. It presents an idea of artists as people who naturally only want to do good, and an idea of art as if it's always for a good cause. Writers, dealers, promoters and curators are all seen as great guys. (Dealers are always incredibly thoughtful and intuitive, and their relationship to their artists is always for the long term, not just for the easy dough.) And all this is right, in a way – it's the moralising message people want to hear about art now. Artists in *Moving Targets* are always exactly like other artists from the past, so it's easy to place them. 'Ah!' you find yourself saying. 'The Dadaists at the Café Voltaire – just like Martin Creed and Owada!' Or: 'Tomoko Takahashi's use of the found object – just like Marcel Duchamp!'

4a. More books

Blimey! – by me – was an unexpected success when it came out in 1997, and it continues to sell well. There seem to be a lot of obsessive cranks who love it, who are always writing nutty analyses of it on the Internet. They report on my appearance, and what they saw me doing at exhibition openings – which is usually leaving early. I don't know why it should attract the mentally unstable. It has many interesting descriptions of art-world language, fashion and behaviour. The style is clear and straightforward, although there is some playfulness with value judgments: 'very good' is used a lot, to mean 'I don't care'. The book has been used as evidence of a sick mind by the art writer Julian Stallabrass, who quotes extensively from it in *High Art Lite*, his study of contemporary art-world decadence. This latter book – the only other recent publication,

besides *Moving Targets,* that attempts to describe what's going on in British art now in an accessible style – probably wouldn't be read by many ordinary people, because it isn't amusing enough. But some of them might buy it by mistake because of the layout, which directly copies *Blimey!* (though it's not clear why).

5
The Internet

If you type in an artist's name on the Internet you'll always get some kind of information coming up. It might be an animation the artist has done, or a work-of-art screen-saver you can download, or a straightforward bit of biographical information – it's pretty random. For example, if you type in 'Bob & Roberta Smith' you get a page called *How to speak Bob*. It's a lot of hieroglyphs. When you highlight one you hear the abstract sound it stands for – some kind of grunting noise. After you've highlighted a few from the row of glyphs, and pulled them down into the empty space beneath the row, you can ask to hear what the sentence sounds like. It's completely meaningless, of course.

11
ROCKING MARXISTS

Julian Stallabrass

Not quite knowing why something is successful

Julian Stallabrass's *High Art Lite* is about the yBas and the new popularity of art. Stallabrass is a 30-something who lives in Henley and looks a bit windswept and handsome in his dust-jacket photo. He teaches at the Courtauld Institute and lectures at Tate Britain – he recently curated a show there of art on the Web. In *High Art Lite* he analyses the rise of the yBas in terms of the socio-economic situation in Britain since the 1980s, and he tries to put together some arguments about the moral and political emptiness of the yBa phenomenon. A typical conclusion he draws is that Chris Ofili may be successful but the success is empty because it hasn't changed anything about the marginal status of black artists in Britain. He wants to deconstruct what 'success' means in current art, but he doesn't have a lot of natural talent for seeing why something is successful in the first place. He approves of artists if there's some clearly flagged politically correct content, plus a bit of modern style. But if there's only modern style and the content isn't capital letter headline pc, he finds he has to disapprove. He doesn't have a lot of mental jumping-about energy, and he has a horror of camp, and both of these seem to go with an inability exactly to set the page on fire with his prose.

High Art Lite, by Julian Stallabrass, published 1999

Further reading

JJ Charlesworth is a young fogey Marxist (or not quite Marxist, as it's not really meaningful or possible to be a Marxist art critic any more) who's always mounting rigorous critiques of artists or writers whom he considers not to be socially responsible enough. He seems to want to be seen as more extreme than Julian Stallabrass. They both write in a rhetorical, pseudo-Marxist style that comes from an imagined golden age of politically committed art writing, maybe the 1960s or 70s. But neither of them seems aware of the dead tone they give to what should be a revolutionary language. Or in Charlesworth's case, maybe he realises it but thinks it's cool, like someone in the early 80s thinking it's cool to own a cocktail shaker. They often mention each other in their writings, either to criticise or grudgingly pay homage. It's a world of mirrors that can make you groan a bit. Frankly, though, anyone wanting to offer a social or economic framework for analysing art's popularity is worth reading. It's a complex and disturbing thing, and we ought to try and work out why it happened and how long it's likely to last. So I highly recommend both these writers.

Man surrounded by Marxists

The other day I found myself talking to Simon Linke. He's an artist

JJ Charlesworth

Simon Linke

G/GOUACHES
0—FEB 3, 2001

who painted ads from *Artforum* in the 1980s, gave it up in the early 90s, and then recently returned to it, with a lot of amazing painterly flair and visual intelligence, doing versions of the same ad. The ad is for a Brice Marden show in New York, and in fact it was at a Brice Marden retrospective at London's Serpentine Gallery that I bumped into him. 'Did you go to the same grinning school?' Nicholas Logsdail, Linke's dealer, who was there also, asked us both. Linke said he never read the art magazines any more, because he just couldn't stand it. On the other hand he found Adrian Searle's columns in *The Guardian* to be more and more brilliant. 'That's interesting', I said. 'Because JJ Charlesworth was mounting a rigorous critique of Adrian in *Art Monthly* the other day. Do you know him?' It turned out not only did he know him, but he'd taught him on the Fine Art course at Goldsmiths'. 'Really – what was he like?' 'Well, you know a blender?' 'Yeah?' 'He wanted to put a goldfish in one as his degree show'. 'Wow – that must have been horrible! What statement was it making – *I'm so hardened to the reality of the class war I can do this?*' 'I don't know!' 'Was he allowed to do it?' 'No!'

Non-sensationalist

In the magazine *Untitled*, Charlesworth says about the Chapmans' *Hell* (disapproving of the bleak statement he reads in it about humanity today) that: 'It's time to start asking what we expect from ourselves, the art we make, and the society it represents'. He is a prophet crying against sensationalism, and that goldfish anecdote is a reminder of just what a non-sensationalist guy he is.

Earn enough to live

Charlesworth and Julian Stallabrass often have little spats in the polemics pages or correspondence pages of *Art Monthly*. Who is holier than whom, is the line. They try and out-do each other with prim social awareness – score points for being a few degrees more aware than the other person of something important that goes on in the world outside art: 'Those Mexican workers couldn't earn enough to live!' 'Damn! I didn't know he was going to pull Mexico on me!'

Marxists in art in real sense

This is virtually an impossible subject. You'll sometimes find references to it in the blurbs on the backs of new books about art – the author is a bit hopefully described as a 'Marxist'. And in newspaper reviews of art books, an art writer might be thoughtlessly attacked for being a Marxist. However, usually the attacked writers don't claim

to be Marxists themselves. Many of them want to be read as voices from the left, but not necessarily as Marxists. Some want to embrace a bit of career-academic Marxism – that is, products of the respectable, more avant-garde but essentially establishment art-history course tend to sound a bit Marxist. But that doesn't mean they are. It just means they know they have to couch their critique within a particular set of Marxist-sounding issues. I don't think anyone seriously believes you can have Marxism without having the politics, and these writers never show any evidence they do have any (just as no artists are really Situationists): they don't tell their students to occupy the Tate, say, or the student building where they're studying. So this type of Marxism is only career politics, not real politics – you can be glad someone's doing it, but you might feel the analysis offered is a bit vapid.

Pretty much JJ Charlesworth
On the other hand there are would-be Marxist-type writers who turn up, where you feel they have the Marxism because they don't yet have the career. They choose Marxism because it's useful to be noticed – it's a market choice. They want to be rude, but also they have a desire to have a bit of a look at an economic analysis.

Pretty much *High Art Lite*
By contrast, a more establishment, settled-in, not-quite Marxist who wants to be noticed might sense readers find an economic analysis boring and unfashionable, and so he'd better sexy it up a bit – so he doesn't go for a hard-line economic analysis. He's a bit compromised, in fact. He looks at the current trendy scene and the big names, and he knows he can't just say these artists are crap and they haven't got anything – he knows he must say in a sugary voice, 'Well, what does Sarah Lucas offer us?' You feel there's something falsely pious and strained here. Clearly he slightly really does think the artists are vacuous. But because they're fashionable and young he's got to have an attitude toward them, otherwise his book won't sell, because basically it's got to sell on the back of them. So this is a market choice too.

Who is best?
Stallabrass and Charlesworth are both worth following, because their subject is important. Of the two, I suspect Charlesworth would be more amusing than Stallabrass in real life, because I suspect Charlesworth's filled with a sort of energetic bile and he might easily be incredibly unpleasant and rude. Whereas Stallabrass would never do a career-breaking fuck-up; he'd be a bit more of a smoothie at all times.

John Roberts

Slides from 'Beck's Futures 2' competition, 2001

Get tenure in States

John Roberts is an art writer whose name used to be seen a lot in the art magazines, mostly *Art Monthly*. His position was something like a combination of Charlesworth and Julian Stallabrass. I like him and have known him for 20 years, but I never have much to say to him when I meet him because I often have trouble following his writing. And the fact is he waits for an opportunity in the discussion, if you're having a drink with him, to refer to one of his books. He used to write articles supporting Art & Language. They were amused by Rembrandtian impastoed pile-ups of Tippex on his manuscripts. But they genuinely welcomed his support – or so I felt whenever they told affectionate anecdotes about him. I suppose they found him less flabby than some art writers you can meet. He edited little-bought books about photography and the real. (The real is not reality but a social notion of what is real.) And he tried to have a go at supporting the demotic-ness of the yBas, when they first rose to power. It was hard to follow but basically I read it as support of some kind. Obviously it would have been a rigorous kind. I sometimes see him around, and I expect him to be head of a department of complicated thought in a university in Virginia or somewhere one day.

Breezy is wrong

This book you're reading now is often breezy, and on the whole everyone is quite breezy when they're just chatting. But in the context of any kind of critical writing, whether it's academic or an art column in the Sunday papers, it can be considered the worst sin to be breezy. It means you're culturally labile. You've got no conviction. You're carried along on a wave of fashion. You're willing to be amused by almost anything. It's the ultimate sign of a liberal.

Liberal is bad

Some people might not know why liberal is bad, as well as breeziness. It's an attitude of pretending to be accommodating while actually merely being utterly unrigorous and flabby. It's the ultimate in offensively bland self-regard. As a liberal, you pat yourself on the back for being so permissive – kind of knowing what it's like to be a black person. In other words, it's a world of feeling rather than a world of analysis. It's a sentimental world. Because if you really cared about anything you'd draw a few conclusions instead of just saying, 'Oh darling! Damilola Taylor, how simply frightful!'

12

A DICTIONARY OF
RECEIVED IDEAS

Ideas in slides

Slides showing work by the artists nominated for the 'Beck's Futures' competition arrived at my house one day. The motto of this competition is 'tomorrow's talent today' – so it's a good idea to analyse the talent. Most of the received ideas coming up in this chapter, then, are from slides, not from actual works. When I eventually saw the real works, at the show at the ICA of the 'Beck's Futures' artists, they were pretty much like the slides, except in one or two cases, where they weren't anything like them at all.

Tim Stoner, *Folk*, 2000

Nostalgia

Art now is full of nostalgia. Tim Stoner's slides showed paintings that looked like they might be nostalgic for a graphic art style of the 1930s, something posterish on a train station maybe. Brian Griffiths's *Blue Peter*-style pasted-together lumpy sculptures seemed to be nostalgic for childhood at about age eleven or twelve, while David Burrows's photos of cut-out blob shapes seemed to be nostalgic for a more toddler stage. Simon Bill's abstract paintings on oval shapes provoked a bit of nostalgia for a past age of non-ironic, high-minded abstract painting. DJ Simpson's painted sheets of Formica and chipboard, with free marks gouged into them with a routing tool, were nostalgic for the kind of ordinary visual pleasure that anyone equipped with a middle-class education in art might understand. Clare Woods's tangled scruffy-edged marks done with gloss paint, suggesting thickets and branches, were nostalgic for nature.

Abjection

The word 'abjection' in an art context – where it has made itself more and more at home over the last fifteen years or so – usually refers to subject matter or materials that people might find disgusting or sickening. Abjection in art, then, is often a challenge to false pomp. This seemed to be the idea of Fabienne Audéoud's and John Russell's slides, when I held them up to the light. They showed paintings done in a lurid, lively, free but slightly weightless brushy style. The style seemed to be about finding a level where there could be some

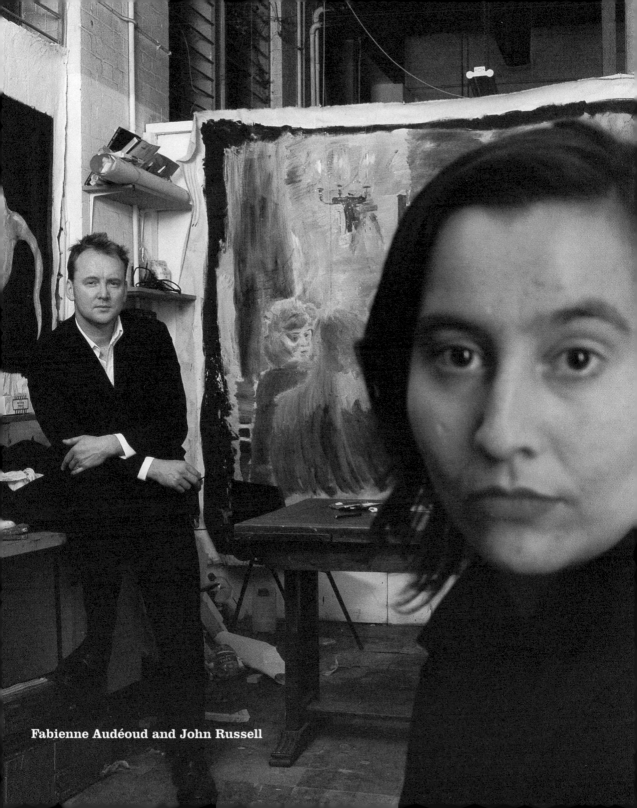

Fabienne Audéoud and John Russell

painterly enjoyment but not necessarily any special expressive mystery. The subjects were photos from art books, some from Renaissance art, some from the 1980s and 90s, but mostly from radical performance art events from the 60s and 70s. These images, mostly of extreme, physically torturous goings-on, were treated as if they were part of the art audience's natural cultural horizons, as something familiar. The duo could just do whatever they wanted to them: give them abject joke titles, reverse them, write over them, make them green, crop them arbitrarily. One was Chris Burden (US Happenings artist) having himself shot in the arm; one was Joseph Beuys saluting; one was Gunther Brus (Austrian performance guy) writhing naked before an audience; one was Hannah Wilke (US video artist) naked; and one was Grunewald's Isenheim altarpiece crucifixion. What did Audéoud and Russell really believe in, if not radicalism or expressionism? There's no point in believing in something that will only be incoherent to an audience. On the other hand, something sullied, dirty and tortured-looking is always of interest.

Fabienne Audéoud and John Russell, *Crucifixion (after Grunewald's Isenheim Altarpiece, 1515)*, 2000

Revolution

A lot of angry-sounding words about what a real revolution might be were painted across Audéoud and Russell's Grunewald crucifixion scene. Straining to read from the slide – I could make out MEAN, CHOKING, THEIR PISS. It's quite rare to see the word 'revolution' in a context of modern-day painterly painting. And the violence of the

other words was mildly funny too. The whole thing was twisted and unreal, with the main elements – violence, revolution, painting – working together with the painterliness in a way that conspired to show just how far away any kind of revolution is from anything anyone believes in any more.

Rock
Rock is for the people, and art should be too. A received idea in art now is that abstraction is impossibly elitist and you can't think about it straight – you've got to reposition it slightly, get it closer to something everyday. And rock is one of the most everyday things we can think of. The slides of abstract art had a few rock music-referencing titles indicated on them. The title on one of DJ Simpson's slides joined together references to different periods of Lou Reed's career, one from the Velvet Underground period and the other from one of his later solo albums. The Velvet Underground were (a) emotionally distanced, knowing, jaded and self-hating – and Lou Reed later on was (b) even more so. Nowadays he often comes across as (c) a bore, with his windy egotism. I don't know if we're supposed to think about all three states. Personally I think a title like David Burrows's *Party Like It's 1999*, with its date – 1999 – immediately following, lays on jaded whimsy a bit heavy. I thought Clare Woods's *Ruberry Hill* was a reference to Fats Domino's *Blueberry Hill* because it supported my good idea about rock references, but it turned out to be the name of a children's home in the country, or a hospital or something.

DJ Simpson, You *killed your European son*, 2000

Political
Don't just be a self-obsessed tragi-comic existentialist alone in your studio reading *Artists Newsletter* – have a bit of political awareness. None of the 'Beck's Futures' slides showed art that had any obvious signs of awareness that we live in a political world. But the art didn't obviously resist trendy political readings either. It was art designed to seem amusing and buyable, but flexible as well – anyone could apply a political reading if they felt the need. They could say the use of routing tools instead of brushes by DJ Simpson was egalitarianism.

Childish
More slides. Being childish challenges intellectualism. And it challenges an art sensibility that is grand or high, though not necessarily intellectual. So the statement made by David Burrows's

childish blob photos and Brian Griffiths's *Blue Peter* sculptures is: 'We aren't Michelangelo or Jeff Koons, but something charming, funny and daft instead'.

Movements

One set of received ideas about the notion of the art movement is that most art is part of one, but there are maverick artists who stand outside; also, movements always have a leader. All this is both true and untrue of the yBas. In fact the yBa movement isn't really a movement – in the way Cubism and Impressionism are movements – since it doesn't have a single idea uniting all the figures thought to be in the movement. It might be more of a movement if it was called Advertisingism, in that the influence of advertising really is the one thing that unites an abstract minimalist-looking painting by, say, Jason Martin, a Damien Hirst dead-animal vitrine and a Tracey Emin drawing of herself having an abortion. All three artists make art that works in the way advertising works: it compresses a lot of information, making it ironic, flat, abstract and popular. If there were to be a leader of the yBa semi-movement, it would be Charles Saatchi, which isn't surprising since he is an advertising guy. He wouldn't be the leader in the sense that he invented the yBas, since the main figures were already up and running before he started buying them – although he did in fact invent the acronym 'yBa' – but in the sense that the public sees him as the main figure. Damien Hirst is a kind of rival king, or partner king, in the eyes of the public. But within the art world the perception of Hirst wavers and changes a lot, whereas the perception of Saatchi never changes – he is the ultimate power. The 'Beck's Futures' slides all showed post-Hirst art. But it was art that still seemed designed to be seen in the Saatchi Collection – so it wasn't post-Saatchi.

Names of movements

Brian Griffiths' slides showed sculptures that had already been in a Saatchi show, in 1999, called 'New Neurotic Realism'. The show was a frankly dubious bid to create a new movement of that name. But there was no genuine movement or tide or new mood there. Only some disconnected success-hungry figures putting their hands up to join an already existing wave of commercially successful art – the yBas – and so the name failed to take off. Of course, it's still a mystery why one name survives and another doesn't, but you can see that although 'new' might work for any movement, 'realism' and 'neurotic' might be burdens.

13

CREATIVE CURATING

Matthew Higgs

Rise of curating

Curators are enormous now – what caused their rise? Partly it was teaching and the creation of new university-style courses with titles such as 'Creative Curating'. And partly it was the rise of theory – someone's got to study that stuff. The stereotype of a curator as an out-of-touch, over-educated, unpleasant posh person still exists. But now there's a definite new curator type, attractively hustlerish and modern, akin to DJs or fashion people – someone on a definite scene, one you'd like to be on yourself.

Voodoo curators

The traditional pseudo-priestly image of a curator – an initiated holy one, who takes streams of unlikely objects from statelessness to a state of art by putting them in blessed places and casting spells over them – is more widely known about and appreciated now. That image wouldn't ever be talked about as mysticism or voodoo by insiders, but as 'professionalism'.

Curators fronting scams

Someone a bit fakely intellectual and curatorish always has to be on hand at otherwise nakedly commercial art hot-spots such as corporate-style New York galleries, or galleries in London that emulate New York, or auction houses, or the Saatchi Gallery. The curators here are bought, and their job is to put a curator-spin on whatever amusing scam the boss is up to.

Curators making you want to hang yourself

When you meet a certain type of curator they seem unreal and bland. Their conversation is torture. They use phrases and terms that are empty. They say things you know they can't possibly believe. This is all terrible and you want to shoot them, if only to put them out of their misery.

Curators talking crap

Another terrible thing is the wall-labels at Tate Britain, which presumably are all written by the Tate's Curator of Interpretation, which sounds like a character from the Rupert Bear books: a quaint cartoon Chinese mandarin. These wall-labels epitomise a certain way of saying something more or less factual but at the same time rather less than what you've just seen already with your own eyes. (Which presumably would have made you want to read the label in the first place, to see if there was anything more you ought to know about.) They say things like 'Everyday materials are used'.

Good curators
But a lot of curators can be thoughtful and intelligent and it's exciting to hear what they say, so you can't just dismiss the whole lot.

The best curator
Matthew Higgs is widely acknowledged as the best curator. He is the man all right. If he's ever involved in a show, it will always be reviewed and there will be a high expectation of it. Of course, I like him and I want him to support me professionally. However, I can't think of anything else important about him at the moment – only his glasses, his drumming, his girlfriends, his mid-Atlantic accent (North of England/USA), and his DJ-ing at international art hot-spots.

Help world
Can you be a successful art-world person and not totally buy into its values? Personally I find it possible. But in Higgs's case, he really does seem to believe what he says. He wants to find some seriousness in art and some moral values there and to believe in what he's doing and help the world with art's discoveries.

Help ICA
Higgs now works part-time at the ICA, making it a more important place. He was one of the organisers of the most recent four-yearly provincial touring 'British Art Show'. He writes for *Art Monthly* and *frieze*. He co-organised 'Protest and Survive'. He's always at the Venice Biennale and the other big shows abroad.

Un-naive
I once bumped into Elena – one of Higgs's girlfriends – just after she'd come back from Jeremy Deller's 'Unconvention' and was still buzzing on the revolutionary greatness of the Manic Street Preachers – something Higgs believes in fervently as well. 'How could you not have gone to Cardiff?' she gasped, when I told her I'd somehow missed this event.

Inkblot
Before Elena, Higgs's girlfriend had been Ceal Floyer, whose art is about a kind of monumental slightness: an inkblot, say, or an audio work with the sound of something being shovelled – maybe coal. Another one was a till-receipt from a supermarket where all the items listed were white, for example milk. And another one was a performance involving a full symphony orchestra, where she stepped

up onto the director's podium and bit her nails nervously; it was called *A nail-biting event*. All these were good because they had humour, rightness, and punky next-to-nothingness.

The happy union
Then last July, when I got married, Higgs was one of our guests at the wedding and he was very moved by it. Now he's got married himself, to an LA artist. When he told me I thought, 'Well, he's certainly been working on the accent'.

Nine hours
Higgs was the drummer in an ill-fated rock-and-roll experimental rock band I had going once. It was ill-fated because I didn't have any great singing or guitar-playing skills, and I wrote all the lyrics and tunes – and I don't have any skills in people-management either. I don't remember the tape running at the time, but I have a recording of the band arguing. The row is about booking practice time at the Playground Rehearsal Studios behind Kings Cross. A few seconds of it goes like this: 'Where's the rehearsal on Monday?' 'Playground'. 'Yeah I booked the session from ten to seven'. 'Nine hours? You've booked the session for nine hours?' 'Oh don't freak me out Matt' – (that's me to Higgs) – 'I told you already!' 'You never told me anything about it!' 'Well, you don't have to come, because frankly your drums hurt my fucking ears anyway!'

Sebadoh
Once I was in a van coming back from Manchester with the members of some other art bands, much more successful than mine, who were discussing Higgs's special ways. Apparently he'd said to one of them that Sebadoh (US alternative-rock outfit) was now his official second-favourite band. It was the precision of the grading that was slightly mind-blowing, but presumably this is the characteristic that has made him a successful curator.

14

MORE WAYS FOR ARTISTS TO BE RIGHT

Rut Blees Luxemburg

First-class photo art

Rut Blees Luxemburg's work calls for a poetic intro. Here goes. It's dark outside. The foxes are running across Yerbury Road. (That's near where I live, in Holloway.) The artists are all staggering home from the studio. But Rut Blees Luxemburg is out capturing authentic modern experience, with her lenses open as long as possible.

Wow at glow

'She does that stuff on a twenty minute exposure!' a curator was saying, the other night at a Luxemburg opening at the Laurent Delaye Gallery, in Savile Row. The curator had dark hair this evening, but the last time I saw her it was orange. She was talking about a yellow photo behind us. All the other photos had a dingy yellow glow too. Everyone was quite well turned out, mostly in black. When Rut Blees Luxemburg was pointed out to me, I saw she was tall and stylish, in a combo of black and brown.

Rut Blees Luxemburg, *Ein Mädchen aus der Fremde / A girl from elsewhere*, 2000

Simon Bill, *Greenhouse*, 2000

Mosel Riesling

'Rut's really perfected a haughty aristocratic manner!' I observed. But it turned out she actually was an aristocrat. 'You should try the wine', she said. The bottle had her surname printed on the label. It came from her parents' vineyard in Germany and it was a delicious Mosel Riesling – 'Yum!' said my wife, who was with me. 'A delicious Mosel Riesling!'

Delicious perfect

And there was something delicious about Luxemburg being in Julian Stallabrass's *High Art Lite*. It was perfect that a Henley socialist's top tip should be a busty German aristocrat with her own vineyard – but he didn't feel he could offer his support for the crass populism of a Tracey Emin.

Sixteen pounds

There were catalogues on a table and I asked if I could have one. A woman asked, 'Signed?' 'OK'. 'That's sixteen pounds'. 'Well, not signed, then'. 'That's sixteen pounds too'. 'Well, could I have one free?' Then she went away and came back again and said it was OK after all, and in fact the artist would sign it, even though I hadn't asked for that. So then Luxemburg came up and signed it. 'Is there anyone you want it inscribed to?' 'No.' 'Are you from London?' 'Yes.' So she signed it 'To a Londoner' – I suppose because her works are urban.

Sell line

Laurent Delaye, the gallerist – or *galeriste* – explained all about the erotics he felt were in the photos, and the influence of literature and Schiller. Because he was French, and also because he was selling a line a bit outrageously, I couldn't totally understand what he was saying about the erotics. He looked at my catalogue and said it was from another Luxemburg show. He got me the one for this show and got her to sign that one too.

Imitate sound of orgasm

Then it turned out the curator I'd been talking to before lived in London but worked in Sweden, commuting there. 'What are you doing now?' I asked. 'Audio porn'. 'Gosh'. 'Yes, it's not all "Uh-uh-uh!" you know'. 'What else is it?' 'Well, it might be possibilities of translation'. I could see her intelligence was formed in an art-world-shaped frame. She turned up sentences unexpectedly at the end

into a little probing *question?* Like many children do nowadays, from watching *television?*

Magnificent drivel
But I liked this curator anyway. She was full of observations. She'd just been on a panel in Vienna. There was a big audience. She was the moderator. The title was 'Conditions of Conflict'. She said Liam Gillick was on it too. 'Wow! What did he say?' 'He was uninterested in conditions of conflict but interested in creating conditions where conflict didn't occur'. 'Ha ha!' – I laughed at the magnificent drivel. 'What are these photos about?' I asked the curator, because she knew Luxemburg, who had lived and worked in London for ten years now, having been to art school here. But she answered obliquely, referring to Luxemburg's choice of essayist for the catalogue – a trendy philosopher called Dutmann. She was glad Rut picked him to do the catalogue because it was a little off to the *side?* Not dead *centre?* It was about a friend of Dutmann's – in New *York?*

Novalis or Hölderlin
The curator pushed me over to ask Luxemburg herself what her photos were about. Luxemburg said the one near where I stood was inspired by a love letter by Novalis or Hölderlin. But then the guy she'd just been talking to before I interrupted them started quizzing me, saying 'Do you like it?' straight out, really earnestly. 'Well, I don't know yet'. I backed off. 'I'm going to think about it later!'

Kisses at fair
Now Luxemburg slipped away and the curator slipped in, in her place, and started teasing the guy, who'd innocently said he ran a little Internet company and was the boyfriend of one of the gallery assistants. They'd met at the Islington art fair, and it was awe for Luxemburg that brought them together.

Intellectuals chilling
Around us, the Luxemburg show was full of little nutty-looking frizzy-haired guys, plus tall ones, women with crew cuts, bald guys – all in joke art-world outfits like extras in a modern re-make of Tony Hancock's *The Rebel* – having a good time, imitating intellectuals chilling. I flicked through the catalogues. I thought it would be hard for anyone not to find the poetic titles of the photos, such as *The Wandering Depth* or *Affliction* or *Attempt at Seduction*, giveaways of unbelievable pretentiousness.

Top award

I looked around at the Luxemburg photos again. They showed a preoccupation with a certain kind of glistening surface effect. The way of using only light from lamp-posts and so on, with everything else dark, brought out a certain richness of grainy dots everywhere. They were urban night scenes – a peeling wall, a puddle, a window, shadows cast by branches, no people anywhere. I thought the dingy glow on everything was the least instantly forgettable thing, if only because that's not a widely acknowledged idea of what something visually pleasing might be. But I saw the work was right for the moment – if not right-on politically, at least it was glamorous, sheened, patterned, monumental, romantic and intellectual, and she'd be sure to get a high award for it soon.

Rut Blees Luxemburg

Initially dry-sounding guy

Simon Bill's paintings nowadays are on oval formats and mostly abstract. They have several clear signs of a mocking, ironic, modern attitude toward painting as a tradition: polystyrene-backed canvases, ironically recycled Modernist gestures and shapes, and quirky bits of figurative imagery that seem to cancel out whatever lyricism there might be in the more abstract bits. But they are quite un-mechanically made, and they have a scruffy sympathetic individualism, which immediately marks them out from most contemporary abstract art.

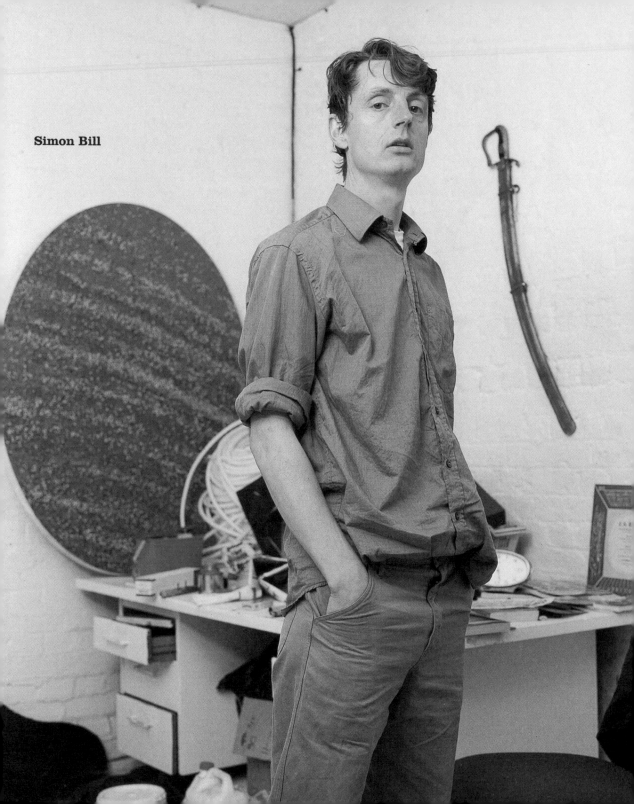

Simon Bill

Simon Bill, *Greenhouse*, 2000

Alien crop circles

In the early 90s Bill used to go on raids to the countryside with some other artists to execute crop-circles – with internal designs of incredible complexity – by night. They were assumed by many to have been done by aliens. They were always turning up on TV news reports and in the papers. His studio art of that time was paintings of Mr Blobby from *Noel's House Party*, but with Mr Blobby re-cast as a gruesome pagan corn god. There was something deliberately disgusting about his Mr Blobbies – they had mouldering waxy colour applied to peg-board instead of canvas, and little bits of pencilled writing on the edges of the paintings describing disgusting tortures.

Please wave real sword at me

I first met Bill in 1994 when I was directing a fifteen-minute *Late Show* item about art. I'd gone round to his studio with a camera crew at night to interview him and some of the other artists there, about their ideas on cow mutilations, alien visitations and crop circles. Compared to what actually used to be seen in *Late Show* art films – usually flashy and soon over – the process of filming is incredibly laborious and everyone involved soon gets fed up with it. On this occasion, he'd sat through an endless interview that was a bit incoherent and disorganised, and a load of shots of someone else painting, before it was his turn to be filmed on his own. By now he was drunk and behaving weirdly, muttering aggressively and waving a real sword at me, which he'd pulled out from a dusty corner of the studio somewhere, while a fearless bushy-bearded BBC camera man who normally worked on nature programmes swooped in to get close-ups. Because of these experiences I see crop-circle activity, aliens, corn-devils and punky obscenity behind the milder paintings he's doing now. And so they have a *frisson* of darkness for me as well as playful formal individuality. But I don't know if everyone else is supposed to see this too, maybe by reading about it in this book. Or if it's something he just wants to forget about now.

15

NON-IRONIC
ABSTRACT
PAINTING

Geoff Rigden

Two different types of abstract painting

A lot of abstract painting today has a tailored, systematic, strategic look, as if a concept had been thought up, involving a minimal design of some kind, and then rigorously followed through. This kind of painting is quite different from the abstract painting of an older generation, which is now out of fashion and consequently never talked about, even though the artists are still painting away in their cold studios. The latter does what it does – improvised shapes, looseness-turning-into-tightness, order, balance, visual pleasure, dynamism, harmony, and so on – from a position of some kind of connection to a painting tradition, which goes back centuries. The former – the more up-to-date, tailored kind of abstract painting – starts from the position of assuming that any connection to tradition is impossible; this tailored type of painting is connected to present-day pop culture, to the media and to advertising. Whereas the other type – done by oldsters, who feel connected to Abstract Expressionism but also to Tintoretto and Matisse and Corot and Titian and Gainsborough and Van Dyke, and so on: the 'painterly' stream of painting – doesn't care about anything pop. The most pop it gets is to acknowledge Matisse's paper cut-outs.

Three non-pop abstract painters

John McLean's paintings are basically shapes disposed in space with a balance of colour and form. Gary Wragg's are made up of free, painterly movement and gestures – big arm-sweeps and so on – with a varied approach to colour. Whereas McLean's colour is discreet and confined to simple, flat shapes, with Wragg colour is more about describing his travels across the canvas. His use of colour is very experimental; it leads to unexpected elisions and fusions and sudden disjunctions – and these can lead to great successes, where you feel you're seeing in a new way, but also failures, where you feel you're looking at something a bit too weirdly discordant. Someone else might censor the discordant ones but he never does, he's open and generous. Geoff Rigden's paintings have worked, layered, lumpy surfaces, unpleasant and pleasing at the same time, with wonky, geometric shapes, and dabbed-in dots, most often either right in the middle of the space or right on the outer edge.

Why do they do it?

With McLean and Wragg, you can feel more or less convinced that every decision is motivated by a sense of balance and visual order. Maybe more so with McLean; maybe it's more experimentation

Gary Wragg, *The Joining and Rotation of Edges*, 1998–99

Geoff Rigden, *Five Spot*, 2000

for its own sake with Wragg. But still, compared to the more fashionable idea of abstract painting today – that a design brief and an idea about modernity and emptiness and the machine-made or computer-generated are the main things – both Wragg and McLean are more visual and more instinctive.

Go on with dots

With Geoff Rigden, who is in his 50s like Wragg (McLean is in his early 60s), I can't say I always believe balance and order are the motivation. In fact there's often a mystery there as far as motivation is concerned. He dots in some blobs, then re-dots them, then does something else and something else again – and it's never clear why he didn't stop at some point or start the dots again on a different painting. Why did he put in so little, in the way of lines and dots or whatever? Why not more? Or why did he go on so long, why not start again clean? Why go on to that level of worked-up crusty strangeness he often gets? It might be because he couldn't afford another canvas, or he was having a laugh, or feeling nihilistic, or he hadn't noticed he'd finished, or was painting while sleep-walking.

Have feeling for right thing

But with all three of these painters, the decisions are right there in the surface of the paintings: one thing changed slightly or almost wholly covered over, another thing brought in, then that thing changed, and so on, until there's an order. The evidence of many different orders at different stages of the process is always clearly visible, as if the final form has shimmered or stuttered into place. It sounds like a formula for a certain type of moral position: 'Look, it took many tries!' And indeed there is a formulaic aspect to this art. But the formula involves a higher element of risk than the tailored, strategic formula, because it depends on the painting coming off visually. And it asks for a belief on the part of the audience and the artist – a belief in the artist having an in-built monitor that registers rightness. And also a belief that there's something compelling and marvellous about the monitor. Which would be weird for a more up-to-date type of abstract painter, for whom 'the marvellous' would be to be offered a show at Gagosian.

John McLean, *Reel*, 2001

Pay little if small

In the 70s, Rigden's work was sometimes put down by critics as an English also-ran, or footnote, to American colour-field painters of the early 60s (the US inheritors of the Matisse pleasure-painting stream), such as Kenneth Noland. But now Rigden is so far out of fashion, his paintings aren't even in the art world but in the world of interior decorating. And not the high end, and not on purpose, but by default: middle-class people buy them occasionally for the house, if they're small. Actually middle-class buyers have good taste in doing so – I've got some myself and they give me daily pleasure. But it's a shame there's no critical framework for his paintings. Nothing really is anything at all in art unless someone's talking about it. And nobody in the papers or on TV talks about him. It's like the fate of Wragg and McLean too, and a number of others of their generation who might be mentioned: for example, Alan Gouk (bright-coloured paintings with slab-like handling) or Mali Morris (subtle, transparent paintings). In the old days, their art was bought for the permanent collections of the big museums – the Tate Gallery, or the Museum of Modern Art, in New York. But now museums rarely buy it, and you never see it in big survey shows in publicly funded spaces.

Hum Young

I've only talked to Rigden a few times – the first time was at the private view of a small exhibition of his works, from over a period of a few years, at the Cross Street Gallery, in Islington, in 2000. When I arrived at the private view, he had a word with me to thank me for writing a recommendation for his invitation card. It was something about Neil Young and Corot. He didn't particularly think what I'd written made any sense. Actually the gallery owner told me earlier that when he first showed him the printed cards Rigden was pleased and hummed *Southern Man*.

Single painting

But Rigden was polite and thankful, anyway. I said, 'Let's have a drink some time!' And he said – painfully slowly, inching the words out – 'Yes. I'll have a drink with you'. I don't know what we'd have talked about, though. I thought his studio would be a mess, with many years' worth of canvases leaning against walls and tables everywhere, and him painting on them all simultaneously, between drinks – but I learned from the gallery owner it's very neat and he only has one painting out at a time.

Knotty crusty

When I came into the Rigden private view at the Cross Street Gallery, I was amazed at how some of the paintings seemed quite crazily uncared-for, with threads of canvas hanging down, or the wooden-strip frames askew. I thought it must be part of the look. The colours had a genuine oddness that was disturbing, not charming. Knotty, crusty globs of transparent, tawny yellow, say, and then childish little squares or circles of blue or black or red, showing through the yellow, or painted over it. But then they seemed not careless but sensitively considered – one oddity or unlikely form or patch balanced against another or a lot of others, the balancing all done intuitively. You've just got to accept it's an art based on feeling, and on your own ability to feel being developed and educated a bit, as you look. It's hard for many people to accept, because changes in the cultural climate have made it seem as if feeling in art isn't worth anything.

Help art

After I'd been at the Rigden show a few minutes, a stranger came up and intoned a litany of familiar-sounding complaints to me about the end of art. 'No young artists are emerging. Modern art isn't taught in art schools any more. There is a real danger it might die'. I escaped and went round the Rigdens some more. Later, it turned out the intoning guy was a sculptor who rents studio space to John McLean and Gary Wragg. It seemed to be some kind of helpful arrangement, or not absolutely top-fees arrangement, so he could help art. I thought of Wragg's and McLean's spaces next to each other. They'd been there for years, but I suspected they never saw each other, and weren't particularly interested in each other's paintings. They probably didn't care about modern art dying either – they just thought about their own shapes and where they ought to be placed – but it's good their landlord cares about it so that he keeps the rent down.

What shall I do?

Gary Wragg came round for dinner the other night. He said John McLean had been in his studio but not so often as he's been in John McLean's. Wragg can't bare anyone to go in his space because he starts reacting to what they say. They'll say what they think it is he's doing and then he'll find himself unconsciously doing it. But McLean is naturally more affable and open, Wragg said. He said he'd go into McLean's space because he'd be invited in. 'What do you think

Gary Wragg

John McLean

I should do here?' McLean would ask him about a section of a painting. 'I think you should leave it, John', Wragg would say, and then McLean would ignore him and change it.

Tai Chi in Mont Mirail
Wragg said the new series of paintings he was working on was going to be called 'Learning to Fly'. He described how he'd been doing his Tai Chi exercises early in the morning in the shadow of a statue of the Virgin Mary, in Mont Mirail, when he'd been painting over there this summer. Some mornings there was a mist everywhere, you couldn't see anything, and suddenly a hawk would glide by. Other times, he looked out at the landscape all around in the morning sunlight, marvelling at the nuances of light and tone.

Tai Chi in shadow
Wragg did his Tai Chi in the shadow because he didn't want to be seen flapping his arms and jumping up and down slightly, like someone about to take off. He imitated the motion with his arms held out, the hands gesturing. I said his paintings looked as if he sometimes did them like that, with both hands. He said he often did, to go against habit and avoid a repetitive type of mark.

Close door
Wragg said he'd been painting with both hands once and John McLean poked his head in the studio and said, 'That's the most symmetrical thing you've ever done!' And he had to quickly close the door.

More motherfuckin' values
Another night, John McLean and his wife Jan came round to our house for dinner. He sang a few songs and told some jokes in Scottish. Then he looked up at Colin Lowe and Roddy Thomson's *Saatchi 'n' Motherfuckin' Saatchi* on the wall, and started admiring its qualities – the two *Saatchis* were in a lighter colour than the bare canvas background, he observed, and *'n' Motherfuckin'* was darker. He said it was clever and I agreed drunkenly that the painting was indeed a symphony of flesh, violet and beige.

16

ART ARISTOCRACY

Tim Noble & Sue Webster, *The New Barbarians*, 1997–99

Queen of slag

When Gilbert & George talk about Tracey Emin's great success
in making herself even more nationally-known and talked-about than
Damien Hirst, they sometimes call her the 'slag'. There's nothing
malicious about it. They recognise her abilities and in any case,
she called herself that first.

House of Windsor

I AM INTERNATIONAL WOMAN, reads the appliquéd lettering
on one of Emin's blankets. Fantastic! What does it mean? I don't
know – no one does. I think it means she's boasting, and toasting –
toasting herself and boasting about being a modern celebrity on the
level of, say, Barbara Windsor. When she comes into a restaurant
now, everyone's heads turn. 'Ooh, it's that Tracey Emin – how dare she
show herself in here!' they might exclaim. Or 'Wow – Tracey Emin!'

Subtle change in status of needlework in art

In the past, in the international contemporary art world, needlework
was the sign for women, but one where, if you were a viewer or
commentator, you had to go in for a lot of piety and not be brassy or
cynical. It's a sign of Emin's achievement, in a way, that even though
she makes art in the holy medium of needlework – which previously
was considered slightly anaemic, a bit like muesli and nature shoes
in the 1970s – people still feel they can slag her off. In fact she's
made needlework more like glam rock than muesli – taken out the
drab hessian and put in a bit of sexy colour.

Have good blub

Recently public feeling toward Emin has changed slightly from
loving to loathe her, to loving to love her. She is still a by-word for
artistic charlatanism, and TV and radio personalities will never
miss a chance to curry favour with the nation by sneering at her.
But somehow she's become a by-word for public outbreaks of
sentimentalism as well – the nation seems to be able to cope with
the contradiction. Articles about her in the middle-class papers
cheerfully re-hash five-year-old stuff from her gallery's press files,
as if it were all completely fresh information. And you can hardly get
past two or three short paragraphs before the writer will be blubbing
like crazy, out of a sense of identification with Emin's pain, and the
pain of international women; and referring to her as 'Tracey' or
'Trace,' or the favourite – 'our Trace'. In a way, as well as Barbara
Windsor she's become the new Princess Di.

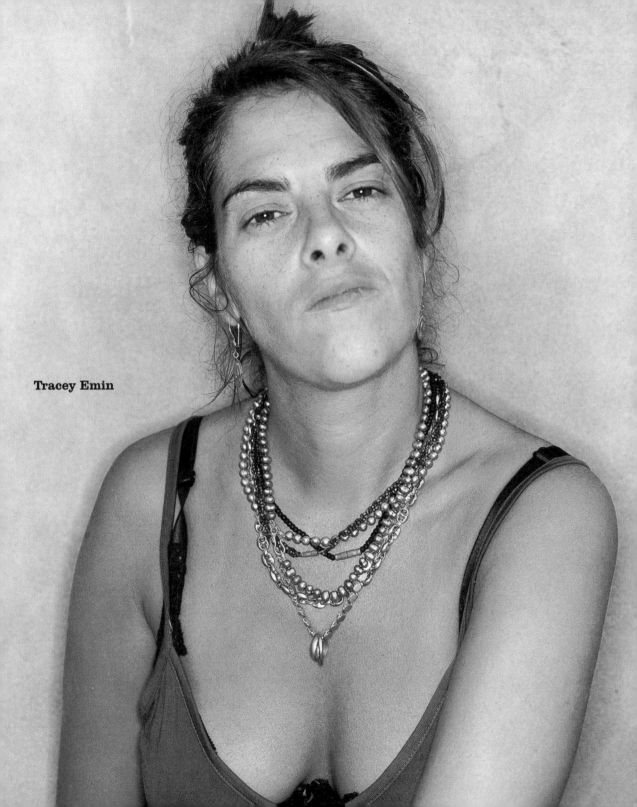

Tracey Emin

HOW COULD I EVER
LEAVE YOU

I LOVE YOU

I SEARCH THE

WORLD

I KISS YOU

I'M WET WITH

FEAR

I AM

INTERNATIONAL WOMAN

Nation's dreams of leaders and queens

It would be clever of *Tatler* if they got Emin to dress up as Di for a front cover picture, as they once got Vivienne Westwood to dress up as Margaret Thatcher. It would be a surreal tapping-in to the nation's dreams of leaders and queens, like the Westwood picture was. Of course, that image was effective because Westwood does look uncannily like Thatcher. Whereas Emin's wonky, eastern, exotic looks are miles off Di's western, dim, suburban look, so it might be strange – but strange is normal for dreams.

Modern classic

Recently I went round to Emin's studio, with my wife, to get a drawing as payment for a catalogue essay I'd written years ago. We went through some folders of drawings and picked one that said STUPID DRUNK, because it seemed like it might be a modern classic. The two words were on the left; on the right was a delicate line-drawing of a tottering, busty, thin, high-heeled, immediately recognisable figure – the artist. But then I felt guilty about picking such a classic, since my essay hadn't been much good, and I offered to give it back. She suggested some alternatives almost in the same moment that I was backing off. But before she'd quite finished suggesting them, avariciousness kicked back in, and I backed off from backing off. So she backed off too – and accepted that the modern classic would be mine, after all. Even though that essay – as she now pointed out – turned out to be a lot of work for her: she had to get Carl Freedman to make something out of it, from a lot of different fragments I'd submitted.

Cat and Mat

Emin's cat, Docket, was there on this studio-loft visit. A neon artwork on the wall spelled out 'Sobasex'. We all laughed when Emin confessed she'd actually thought sober was spelled like that. The place was a converted light industrial space, but there was a green patch in one corner, a lot of carefully tended pot plants. We all had tea. She said she fell out with Tara Palmer-Tomkinson in the hospitality room before going on the David Frost show once. Then Palmer-Tomkinson didn't mention her, in one of her round-ups of celebrity guests at a fashion show, even though Emin had been sitting right opposite her. Mat Collishaw, who has the loft on the other side of the hall, came in. I told an amusing anecdote from yesterday's papers, about David Beckham telling an interviewer that he and Posh Spice were thinking about having their baby christened

– but they didn't know what religion to choose. But Emin and Collishaw both looked a bit blank at that.

King of slaughter
Damien Hirst is still the most well-known contemporary artist and the symbol for a popular audience of a genius, along with Dali and Warhol. He's still expected to be a shocker. He is known as the artist of dead animals, and of death generally. The audience isn't particularly interested in death. If they were, they'd find something a bit more profound than his art to revere. In interviews, he acts like a mad genius-artist. The media assume this is the only way a modern genius-artist can possibly behave. They take it for granted it's a mark of his genius that he actually does behave like that. So you've got to admit he's got a good sense of the media and he understands how that mindset works, although you might still question if that's really such an amazing achievement for an artist. He never actually says anything genuinely compromising or revealing, but we're all supposed to be amazed at his shocking candour anyway.

Pay millions
I keep seeing Keith Allen's *Fat Les* taxi near my house in Holloway, with Damien Hirst dots all over it, and a picture of fried eggs and sausages on one of the doors. Otherwise, I don't think about the Hirst story much. You sometimes read that he's been wringing his hands about having a shark killed, and now believes it might have been wrong – so that's mildly amusing. Usually what you hear, though, isn't worth thinking about, such as the news that Saatchi paid a million pounds for Hirst's sculpture *Hymn* – a giant man cast in bronze, scaled up from a shop toy. It's obvious it's only to keep the myth of Saatchi's main art investment going, and to keep the market for Hirst's stuff strong: Saatchi's investing a million in order to make more millions from the same source.

Be modern
But at the Gagosian Gallery in New York, where he recently staged a large, intricate installation, of which *Hymn* was just one part, you could see what's genuinely impressive about Hirst (now that he's no longer coming up with any ideas as such): he is quite a visual guy. Everything in this show, including *Hymn* (which had looked crass at Saatchi's), was integrated with everything else. Everywhere you looked, there was a dazzling interplay of colour-textures. Metal

painted with flesh-colour played off against real meat; shiny chrome, knives and coloured pills played off against bones, glass, white plastic balls and black polythene bin-liners. Gridded wallpaper with pale dots provoked faint memories of Hirst's spot paintings; but then here and there were actual spot paintings in a pale register hanging over the wallpaper. Other textures included glinting tropical fish, the white cotton of surgical gowns, matt-white Formica shelving, TV monitors playing lurid, US-style TV announcements and ads, and bohemian scruffy oil-painting surfaces (old palettes, brushes, newspapers, cardboard). There were no new ideas particularly, but everything had an association or memory of his old ideas, so there was a narrative feeling at every point – a story of life, death, age, youth, drugs, stimulation and blankness. It wasn't a profound narrative but profundity is never the issue with him; the issue is 'how to be modern'.

No need for food

Live tropical fish in the Hirst show were an amusing self-reference, I thought – a good twist on dead sharks. Bin-liners with cheap plastic air fresheners on top of them, in a vitrine with the words STOP ME B4 I KILL AGAIN scrawled on a mirror, were funny too, if you think of the genuinely shocking stink of his maggots installation, in 'Sensation', after 'Sensation' had been up for a few weeks. Another work was a bisected vitrine that seemed to have an old man/young man theme. On one side was a copy of *The Sun*, and on another a copy of *The Times* – a play on 'son' and 'time', possibly. The old side had a half-eaten sandwich, but the young side had a credit card, kind of set at an angle into the surface of the table. I took the meaning to be that the old (working-class) side is too poor to have anything for lunch but a sandwich. While the young (classless) side doesn't have to eat at all because of being on coke.

Nouveau royales

The artist-duo Tim Noble & Sue Webster seemed to be hanging around at private views a bit aimlessly for a while, and then suddenly they were stars. They're both beautiful in a dark impish way. She has more of a classical beauty edge to her impishness, while he's more like someone who might be in a band of child thieves, in a movie version of Charles Dickens. They can be snarling or friendly. Either way seems to be for the same purpose, to get ahead in art, but still be recognised as punky attitudinists – with an attitude of not caring about getting ahead.

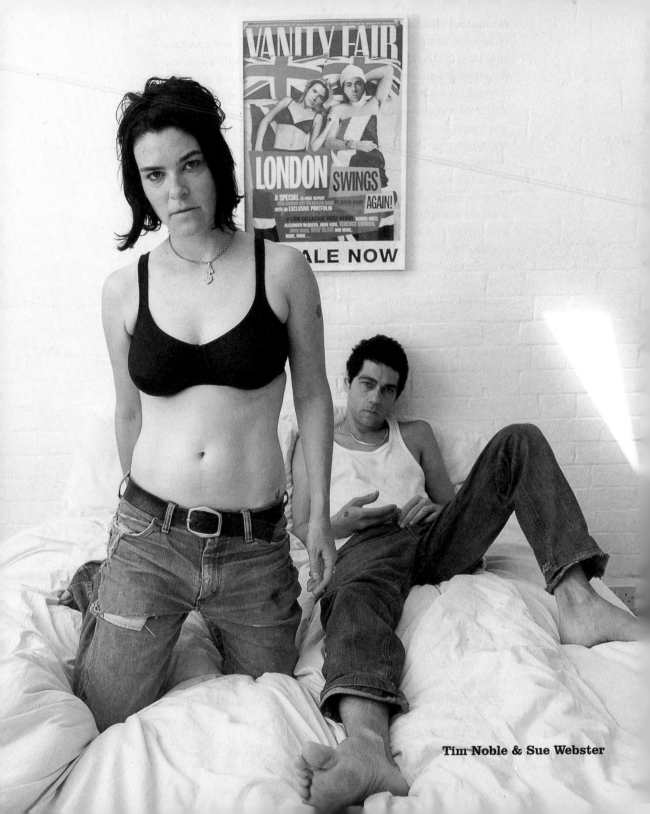

Tim Noble & Sue Webster

Be successful but distanced from success

Noble & Webster make installations out of rubbish and shadows: they project a light onto rubbish that has been artfully piled, so it casts a shadow that looks like their own self-portrait silhouettes. The skill is impressive. The shadow has a realistic mixture of softened and sharp edges. At an exhibition space in Chelsea, a few years ago, they showed a little garden installation with fake grass and a pair of mechanical rabbits having sex – it was sentimental and cynical at the same time. They had a few works bought by Saatchi, and some publicity in the papers, and now they're in all the shows. They're a typical modern art success story, but also atypical, since success seems to be their theme in an open and frank way, rather than a hidden way. Their installation in 'Apocalypse' was a shadow-image of themselves, apparently on a rubbish heap, with a neon sunset opposite. It was as if they'd made it to the top of the pile and now they were looking out over an urban romantic trash landscape. They cleverly express a success and celebrity theme, but also distance themselves from success, as if they're saying 'It's only rubbish!' I think in their case, people respond positively to the success theme because of the theme of shadows that goes with it – maybe the audience feels the shadows symbolise shadowy origins, or punky, working-class origins.

Monkeys wrong

I saw another installation by Noble & Webster, once, at the Chisenhale Gallery. The opening was crowded, the space was echoey and it was hard to understand anything anyone said, because of the audio-distortions. Jemima Stehli introduced me to David Burrows, who's an art reviewer as well as an artist. 'I used to like your old programmes on TV', he said, and he recalled a bit of commentary from one – 'The collection in the Museum of Modern Art, from Cézanne to Frank Stella, all straight lines, like the streets in New York'. I felt uneasy, because I didn't find that line funny, and I didn't want anyone remembering it. It was from *The Late Show*. But you can't control what people remember about you. 'I liked your painting of yourselves as monkeys', I said now, to Sue Webster. 'No, it was Hell's Angels', she said, handing me their catalogue. Then someone else said, 'I love seeing you on TV, it's fantastic.' 'Thank you very much!' I said. 'Sorry?' the voice seemed to say. 'I said thank you very much!' The voice shouted, 'I SAID I LOVE SUE AND TIM, THEY'RE FANTASTIC!'

Uncanny right

Then I was in the main space of the Noble & Webster installation.
It turned out to be only two little figures. They were sculptural portraits,
incredibly realistic, of the artists as Neanderthals. They were only a few
feet high. Perhaps they'd looked up in a book that historically, or pre-
historically, Neanderthals really were this height. In all art catalogues
nowadays the word 'uncanny' is used about 96 times on every page, so
it has about the same value that 'nice' has. But with this Neanderthal
installation, called *The New Barbarians*, I really was struck by how
uncanny it was that they looked just like Neanderthals but were
immediately recognisable, at the same time, as themselves. There was
nothing else in the space except a curved wall, which rose up from a
perfectly smooth white floor – the floor merging into the wall – and a
bright, science-fiction white light shining everywhere. It was a pretty
striking sight – at least, here we all were, struck by it. It seemed to
be a joke about artistic skill, worldly success, and the forgetfulness
and barbarism of now – culture being dumbed-down; plus society's
fascination with anyone who can get in the spotlight for whatever reason.

Incredibly 60s guy

Damien Hirst's London dealer, Jay Jopling, is always being profiled
in style magazines, so much so that the only thing I can ever really
remember about him is that he's an artisto gallery guy who seems
incredibly 60s in his style. He looks 60s in his clothes and self-
presentation and he seems to have a 60s idea of socialising: he always
wants to be known as someone who hangs out with celebrities. He
never misses a chance to mention Elton John. In fact I was looking
through one of his catalogues the other day, and at the back there was
Elton's name again, in the list of thank-yous. If he was a more 70s guy,
he'd want to be known as someone who hung out with Martin Amis.
Whenever I meet him he's pretty nice. I met him in a cab in Minneapolis
once and he lent me 40 dollars.

Ambassador of plum

The best-known art critic in Britain today is Brian Sewell. He stands
for a middle-England idea of what an art critic should be: aristocratic,
a connoisseur, at home with tradition and history, and possessing an
outrageously upper-class accent. The other day I noticed *Artforum*
had cleverly used a photo of a lifelike waxwork of Sewell to illustrate
a review of *High Art Lite*. This waxwork was by a couple of graduates
from St Martin's Art School. They'd executed a whole set of paintings
and sculptures featuring the great critic.

Jay Jopling

Glossary of Critical terms to be used
when encountering art.

Approval

- Has something to commend it.
- Redeemed.
- That hint of extravagance.
- Audacious chiaroscuro!
- Loquacious, yet with a
 certain reserve.
- Silver-tongued sublimity.
- To raise metier to masterful in
 one fell swoop.
- Visual nectar and ambrosia.
- It is surely the Galatea for
 everyone's Pygmalion.
- Seldom is such opulent artistry
 witnessed.
- The epitome of dextrous.
- One can only marvel at …
- A punctilious attention to the
 minutae.
- Ebullient.
- Vivacious.
- Mellifluous.
- Verisimilitude.
- Piquant.
- Dulcet.
- Adroit.
- Elysian.
- Coup - de - maitre.
- Daedalean.

Disapproval

- Philistinism.
- Vandalistic barbarity.
- Malingering malcontent.
- Hotch potch.
- Lamentably limited.
- Chimera.
- Tired tittle tattle.
- Florid curlicues
- Suggestio falsi,
 suppressio veri.
- Bluff, bamboozle and ballyhoo!
- Not a jot or tittle.
- Decorators junk.
- Utterly disconsolate
 sagacity!
- A spent force.
- Purile piffle.
- Inconsequential.
- Ill conceived.
- What monstrosity is this ?
 and to what end ?
- It is the work, if you can call it
 that, of a deluded delatente!
- Harbours pretensions well
 beyond its measly quagmire!
- I wouldn't sniff at it.
- Nincompoop.
- Fie !

Pay sheep

One set of Sewells by the graduates was included as an attraction
at an art fair featuring young contemporary art, on the South Bank,
organised by Gavin Turk – a genius at thinking up these events. This
particular one was called 'Livestock'. The theme was an English
country fair. You paid for things from the stands using sheep: one
sheep was worth one English pound. The Brian Sewell artists' stand
featured a life-size copy, in pastels, of Holbein's *The Ambassadors*.
There was a real bowl of plums, as well. The plums were quite funny
because a plummy accent is his identifying trademark. The artists
wore Brian Sewell wigs and old-fashioned artists' smocks. The idea
was to have a lesson at the Brian Sewell Academy (for the price of
a few sheep) and get some help with your drawing. 'Good drawing'
would obviously be a sound basis for any kind of art, a reactionary
art critic might be expected to think.

Royal purple prose style

Art-world people often say, with a weary sigh, that Sewell 'doesn't
really understand contemporary art' – it gives them a warm feeling
of belonging to imagine that they do understand it. But it's more
that he can't be bothered to understand it, which I think is admirable.
And I don't know that his attacks on it are all that uninformed or
unobservant. In fact the way he applies his mock old-fashioned,

Darren Phizacklea and Rory Macbeth, *Waxwork of a Brian Sewell Lookalike*, 2000

'fine' writerly style and camply elevated – or even sometimes quite genuinely elevated – critical tone to the art world's sacred artist-cows of emotional vacancy and distance can be quite effective.

Go easy on Tomoko Takahashi

When Sewell was on the Channel Four Turner Prize TV programme once, going round the show with me and commenting on what he saw, I found him restrained and thoughtful, and I was impressed that he tried to find something worthwhile in everything. Driving home after the filming, I got in a panic that the discussion would never be used in the final programme, because I'd been a bit facetious and insulting about some of the work. I thought I'd blown my good idea of getting him on the programme to give it a different texture than usual. But then when the item was broadcast it was skillfully edited so we both came over as thoughtful philosophers, seeing the bigger picture on every issue.

Good

Chatting with Sewell before the Turner Prize filming, I found him interesting, educated, sensitive and genuinely desiring to be friendly. And when he got into a discussion about Palestine with my wife – who was also backstage – it turned out he had a liberal pro-Palestine line. He was against the Balfour agreement because he thought it sold out the Palestinians. It's clear from his non-art *Standard* columns he's a bit of a sympathetic leftie guy, even if his art ones are conservative.

17
CALYPSO

Norman Rosenthal

Different type of DJ

It was November 2000. Wolfgang Tillmans went up on stage
to accept his Turner Prize. He made a speech full of dignified
formalities but with some giggling mixed in, to suggest he
felt uneasy with formality, even though he was wearing a tuxedo.

Tramps not carousing at Turner Prize

Tillmans gives the impression he does photography for one or two
magazines, but he has a special affection for *The Big Issue*. But
somehow the Channel Four cameras failed to pan round to little
scenes of invited-in homeless people quaffing champagne at the
dinner tables, at the Turner Prize. Maybe he's got an eye and he's an
airhead as well – this shouldn't be an impossible contradiction. After
all, it's more or less how Cézanne praised Monet. I personally can't
take his photos seriously, because I think they're for a younger age
group. But when I see a lot of other photo-art – with its Emperor's
new clothes approach to meaning – I appreciate the point of him,
because he comes up with some good asymmetrical arrangements
now and then.

No need to always be profound

In one of the groups that gathered after the Tillmans speech at
Tate Britain, Norman Rosenthal, the Royal Academy's exhibitions
secretary, said his nickname now for 'Apocalypse' was Calypso. He
said he thought the actual title might have been asking too much
from the audience; they expected gore and forgot that Apocalypse
can mean heaven too. He said he had a show of Turner watercolours,
in the Sackler gallery, upstairs at the Royal Academy, and at the
special dinner given for the opening of the show last night, some
Japanese guys had turned up, under the illusion it was the Turner
Prize. Some light scoffing at Tate Britain and its arbitrary
juxtapositions of old and new paintings started up. The *Sunday
Times* art critic, Waldemar Januszczak, said thematic shows were
doomed to fail – as he was saying only the other day to Michael
Jackson, the confusingly named director of Channel Four. Of course,
a Michael Craig-Martin glass of water and a Braque glass of water
are both glasses of water, he philosophised – but people want a solid
narrative and a bit of meaning. 'I agree', I said. 'Do you know Karen
Wright, the editor of *Modern Painters*?' I asked him. 'What a
fantastic magazine you run!' he said to her. Norman said he told the
Tate Britain director, Stephen Deucher, the other night, the only
hope for Tate Britain was to make itself into Amsterdam's Van Gogh

Norman Rosenthal

museum, only with Turner instead: 'There just isn't enough there otherwise!' 'What a fantastic idea!' I said. I really did think it was quite good and it became my campaign too, for about half an hour. But usually when I'm agreeing with this kind of thing, I'm only being oily. I don't see there's anything wrong with that. About two out of a hundred comments might be interesting in any social situation – you can't just glare furiously until a profound one comes up. Rosenthal is very theatrical, with a decadent Roman look. Whenever I see him, I exclaim 'Darling!' as a joke, partly out of nervousness as well. But gradually it's become a reality and it feels natural now. When you shake his hand, he goes on holding it and launches into stories about himself and his own cleverness. And the fact is, he *is* clever and it's enjoyable.

Busty

After this schmoozing in the Tate rotunda with strawberries, there was further schmoozing for all the nominated Turner Prize artists at a party in Shoreditch Town Hall, near Hoxton. The women taking tickets at the reception, and serving free vodkas and Beck's beer upstairs, all seemed to have been hired by an outrageously sexist agency, since they were uniformly busty, blonde and young. No one minded the sexism, though, because it was sexy.

Charming

The music at the Town Hall was loud and everyone had to shout to talk. At these art parties, people want the do to be visually young, sexy and trendy. In reality, beyond about age twenty-three, it's hard to bear the full reality of loud music and partying, to be shouting continuously and sweating. Hands touched my back. I turned round and it was Andrew Graham-Dixon, the presenter of the BBC TV series *Renaissance*, waving his arms and shouting. He looks like a charming doleful French detective from the 1930s, and women always want to kiss him. 'What are you doing now?' I shouted. He bellowed whatever it was he was doing, some writing or other. Then he bellowed that there was someone he wanted to find, and I bellowed, 'How marvellous!'

Blasé

Still at the party, I tried going out through some nearby doors to get some air, but they only led to darkness and I was afraid to be alone out there. So I went back through the crowd to find the stairs down to the main entrance where lights blazed. On the way, I got a lot of

bellowed congratulations for the amazing rudeness and blasé bored irritating knowing laziness of my commentary for the live Channel Four film of the Turner Prize award ceremony earlier in the evening. What a triumph the evening was turning out, I felt.

Ream

Downstairs in the Town Hall's reception area, some of the party guests rested their ears and cooled their sweat glands. I looked over at a writer and told the BANK artists – one of them was saying she'd met this same writer the other day – that all this writer does is hack out a lot of out-of-control feminist nonsense: 'Hysterical, reams of it'. Then the writer came over and I said what great artists BANK were and how fantastic the writer was.

Perils of cool

The other day at lunchtime I came down the stairs at the Groucho Club and saw Sarah Lucas on a sofa, laughing. She wore a calfskin jacket I hadn't seen her in before. Since I was looking at her, and not where I was going, I walked into the piano at the bottom of the stairs and gave myself a severe dead-leg. 'Hi, Sarah', I gasped. 'You look nice'. I had to bend over sharply in pain, but tried to go on walking at the same time, to seem in control. From this position I got a semi-upside down view of Damien Hirst, on the sofa opposite Sarah, also laughing and talkative. Maybe they'd been there all day. Perhaps they'd just come back from Hirst's private view at Gagosian in New York, which he'd flown 60 mates out to at his own expense. He put them all up at the Soho Grand, and the police had to come and tell them to turn the noise down. In the *Vanity Fair* article where I read about this, the whole idea was of Hirst's fantastic, Iggy Pop-like, party-animal lifestyle. 'You're insane, really insane!' was one of the quotes, from one of his publicists, I think. It was like the Situationists' worst nightmare – total idiotic, unreal media fantasy being allowed to stand for reality, because everyone is too conditioned by it to ever think of challenging it. But the fact is I found myself looking at him and Sarah on opposite sofas at the Groucho, and thinking how entertaining they looked. He was particularly entertaining because he'd dyed his hair peroxide-blond. Then out in Old Compton Street I thought that even though I hadn't liked it very much when it was happening, I'd had an important insight today. Doubled up in pain in an undignified position – virtually on the floor – all I could think was how cool the core yBa artists still are.

▶ A SECONDARY CONSEQUENCE OF ADDITION:
J.P.S.' GENITAL NAUSEA HEWN FROM THE ROCKS OF THE EARTH.

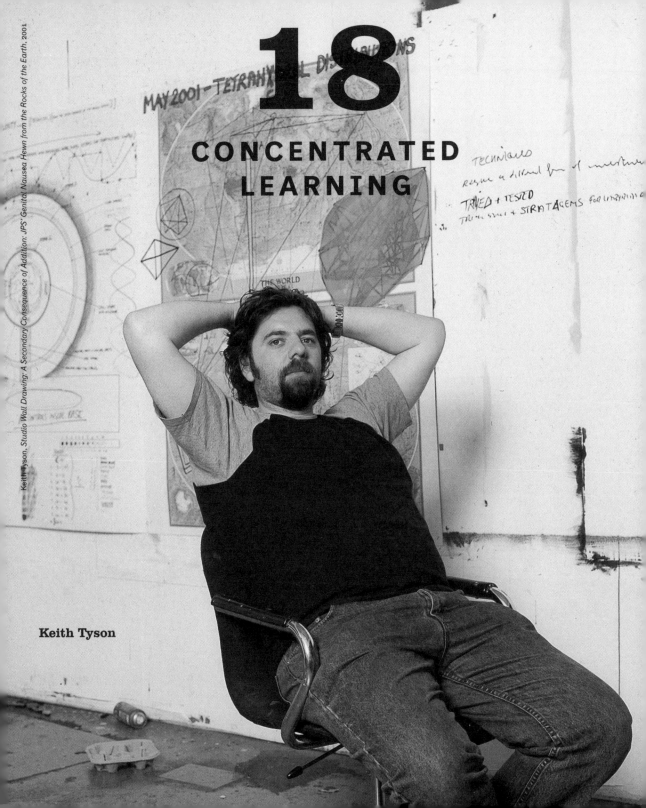

18
CONCENTRATED
LEARNING

Keith Tyson

Keith Tyson, *Studio Wall Drawing: A Secondary Consequence of Addition; JPS' Genital Nausea Hewn from the Rocks of the Earth*, 2001

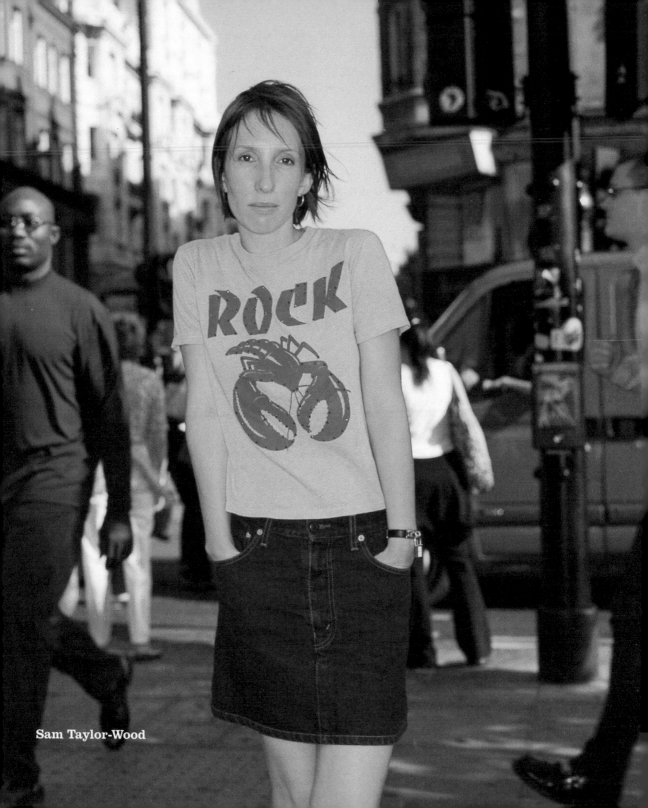

Sam Taylor-Wood

The great poets and art today

When you meet anyone famous, it's striking how they have the same resentments about other people's success that people who haven't yet achieved any success typically often have. You might think it's the solipsism of the age, but it was the same in previous ages. In *Byron and Shelley: The Last Days*, Edward Trelawney describes how he met Wordsworth for the first time. In a state of excitement he tried to get down to a bit of serious interrogating straight away, so he could record it for posterity. What did Wordsworth think of Shelley? 'I would never read him!' said Wordsworth. '*The Cenci!*' gasped Trelawny. 'Not good enough!' said Wordsworth. After Shelley was safely drowned, Wordsworth started publicly expressing how he had a bit of sympathy for Shelley and found him marvellous. And the fact is, when you find an artist surprisingly enthusing about another contemporary's greatness you can bet they probably share the same gallery or agent, or there's some other mundane explanation. And usually all you'll ever hear is bitching and carping.

What?

In Sam Taylor-Wood's early work, which was funky and funny and a bit obscene, there was little to indicate she'd be rising as high as she has done. But then gradually it was clear there was a sexy, fashionable exciting atmosphere about her photos, as they began to be populated by stars like Elton John, and Ray Winston – the star of *Nil By Mouth* and *Sexy Beast*. Looking at something by her the other day, with all its gloss, I could see there was a bit of aesthetic judgment going on there, and a flair for staging and arranging. I remembered she'd turned up with Jay Jopling, her husband, and Hugh Grant, to the wrap party for *Bridget Jones's Diary*, which for some reason I was at too. A jazz/world music/contemporary r'n'b/ fusion sound, which would have made Lester Bangs cringe and twitch in his grave, came out of the amplifiers of the live band. She shouted hello over the racket and laughed, saying, 'I don't know what on earth I'm doing here!' As if, because of her being an art person, a light-hearted celebrity-do was the last place you'd expect to find her. But I was awestruck at finding myself face to face with Hugh Grant. I could only think that media stars are spectacular representations of living human beings, distilling the essence of the spectacle's banality into images of possible roles. Before any more Situationist quotations could flood into my mind, I tried to think of a way to make conversation. I asked, 'Are you glad it's over?' because it was a wrap party, which means end of filming. But because of the music

Sam Taylor-Wood, *XV Seconds*, 2000

he couldn't hear. He shouted back, 'What?' I said, 'Are you glad it's over?' He shouted the same thing again: 'What?' I couldn't understand what he meant so I asked, 'What?' Then he shouted, 'Are you?' I said, 'What?' He shouted, 'Are you?' Then he'd obviously had enough of the impasse because he turned away sharply. After a moment, when I looked up I saw him in the distance ascending a metal staircase. I felt disturbed. I had the horrors he might have thought I was referring to his break-up with Liz Hurley, which was in the papers a lot at that time.

Spectacular laser show
Readers may be wondering how that Tate Modern opening party at the beginning of this book ended. In fact it was on a note of personal shame. Everyone was politely turned out of the new gallery and they streamed into the night. I left with my wife and some friends of ours, including Andy Gill, the former guitarist in the Gang of Four, who'd made a big hit tonight with Jilly Cooper. Why mention celebrities at all? I don't know! It's infectious, I suppose. But then I realised I'd left my bag behind and I had to go back and get it. And when I came out into the dark, alone, this time feeling a bit existentially doubtful – had I been inane on TV? Was I really going to go on wasting my life like this? Did I look fat? – I saw Keith Tyson, the artist. He started grilling me about an article I'd written for *Observer Life* magazine, where I'd said his work was 'bullshit'. Behind us crowds watched a spectacular laser show shooting up the side of Tate Modern's brick tower. Tyson, who is in his 30s, and a very big guy, does a playful, questioning type of conceptual art, where you can't tell if he really means the questions, or even exactly what they are. The notions seem familiar but at the same time slightly far away, as if they don't have the urgency of something newly minted, but already exist, out there in the ether, or at least in art-world ether. That's what I felt when he talked about a large blackboard drawing in his studio, when I was interviewing him.

Resist Delfina

The *Observer Life* article was supposed to be a day in the life of
the art world. It used a cliché journalistic form, where the writer
goes round to a lot of different places, interviews people, and a
photographer takes shots, and it's all supposed to be a normal day
in the writer's exciting life. At one point, I'd turned up at the Delfina
Studios. It might have been out of an unconscious impulse to put
up a bit of resistance to the extreme trendiness of this place that
I wrote something negative about Tyson's work. The Delfina is a
restaurant/studio set-up, near Tate Modern, kind of an art veal farm,
where you can get some concentrated learning atmosphere for a
couple of years, if you're a young artist. And then you come out the
other end even more concentratedly trendy than when you went in.
At this time, Tyson was on the board of people who decided who
was trendy enough to be admitted.

Millions of things

I could see immediately there was no way of explaining what Tyson's
work is about, except to say it's about a hundred million things. It
isn't about a single concise thing – and that, for me, is the work's
drawback. It's my own little tic, or neurosis, of wanting not to be
drowned in a sea of art-world gibberish, that makes me feel I have
to ungenerously say that a nonsense element is there. You look at his
paintings on paper, they look good, very confident and talented and
energetic. But if you really do read all the writing that's in them, you
can feel let down – both because of a lack of clarity to the ideas and
the way they're familiar from quite a lot of contemporary art. On the
other hand, I often don't really care about ideas anyway, and when I
see a patch of writing in one of his paintings on paper, among many
other patches, reading something like *fusion of the exhaust output
with squid ink from the other logic*, I have to smile. And when I see
his talent for colour and for the placing of forms, plus his light touch
as a draughtsman, and his good use of a Jean-Michel Basquiat visual

design language, I have to admit he's certainly found a way to frame hyperbole so it works.

Merciful

There was another bit of the *Observer Life* article I regretted, where I'd asked Gilbert & George why they left Anthony d'Offay – 'Because he's a cunt!' they laughed. But whenever I see d'Offay, he's always friendly and says, 'I like your horrible books!' And his assistants fill my arms with free catalogues. So I thought I'd be OK with him. Mercifully amnesia intervenes as far as the whole encounter outside Tate Modern went. But I do remember one bit where Tyson said, 'OK, everyone liked the Gilbert & George story, but what do you mean dismissing my work like that?' I couldn't help noticing that I felt bucked up by this bit of sideways praise. I said it was a misunderstanding that I didn't like his work, which was true, and wriggled off like a worm.

Combative

I met Tyson again, nearly a year later, at the opening of the 'Beck's Futures' competition at the ICA. He said he really had been revving up for combat last May, because someone had told him I was used to fighting. I said that, on the contrary, I would always be the one in the room guaranteed to run away. Although, it's true I did hit a poet once at *Artscribe* (the art magazine I used to edit), but I was sacked for doing it. In any case, Tyson seemed willing to forget about having a fight now. I asked him if I could go round to his place soon with a photographer, to take pictures for this book, and he agreed.

Artist of the people

Keith (I felt he was my friend now) and I agreed: our favourite artist, in terms of keeping up an old-fashioned artist-persona in a pc world often hostile to the old-fashioned ways, is Julian Schnabel. And Schnabel's most magnificent recent act was his gag of a thousand paintings for a thousand dollars each, where he really did do the paintings, sold one each to all-comers for a thousand dollars, made a million dollars, and said, 'There you are, I'm an artist of the people!'

JACKSON POLLOCK
De Kooning
Greenberg
Neo Dada
Rauschenberg
formalism
Feminis[m]
Abstract Expressionism
abstraction
post painterly abstraction
Stella
Social art
POST MINIMALISM
Political art
a
process
Colourfield
B. Newman
OP
Sculpture
Lightart
PERF[ORMANCE]
happenings
Scribble
assemblage
hard edge
MINIMALISM
documentation
Andre
action painting
Kinetic
CONCEPTUALISM
TEXT
Environments
POP
Photo realism
landart
Judd
earthart
Schnabel
NEW YORK
THE 80's
Nouveau Realisme
Critical realists
Fluxus
Arte Povera
Soft Sculpture
Capital realists
Neo expressionism
Neo Geo
Situationism
Salle
Graffiti
Pop
Andy Warhol
hyper realism
New Spirit in Painting
Super Stardom
AIDS
Gender
sexual politics
Po[p]
International Transavantgardia
Consumerism
Market
censorship
religion
Polke + Richter
neo minimalism
everything as a "look"
neo figuration
neo abstraction
neo formalism
fill the gaps
neo anything
everything

19

THE PEOPLE'S ART

Scatter

pain art

body art

actionism

striptease

anything goes

photography

video

J. Koons

neo conceptualism

ceptual bstraction

appropriation

new feminism

ERNISM

post post modernism

identity

everything

for copying!

lots of painting

So it reads like a List

Quotation

in a new

The 90's

Context

hobby art

Craft

shopping art

Looking to the past

RECYCLING

Reassembling

recontextualising

ie. it goes off in lots of directions

abject slacker

grunge

trash + Scatter

No More Movements

NO More geniuses?

Just Trends

reacting to what exists

Political Correctness

Helter Skelter

super highwa

confessional

recession busting

loads of video

state of art High proc valu

bad painting

leisure

Sensation

DAMIEN HIRST

personalities

YOUNG ARTISTS

attitude

YBA

eco consciousness

anti-P.C

new age

Globalism

post Scatter

featuring

along trash

LA

LONDON

BER

Horror

fu o Cura

-isms

PLURALISM

Shaved head style

Recently I went to a Georg Baselitz opening at Gagosian's London gallery. Baselitz invented the shaved head look for up-to-date artists, twenty years ago. There were lots of them bobbing in the crowd here tonight. Baselitz himself still had it, I noticed, but he didn't have the same stubbly beard he used to contrast it with, only a reigned-in Hoxton goatee – perhaps he was showing respect for the success of young London art. Or maybe it was a parody and he was laughing at London.

Man's dreams

These new Baselitzes were lightweight, I felt – runny, thin paint trickled across huge expanses of expensive, heavy-grain, expertly lead-primed canvas, the shapes lazily describing upside-down wispy dogs. But he's the kind of magnificent painterly genius you can forgive for occasional silliness. In fact he's always partly silly, because he paints upside-down, but his paintings usually have more impact than these ones tonight had. A man came up and said I'd been in his dreams twice now, and he'd like to introduce himself so he could check the real thing. I praised Baselitz to him, to stave him off, and tried asking if he thought this show was cleverly thin or badly thin, but he said he didn't like Baselitz at all. But then I saw him later talking intensely to Baselitz – about him being in his dreams too, I expect. Some other people came over to pay homage because I'd been on *Have I Got News For You*, and celebrity is a kind of sickness in Britain now. Instead of avoiding the plague, people want to touch others who might have it. Everyone looked around crazily to see what other minor celebrities they could recognise. I saw Baselitz's dealer, Michael Werner, was here, plus Tim Noble & Sue Webster, and then suddenly Charles Saatchi walked in. He's another great style-innovator, like Baselitz, of twenty years ago. He innovated finding art to be glamorous instead of obscure or boring, which no one in Britain had thought of before. He looked good, I felt, in my good mood. Well done to him for coming to a private view at all, since he never usually does. You never know what kind of difficulties you're going to run into at these things.

Woman's dreams

Out of the same Gagosian crowd, a woman came up and said she'd bought my books and seen my films. 'Mm'. 'Can I make a criticism, though?' 'Sure'. 'Well, you shouldn't be in your films so much'. 'Er...' 'You shouldn't be so flippant'. 'Oh OK'. 'Today's artists are

Previous page: Peter Davies, *What goes around comes around – Jackson Pollock Text Painting*, 2001

Artist's Cover: Liam Gillick, *Were people this dumb before tv?*, 2000

originally published in *Art Monthly*, December/January 2000/01, No. 242

very serious, you know. Somebody watching you on the TV who didn't know would think what they do is crap'. 'I see'. 'Of course, we need these films, except they're on so late at night, eleven or twelve o'clock – ha ha!' It was like racehorses galloping out of the gate – somebody's pent-up, complicated emotions, suddenly bursting out. 'We're supposed to be quite thick, you know!' she went on laughing, like a crazed banshee. In my pocket I had a copy of the new *Art Monthly*. It wasn't that I was thinking of rolling it up and hitting her over the head with it, but I suddenly thought of its cover, a specially designed one, by Liam Gillick. It was a sentence printed on a white field, with the words repeated several times in different colours and the repetitions overlapping, so you had to look at the back of the mag, at the list of credits and contents, to find out what the sentence said. It was a question: *Were people this dumb before TV?* I liked the magnificent use of the distancing 'people' instead of 'we' – which would have been more democratic.

Clouds move a bit
On Remembrance Day, November, 2000, I found myself in the cafeteria at Tate Britain, where I saw the architect and art collector

Peter Fleissig, and then the artist Josephine Pryde. She wore the same pin-stripe black trousers Wolfgang Tillmans had photographed her in, in his photos in the Turner Prize exhibition of an anonymous pin-stripe trousered leg. Fleissig showed me his new book of his own photos. The book is very stylish, showing private homes round the world where art he owns has been installed. He lends it out, so his collection is always mobile. It's some kind of modern idea he has. I thought I noticed the same shot of the British Telecom tower on different pages – but he said it wasn't the same shot, but slightly different, with the clouds in different positions. It was to show time passing. Only someone in the art world would find that interesting: 'The clouds moved a bit!' He's well known for an eccentric way of talking. I suppose it's because he's afraid of being bored. He talks out of synch with whatever was just said, which is an effective way of dominating the conversation, so the other person has to struggle to make sense. And he name-drops outrageously. He related some confusing gossip about the curator Harold Szeemann – a great hero of his – getting his girlfriend into the Chinese painting exhibit in the last Venice Biennale. 'Wow', I said. 'He built up a whole Chinese theme for that Biennale – and now you say it was just to get his girlfriend in!' But I eventually realised from his out-of-synch replies that she wasn't Chinese, but a hippie called Ingebord. And Szeemann, one of the classic bearded old Conceptual art-worshipping guru-curators of the 1960s, who still reign over there on the Continent, had put her in the show under a pseudonym to be provocative intellectually, not out of anything base like nepotism.

Please dominate me

Another of Fleissig's tricks I've noticed is to suddenly look profound and thoughtful and then offer to place my paintings in an important international painting survey exhibition, in Washington or Stockholm, or wherever one happens to be coming on soon. He wants to dominate me and also to show he knows which way the wind is blowing. 'What are you painting now?' he'll ask. 'Kind of diamond shapes'. 'Hmm, yes, diamonds could be good now'.

Heaven

Still in the Tate Britain cafeteria, Jo Pryde said she thought Wolfgang Tillmans was good. And I think she found his new big abstract photos of empty sky with artful scratch-marks done directly on the print to be good too, or maybe bad. She said she was at the

Cambridge Darkroom yesterday and David Batchelor (coloured plexiglas sculptures) had a show somewhere in Cambridge. I don't know if she said he was good or not. She'd just come out of the William Blake show. She said she didn't know Blake used 'contraries' so much. I was glad to have a chat about him – 'Yes! He's full of contradictions!' But when I flicked through the Tate's Blake catalogues, later, I saw something about his very specific notion of 'contraries', relating to Heaven and Hell, and making poetic reversals of values – and I wondered if she'd really known what she was saying.

The fallen

I fell into a discussion with Jo about the yBas: we agreed they still rule. Although, of course, anyone serious nowadays must address the social realm and they will tend to reject what is coherent, new or spectacular, making works that resist assimilation and create a space for speculation and complexity. Even as these words came into my head, verbatim from a review I'd read in *frieze* recently, I fell into a depression and couldn't talk any more. I dragged myself out to Pimlico tube and got the train to Piccadilly, where I'd left my car in a side street because I'd been jammed up by the crowds gathered in Whitehall that day remembering the fallen.

Films going slow

Another day, I intended to go round a great number of shows, but had too much lassitude and had to give up after just one – Tacita Dean's exhibition at Tate Britain. It was a lot of films of mostly unremarkable sights – English landscape scenes, some featuring industrial-age objects that now have a bit of nostalgia about them. I couldn't tell why the scenes were slightly out of focus, or why the shots lasted much longer than you'd expect for a normal film, but not as long as they would if it were Andy Warhol. The projectors were old-fashioned, and you could see the old film reel going round, so the whole projector experience was part of the nostalgia experience. Some of the films were a few minutes in length, but one was 63 minutes. You couldn't stay in any of them for long. There was one audio work where someone was supposed to be trying to find Robert Smithson's *Spiral Jetty* (earthwork from the early 70s). You listened to earphones, and heard voices talking confidently but inanely – as if it were a school project at a progressive school and someone had left a recording machine on by mistake: 'A gate – that's interesting, I must photograph it'.

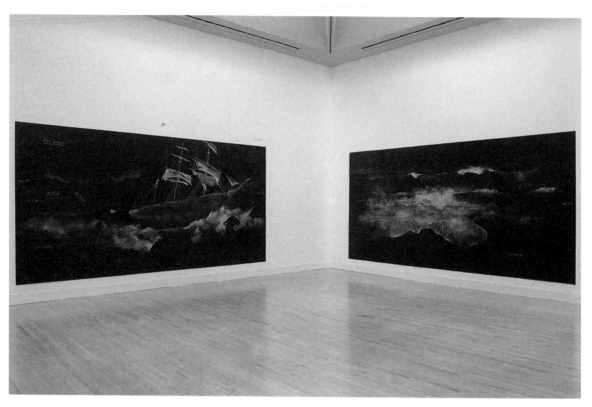

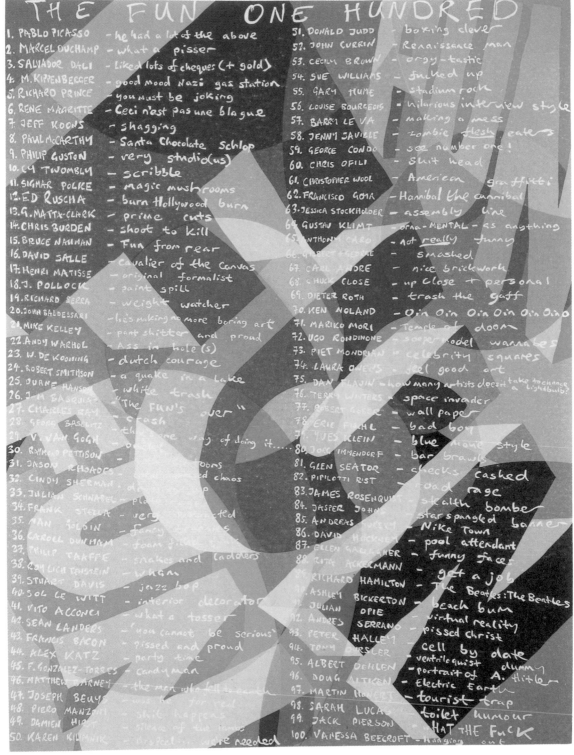

Peter Davies, *The Fun One Hundred (Fun From Rear Version)*, 2000

Dan Perfect

Miss, I've drawn a boat

Another installation at the Tacita Dean show was some large blackboards covered with wispy structureless chalk drawings of sea and boats, with words here and there. A few of the words were semi-rubbed out, but not so much that you couldn't still read them. The whole show seemed like an exhibition for someone who might be feeling like some art with a middle-class, pseudo-tasteful, twee feel, as a relief from the usual yBa decadent ironic fun feel. The successful art of now tends to evoke a tabloid world of shocking excitement. The main exception is Rachel Whiteread, whose calm lovely casts, sepulchral and dusty, with their intimations of domestic intimacy, evoke a world of lonely bedsits, with a Piero della Francesca poster on the wall. And now Dean – who was nominated for the Turner Prize in 1999 – has become another exception. The words on her blackboard drawings might have said anything really, but instead of 'Miss, I've drawn a boat' or 'black velvet paintings are quite cheap', they said things like 'The Tempest' and 'Derek Jarman'.

Drag

After the Dean show, I dragged myself home in my car. I'd planned to see 'I Am a Camera' at the Saatchi Gallery, which had been kept open a few more weeks to exploit the excitement generated by the press scandal over nude children. But I couldn't get up the energy to drive on past my own road, halfway between the Tate and Saatchi's. And then when I pulled in to my driveway, already feeling a bit despairing, I noticed I'd kept my old tax disc and fixed it in the window but thrown away the new one I'd bought this morning. For months I'd been driving around with an out-of-date disc, longing to go legit, but somehow always being too tired from thinking about art, or writing about it or filming it or whatever, to ever go to the post office. And now art had done me in again.

Fleetwood Mac

I couldn't help feeling dismayed at not seeing my name on the list of *The Fun One Hundred*, one of the paintings in Peter Davies's exhibition at Gagosian, in Heddon Street. It was the private view. I can't seem to stay away from this ritzy gallery. I saw George Condo's name at about 59 and Picasso's at No. 1. Beside Condo's name, it said *See No. 1*. And next to Picasso's, it said: *Always had plenty of the above*, meaning fun. Then beside Salvador Dali's name it said *Liked lots of cheques (and gold)* – which I thought had a familiar ring. It was from my commentary for the TV series *This Is Modern Art*, he told me. I felt cheered up suddenly, which was an achievement

because I was in a bad slump of exhaustion from hacking out commentaries for *Hello Culture*, the follow-up series. There was a dinner after, at a restaurant called Hush. Dan Perfect was there. His aunt is in Fleetwood Mac. You'd think he'd never have to work. But in any case he's an artist, and he was about to be in a show at Anthony d'Offay, curated by Martin Maloney (artist and curator). The title had 'insects' in it and 'capitalism' – it was some kind of phrase from a revolution from the past, in Havana or China or somewhere. Apparently when Maloney phoned Dan to be in the show, he said, 'This time everyone I've chosen is good'. You'd have to wonder, though, wouldn't you? Did he mean it – that you were good too, along with everyone else? You were all good? But in the past some of his choices had been bad? Would that be good? Or did he not really mean it? Some of you weren't really good? Maybe you among them? I had a chat with Perfect about the time he'd been round at my flat in Stoke Newington with Adrian Searle, when I'd just been sacked from *Artscribe*, and all the locks at the office were changed to stop me getting in. It was 1987. I'd always remembered it as a black night of despair, but he told me now I was full of jokes and he was impressed at how emotionally distanced I'd been.

Die

Earlier, at the Peter Davies private view, the actor Vincent Gallo, from *Buffalo 66*, was in a little room, heavily unshaven like an Italian Renaissance Jesus, being filmed by some girls. They were from the BBC, making a three-part oral history of the London art world, from a gossip point of view. Then two women came up to me – one of them seemed to be in charge of the other. She said she'd e-mailed me, or written to me, or something, and could I give my impression of Portsmouth? She was weighing up whether the other one ought to go there or not. 'Is it an art school?' I asked. They both looked aghast. Then the other one said she was writing a dissertation on Peter Davies and could I review the show for her, now. So I got into the mood of the situation and wrote a review for them about the flatness and whether it was working or not in all the paintings. I felt the sweat dripping off my face and I saw some drops of it on the scrap of envelope, or whatever it was, which one of the women was actually holding out in the palm of her hand for me to write on. And I felt I was going to have a heart attack and die if I didn't get out.

20

TATE GUY

Gilbert & George

La di da

It was just after midday on a Saturday in April 2001, with the torrents
coming down, when I went to Hoxton Square, and bought a copy of
Untitled from the Lux Gallery bookshop. I laughed at a specially
commissioned painted sign that said *The LUCKS* by Bob & Roberta
Smith, running across the doors of some old lockers behind the shop
counter. Earlier, I'd frowned at White Cube[2] when I'd been round
there to see the Tracey Emin show, which was full of queues. Doesn't
Jay Jopling realise that gag doesn't work – a cube would be a [3] not
a [2]? I took the *Untitled* round to the bar next door, and read an article
in it by Dave Beech, someone who often makes me smile, with his
heroic sense of class struggle. It was about Tate Modern's 'Century
City'. There were some paragraphs about how art scenes are
perceived, and how cities come to acquire a cultural identity. And
there were a few lines about the poignant greatness of City Racing,
and how a retrospective of City Racing's activities, put on at the
ICA by Matthew Higgs, was more moving than 'Century City':

> It is also, for what it's worth, a more accurate portrayal of
> my memories of London in the 90s, hanging round south
> and east London, rather than hob-nobbing with ad-men
> and restaurateurs. Their history is not mine.

I absently-mindedly doodled 'ha ha' and 'la di da' and 'get her dear!'
in ball-point pen in the margin next to these lines. And then, just as
I was absent-mindedly doodling 'Bleedin' 'eck...' beside the opening
sentences of the next paragraph –

> You can't politicise history, or get anything worthwhile
> from the past, with an organic and homogenous model of
> the social totality. Only a totality that is split by division
> can do that...

– I remembered the restaurant I'd been hob-nobbing with Gilbert
& George in last night, in Charlotte Street.

The woman nobody knew

It was a recently opened spin-off from Carluccio's in Covent Garden.
The party was made up of Gilbert & George, a mild art-book writer
and a mild art-book publisher, a curator from the Tate, and me – plus
a woman journalist everyone wrongly thought someone else knew.
'Oh, you must be rubbish!' Gilbert was saying genially, with his weird
Dolomite syntax, but with an undertone of faint menace, to the Tate
curator, about five minutes into the antipasti. Foolishly the Tate guy
had just confessed someone had told him 15 years ago they knew
for a fact that Gilbert & George were anti-Semitic. G & G had said

something so anti-Semitic in the presence of this person – who the Tate guy respected to the utmost – that the person wept to recall it. And ever since, the Tate guy had allowed this notion to colour his view of their work. He clearly thought now that it was honourable and even courageous to express out loud something awkward that bothered him. But to Gilbert & George it was the height of annoyance, because the Tate has never given them a show or much recognition of any kind – and here was a Tate guy saying he'd allowed somebody's prejudiced fantasy about them to prejudice him against them for 15 years.

Tortured selfhood

The occasion for this Gilbert & George dinner was a showing at Tate Modern of the film *The World of Gilbert & George*, made 20 years ago. It started off with a slow, magnificent pan round gloomy East End streets, from the artists' rooftop, and then didn't hit a wrong note for the rest of its length, which was an hour. Throughout, the sense of a ten-years-later idea of what it is to be a British artist seemed to be blueprinted loud and clear. The interviews with lost working-class boys were pure Gillian Wearing, the sides of meat were Damien Hirst, the howling and moaning about tortured existence was Tracey Emin. And Gilbert & George making themselves into celebrities, and making their own celebritified selves the subject of their art, was pure Tracey Emin, as well, but also Sarah Lucas and Gavin Turk. The film definitely had a lot going for it, in terms of richness of ideas as well as amazing prescience and surprising beauty – the rainy streets, the close-ups of buds and twigs – not to mention acting, with its many scenes of Gilbert & George writhing and dancing.

Story of Tory

At the time *The World of Gilbert & George* was made – 1980 – the art world was torturing itself more than it does today about whether everyone in it should be left-wing or not. Today, that kind of torture is entirely mannerist – no one believes for a moment that an artist would have anything real to say about politics. But in those days, the giddiness, lightness and emptiness of social existence that we're familiar with now hadn't yet set in. And the fact is, Gilbert & George really are Tory. Or at least, it's as real as the fact that George did once vote Tory. Usually they don't bother voting. But it is certainly part of their act to be Tory. They used to say in their interviews in the 80s that Thatcher was good, and when Major came in, in the 90s, they said he was good too. I think the notion for them was that it

was ordinary instead of arty to be Tory – and ordinary was more powerful than arty. They wanted to be real artists. They felt this involved rejecting an art-world idea of what an artist should be, and having their own idea instead – something like Andy Warhol mixed with Magritte's bowler-hatted men (which makes sense, because Warholism is universal and Surrealism is the one modern art ism that British people feel thoroughly at home with). And, of course, from early days they wore suits and had short hair, instead of art-world regulation gear. And it's part of the nutty literalism of the art world's thinking about political issues for it to have seen the suits of Gilbert & George as unqualifiedly right-wing, instead of perhaps seeing them as making some more complicated statement of otherness.

Upset balance

When you look at Gilbert & George's works from any period since they began, in 1968, it's hard to find any racism. But in the 80s, it was common to hear people in the art world talk about them as if it was a simple fact that they expressed right-wing views, including racism – so why shouldn't they be anti-Semitic? On the other hand, shouldn't a Tate curator rise above gossip? In the restaurant – still – George kept insisting it was them, who, living in Spitalfields, virtually only knew non-white people, went in their houses, had them in their house, and carried on their ordinary everyday lives in their company. It wasn't intellectuals in Hampstead – like people at the Tate all obviously are – who did that. It was an impasse of broad stereotypes: 'We are the guys who know real Asians, while you Tate guys are just blowing it out your asses!' kind of thing. In terms of the moral high-ground, though, Gilbert & George had the edge. What was a curator at the Tate paid for, it if wasn't to be observant on his own account? In 15 years, why hadn't he just asked them outright if they were racist? Unfortunately the fineness of the balance of the two positions – him feeling he was being honest about a genuine confusion, but actually being slightly oblivious, in terms of tactful behaviour; and them acting a bit obliviously self-righteous about something that was genuinely hurtful – was upset by the woman journalist whom no one knew. Perhaps because of the effect of the fine wines and *digestifs* we were all knocking back, she took the tack of pretending to be a bohemian. She kept talking ostentatiously in Italian to the waiters, and then saying to the Tate guy with a silvery laugh, 'Look, don't be so uptight, we don't talk like that, we're artists' – which was untrue, since she was a journalist. It drove the Tate guy mad, because obviously it was idiotic. But also it wasn't in the

rules of his argument, or his idea of fair play, for a mad woman to be joining in and just saying any nonsense that came into her head. So he started sputtering even worse, and in fact swore quite violently at her.

More difficulty
The Tate guy probably also found it quite difficult to cope with the mild art writer and mild art publisher. They kept piping up with lines like, 'Oh, I really don't think politics is very interesting, do you?' 'No, I heard something political the other day and it was awfully boring!'

Don't swear
'Don't swear, you'll really find it much better if you don't!' George was saying now to the poor Tate guy. But the row wouldn't die down. The Tate guy said several times, 'Well, are you saying you want me to leave?' (Since it was Gilbert & George paying.) But George said no – he wasn't important enough for that. That was cruel, I thought (but funny), as we all went off separately into the night, with the rain pouring, the wet streets glowing in the lamplight, and the feelings smarting.

WRITE YOUR PROTEST HERE

................TONY BLARE............

................HELP...................

................POOR..................

................PEOPLE.................

PLACE YOUR PROTEST IN THE BLACK BOX

Bob & Roberta Smith, protest card from *Stop It Write Now*, from 'Intelligence', at Tate Britain, 2000

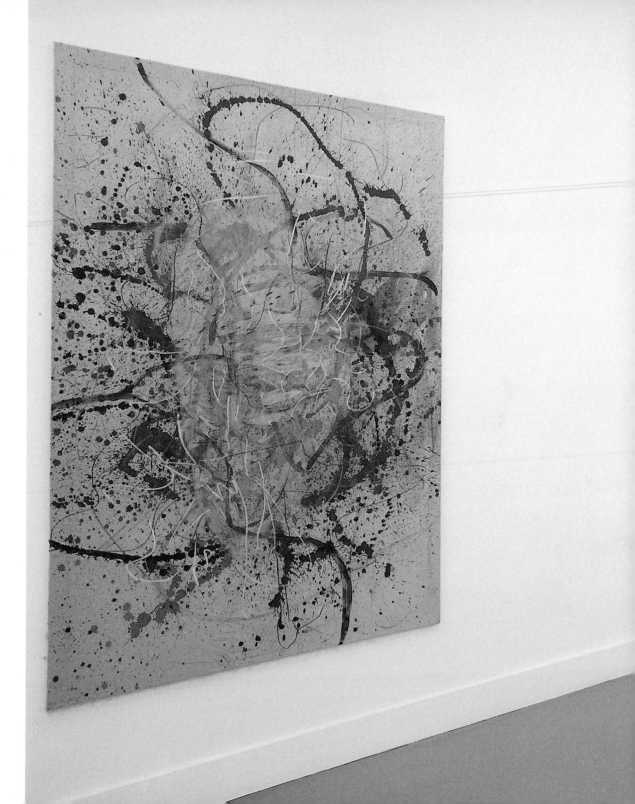

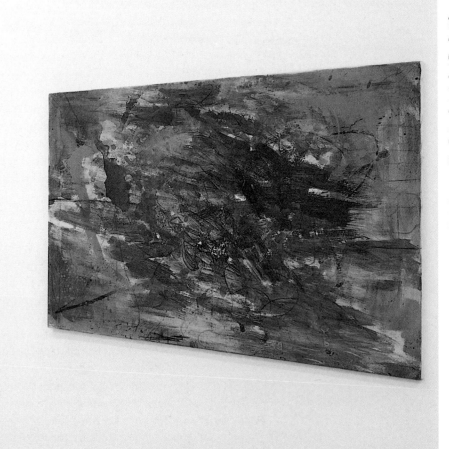

Merlin Carpenter, *When Traktors Drain the Pool, They Don't Consult the Frogs First* (installation view), 2000

Nostalgic for German art

One day I received an announcement by e-mail from White Cube that Merlin Carpenter was going to be showing there at the end of the month. This was staggering news. He's not politically correct in any obvious way so it meant being pc wasn't necessarily the only thing now. But what was he, then? I racked my brains – nostalgic for German art? Would you know that, though, from his last exhibition, which seems only yesterday, at the Magnani Gallery in Warren Street? I thought the answer was yes, because of the look of Sigmar Polke that his transparent, washy paintings had in that show. And from that, you'd have a Sigmar Polke-ish mental framework for working out what Carpenter's cartoon drawings of cars – in the same show – might be about. But what is German art, in the Sigmar Polke sense? It's nothing. It's the best of nothing. It's the best of fashionable Post-Modernism, where you don't know what anything means. So Carpenter is about being nostalgic for some kind of German ironic distanced relationship to nothingness, or not-knowingness, that took off internationally in the 80s? I hoped he'd be at the 'Beck's Futures' opening party, at the ICA, which I was going to that evening, so I could ask him.

Nostalgic for Kippenberger

I have a German art association when I think of Merlin Carpenter, because he used to be the assistant of Martin Kippenberger (German subversive conceptualist, painter and mixed-media artist, who died in 1998). He was a student in his last year at art school in about 1990 when I introduced him to Kippenberger at the Chelsea Arts Club, where I'd invited them both to dinner, because Kippenberger was over in London to make something for *The Late Show*. He said he'd like to be Kippenberger's assistant, so the next day I went round with Kippenberger to Carpenter's parents' house in Chelsea where he was still living. We looked at his sheaves of A4 drawings that copied Kippenberger's style and the style of Kippenberger's painter colleagues, Albert Oehlen and Werner Büttner. The drawings were in felt pen or ball-point, or the pencil line was so regular it seemed like felt pen. Kippenberger said it was a bit disturbing, like going round to your stalker's house. He also said the drawings were good in neat piles, almost sculptural, they didn't need to be seen individually – clearly there was some sympathetic chemistry here between Kippenberger and Carpenter. Then the next thing I heard, Carpenter really had been taken on as an assistant by Kippenberger in Cologne, and as some kind of

project he'd been sent round to Oehlen's and Büttner's studios too, to assist them, each having him for three months. He started jetting round the world, being a superstar assistant.

No to sense

After that, a little scene of ex-St Martin's students started up in Cologne. Carpenter became more and more of a superstar artist himself. His art was model cars and paintings from computer-generated drawings of any old thing, it seemed; it was a coded world. But it looked like European obscure superstar art, and it worked on a European superstar circuit. Then he was back in London in the mid-1990s with a little project going on in Charing Cross Road, called Poster Studio, where various underground art activities went on. It was hard to understand what any of them meant, or why they were good – which was obviously excellent. But gradually it became clear there wasn't any real acceptance of his superstardom here, only abroad, where he continued to have shows at incredibly prestigious venues. It made sense he should be at Magnani the other day, because they show a lot of obscure contemporary continental European art there.

Find own intensity

Lost for something amusing to say, at the Carpenter private view at Magnani, I asked him if he'd ever met JJ Charlesworth, and he laughed and said yes, in fact he was upstairs now – I would recognise him because of his young-fogey clothing style. But he'd left already. So I asked Carpenter what his drawings meant. Or maybe he just told me anyway without me asking. But I still couldn't understand it, even when he told me quite clearly what it was. He's always clear, intelligent and civilised in person. He never acts like he's about to punch your face in, which is how many artists do act nowadays – I suppose because they're struggling to find some point of intensity or authenticity within themselves.

Find own level

Last night at the 'Beck's Futures' award ceremony at the ICA, Patrick Brill (Bob & Roberta Smith) stood on the stairs. I went up to him with my wife to say hello. He said, 'Don't take this the wrong way, Matt, but would you be interested in putting something in an exhibition I'm organising?' The little card he handed me with details of the show's title and how to submit a work to it included the line: *Bob & Roberta Smith host the search for the worst work of*

UNATE

a Smith host the search for
k of art ever produced

ZE
ed during the private view on
0pm

art ever produced. That put me on edge for the rest of the evening, although I had to acknowledge I still had a warm feeling for Patrick's contribution to 'Intelligence'. This was his installation *Stop It Write Now*, where he invited members of the public to fill out little cards with their notions of what a social protest might be. He sifted through these gems and painted the best ones up on the Tate walls. He has a genius for joining together different rhetorical styles to make something mildly anarchistic. Even the mildness has a touch of genius, since anything stronger would be too conventionally arty.

Horses and foxes

After that, I saw the curator I'd enjoyed talking to at the Rut Blees Luxemburg exhibition recently. She stood next to Brian Griffiths's sculpture, a horse and rider about fifteen feet long, which looked as though it was made of bits and pieces from jumble sales. The rider had a black plastic rubbish bin instead of a head. I asked her if she thought it looked like it had any integrity, or did it only exist to be bought by Saatchi? She said she had problems with the base. 'I've been to 50 studio visits this *week*? And they've all done this elaborate hand-made type of *base*?' She said she thought it was the influence of Thomas Hirshhorn, the Swiss artist. She was amazed I didn't know him: 'He got the Marcel *Duchamp* prize?' This is the new French equivalent of the Turner Prize, which is progressively international, not regressively national like the Turner Prize. The curator had just been over to see it in Paris, and she'd been incredibly observant about the signs in the customs hall. 'It said Food and Mouth instead of Foot and Mouth'. 'Ha ha'. 'Because of Food and Mouth, you couldn't bring back any meat – and no *trophies*?' We laughed at the idea that in France they still think Britain is a fox-hunting nation and anyone who comes here wants to take home an animal head. This curator really is red hot.

Fridge magnets

'Ah hello, Sarah', I said, when Sarah Staton appeared next. The rest of the 'Beck's Futures' crowd was mostly much younger, the strivers-to-make-it in 2001 rather than *c.*1991, which is her generation. She's a friend of Merlin Carpenter's, but she said I couldn't interrogate him tonight because he was in Berlin. She was with Jo Pryde, whom she'd been with when I first met them both, which was in fact in 1991 when they'd been round to a party at my flat in Stoke Newington. Damien Hirst had been there too, grinding out fags on the carpet, and filling up not quite drained lager cans with further butts, before

Sarah Staton

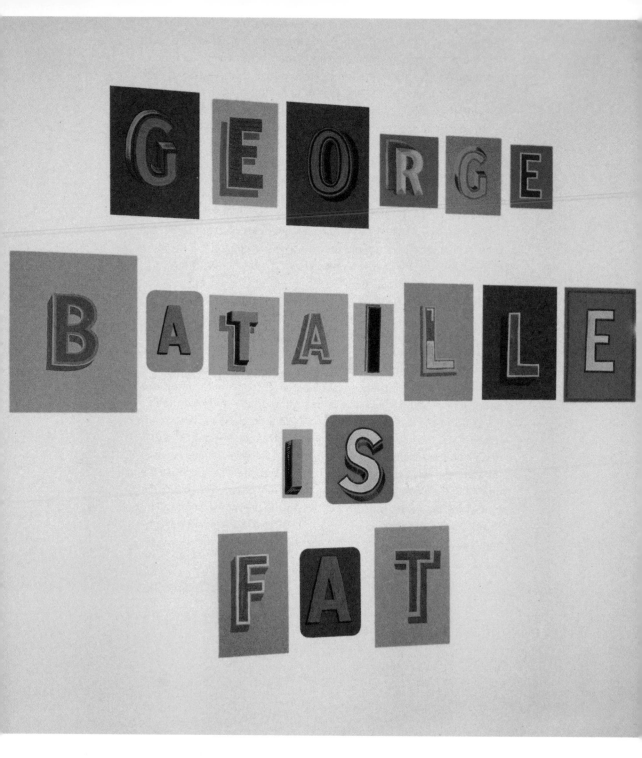

leaving early. Then after a few hours there were only a few people remaining, all sitting in the kitchen. One was Liam Gillick; the rest was Merlin's crowd, including Jo and Sarah, and some other friend of theirs. And for amusement they all turned on Liam – whom they'd all only just met tonight – and teased him. They tried to freak him out with their mockery. In the meantime, I noticed they'd arranged my little daughter's fridge magnets to read M-E-D-I-A-G-U-Y on the fridge door, to give me the evil eye too. Then Merlin asked if I thought they ought to leave and I said, 'Yes!' So they all did. Afterwards, Liam had a bit of a soul search – in his own emotionally distanced way, of course – about what they could have meant by giving him such bad vibes. But with the benefit of hindsight it's easy to see the reason, which is that he was a writer on *Art Monthly* at the time, and still being students they were over-excited about being in the same room with an art-world power person.

Nation's website junk

Now here was Sarah ten years after, at a plastic youth event at the ICA. I like her; she's always friendly. I like her paintings and the paintings of her husband, Simon Bill, who was in the 'Beck's Futures' show tonight, even though he's a relative oldster – 42. She was having a show of paintings on jeans material somewhere, and I asked her how it was going. She said it was going great – and how about me? I told her I was writing this book about the nation's nervous breakdown, and how it was expressed by art. And she said, 'Yeah, that's about it – and everyone wants to do business courses now so they can start up eyestorm.com!' This is a website where you can buy limited edition screen prints by contemporary artists. We rolled our eyes at the madness. She asked, 'What's the line of the book again?' I said it was a description of the art world from the point of view of someone who wished it could be better.

Sarah Staton, *Krazy*, 1999

PICTURE CREDITS

We are very grateful to the artists, curators, critics and other participants for their permission to reproduce the works and for agreeing to have their photos taken.

The publishers also wish to thank the owners and photographers of works reproduced in this book for kindly granting permission for their use. Photographs have been provided by owners and those listed below:

INTRODUCTION
Photograph by Rory Carnegie (pp. 4–5)
Courtesy The Saatchi Gallery, London (pp. 6–7)
Photograph by Prudence Cuming Associates Ltd. (p. 7)
Courtesy Cabinet Gallery, London (p. 13)

CHAPTER 1
Courtesy *The Independent*/David Sandison (pp. 14–15)
Courtesy Tate, London (pp. 16, 19, 22–23, 26)
Photograph by Imagination, London (p. 16)
Courtesy Jeremy Deller (p. 17)
Photograph by Desmond O'Neil (p. 19)
© Mark Wallinger, courtesy Anthony Reynolds Gallery, London (p. 29)

CHAPTER 2
Courtesy Tate, London (pp. 31 and 42)
Courtesy Wayne Lloyd (p. 33)
Courtesy Stewart Home (p. 36)
Courtesy BANK (p. 37)
Courtesy Jason Evans (p. 41)

CHAPTER 3
Courtesy BANK (p. 45)
Courtesy Anthony d'Offay Gallery, London (pp. 48–49)
© Sreve McQueen, courtesy Thomas Dane Ltd., London and Marian Goodman Gallery, Paris/New York (p. 51)

CHAPTER 4
Photograph by Rory Carnegie (pp. 52–53)
Courtesy Colin Lowe and Roddy Thomson (pp. 59, 61, 62)

CHAPTER 5
Courtesy Jeremy Deller and Alan Kane (pp. 65, 69–73)
Courtesy Billy Childish (p. 66)
Courtesy Eugene Doyen (p. 66)
Courtesy Marisa Starwell (p. 67)
Sleeve design by Alison Wonderland for Damaged Goods Records, London (p. 67)
Courtesy Corvi-Mora, London (p. 76–77)
Courtesy Tate, London (p. 77)
Courtesy Artangel, London (p. 82)
Photographs by P Taghizadeh (p. 82)

CHAPTER 6
Courtesy Jay Jopling/White Cube, London (pp. 83, 85, 88, 90–91)
Courtesy Lux Gallery, London (p. 86)
Photograph by Stephen White (p. 88)

CHAPTER 7
Courtesy Jemima Stehli (pp. 93 and 99)
Courtesy BANK (p. 94)

CHAPTER 8
Courtesy Fiona Banner/Frith Street Gallery, London (p. 102)
Photographs by Matthew Collings (pp. 104–107)

CHAPTER 9
Courtesy The Whitechapel Art Gallery, London (pp. 108–109)
Courtesy Rory Carnegie (p. 110)
© Hans Haacke/VG Bild-Kunst, Germany/DACS, London (p. 113)
Collection of Lila and Gilbert Silverman (p. 113)

CHAPTER 10
Courtesy BBC Picture Archives (pp. 116–117)
Photograph by Richard Kendall for BBC (pp. 116–117)

CHAPTER 11
Courtesy Verso Publishing, London (p. 124)

CHAPTER 12
Photograph by Rory Carnegie (p. 131)
Courtesy ICA, London (pp. 132, 134, 135)

CHAPTER 13
Courtesy Visual Arts Administration, Royal College of Art, London (pp. 138–139)

CHAPTER 14
Courtesy Laurent Delaye Gallery, London (p. 144)
Courtesy Modern Art, London (p. 149)
Courtesy Rod Dickinson/John Lundberg (p. 150)

CHAPTER 15
Courtesy Flowers East, London (pp. 153, 155, 156, 162–163, 165)
Courtesy Mark Wilson Fine Art, Cross Street Gallery, London (p. 154)

CHAPTER 16
Courtesy Modern Art, London (p. 167)
Courtesy The Saatchi Gallery, London (p. 170)
Photograph by Stephen White (p. 170)
Courtesy Darren Phizacklea and Rory Macbeth (pp. 178 and 179)

CHAPTER 18
© Keith Tyson, private collection, Switzerland (p. 186)
Courtesy Anthony Reynolds Gallery, London (pp. 186 and 192)
© Keith Tyson, collection of Thea Westreich and Ethan Wagner, New York (p. 192)
Courtesy Jay Jopling/White Cube, London (pp. 190–191)

CHAPTER 19
Courtesy Gagosian Gallery, London (pp. 194–195, 201)
Photograph by Stephen White
Courtesy Art Monthly (p. 197)
Courtesy Tacita Dean/Emanuel Hoffman Foundation, Basel, Switzerland/Tate, London (p. 200)

CHAPTER 21
Courtesy Bob & Roberta Smith (pp. 210–211, 214–215, 218)
Photograph by Rory Carnegie (pp. 210–211)
Courtesy Magnani, London (pp. 212–213)
Courtesy Sarah Staton (p. 219)

Portraits © Rory Carnegie (cover, pp. 28, 34, 55, 58, 75, 78, 87, 89, 95–98, 100, 103, 123, 125, 126, 129, 133, 137, 143, 147, 148, 151, 159, 160–161, 169, 174, 177, 181, 183, 187, 188, 202, 205–206, 209, 217)

The publishers have made every effort to contact all holders of copyright works. All copyright holders who we have been unable to reach are invited to write to the publishers so that a full acknowledgement may be given in subsequent editions.

ACKNOWLEDGEMENTS

Thank you very much to everyone who helped with this book. Above all, my wife, Emma Biggs, who patiently put up with a lot of inane questions being fired at her over a long period, along the lines of, 'What is the meaning of...?' I have been helped immensely by my editor, Linda Saunders. Thank you also to Rory Carnegie and his assistant, Charles Glover, for great photos, Fraser Muggeridge for amazing patience over the whole design and layout process (plus great ideas and imagination); Miranda Glover for being in charge; and Marisa J Futernick for superlative research into a lot of weird-looking art-works and their titles.

Matthew Collings, September 2001

ALSO BY MATTHEW COLLINGS FOR 21 PUBLISHING

Blimey! From Bohemia to Britpop: the London Artworld from Francis Bacon to Damien Hirst

ISBN 1-901785-03-3
£19.95/$29.95

Blimey! is a racy account of the London contemporary art scene: a snapshot of the new Bohemia of the 1990s, interwoven with episodes from the author's own life in London. It's a journey from the anguished screaming canvases of Francis Bacon to the witty ironic sliced farmyard animals of Damien Hirst. Its specially-commissioned photos by documentary film-maker Ian MacMillan bring you face to face with London's artists, dealers and critics.

'Hilarious and horrible, intelligent and frightening, Blimey! is the book the art world deserves'. Adrian Searle, *The Guardian*

'In its laconic way this has the moral weight of great criticism'.
David Sylvester, *Independent on Sunday*

It Hurts: New York Art from Warhol to now

ISBN 1-901785-00-9
£19.99/$29.95

Matthew Collings turns his attention to the New York art scene, and applies the same keen, unpretentious intelligence and perceptive wit that made *Blimey!* such a resounding success. Here, at last, is an art critic who neither inflates his language nor 'dumbs down' his observations – Collings has created a new, immensely readable but no less thoughtful way to write about art and art makers. From Warhol himself to the critics, artists and dealers in the 60s, to super-brats of the 80s like Koons and Schnabel, and right up to the young players of the 90s – all of them come to vivid life on the page, and are as believable, human, vulnerable and monstrous (often all of these at the same time) as the characters in a first-rate novel. Lavishly illustrated with works of art and specially-commissioned photographs of New York's main players by Ian MacMillan.

'It Hurts ships the bemused Brit across the Atlantic. Collings capably hammers together reportage, assessment, and a lot of dish and adeptly breezes away the fog of blather that accumulates around art'. Dom Ammirati, Newsweek

Both titles are available direct from www.21publishing.com or through all good bookshops.

ABOUT THE AUTHOR

Matthew Collings is an artist and writer. He went to the Byam Shaw
School of Painting, 1974–78, and to Goldsmith's College, 1990–92.
From 1983–1987 he edited the magazine 'Artscribe' and from
1988–1996 he worked as an art critic and occasional presenter for
BBC2's 'The Late Show'. Since leaving the BBC, he has written
and presented two major television series for Channel 4 – 'This Is
Modern Art' and 'Hello Culture'. A further series on the art of the
old masters is currently in production.